SPECTACULAR DIGITAL EFFECTS

SPECTACULAR DIGITAL EFFECTS

CGI and Contemporary Cinema

KRISTEN WHISSEL

DUKE UNIVERSITY PRESS

DURHAM AND LONDON 2014

© 2014 Duke University Press
All rights reserved
Printed in the United States of America on acid-free paper ♾
Designed by Heather Hensley
Typeset in Whitman by Tseng Information Systems, Inc.

Library of Congress Cataloging-in-Publication Data
Whissel, Kristen
Spectacular digital effects : CGI and contemporary cinema /
Kristen Whissel.
pages cm
Includes bibliographical references and index.
ISBN 978-0-8223-5574-8 (cloth : alk. paper)
ISBN 978-0-8223-5588-5 (pbk. : alk. paper)
1. Computer animation. 2. Animation (Cinematography)
3. Cinematography—Special effects. I. Title.
TR897.7.W493 2014
777′.7—dc23 2013027242

FOR ISAAC AND ISLA

CONTENTS

ACKNOWLEDGMENTS

I would like to thank Ken Wissoker for making the publication of this book possible. It has been a pleasure to work with him once again, and with editorial associates Elizabeth Ault and Leigh Barnwell. I am also grateful for the efforts and professionalism of the two anonymous readers who provided insightful, detailed, and extremely helpful comments on an early draft of this book.

The completion of this book would have been significantly delayed without a five-year Mellon Research Grant. I am extremely grateful to the Andrew W. Mellon Foundation for their generosity and ongoing support of research in the Humanities and to the University of California, Berkeley, for its Associate Professors' Research Program. UC Berkeley's COR Research Enabling Grants made the purchase of important research materials possible.

Portions of the research and writing in chapters 1, 2, and 4 have been previously published as shorter and substantially different articles and anthology chapters. An earlier version of chapter 1 was published as "Tales of Upward Mobility: The New Verticality and Digital Special Effects," *Film Quarterly* 59.4 (summer 2006). An earlier and shorter version of chapter 2 was published as "The Digital Multitude," *Cinema Journal* 49.5 (summer 2010). A shorter and substantially different version of chapter 4 was published as "Prisons and Plasmatics: The Digital Morph and the Emergence of CGI," *The Wiley-Blackwell History of American Film*, vol. 4, edited by Roy Grundman and Art Simon (Blackwell, 2011).

I extend my sincere appreciation to my colleagues, graduate students, and friends who read and commented on drafts of chapters or provided feedback on presentations of sections of this book, including (in alphabetical order) Jennifer Bean, Brooke Belisle, Scott Bukatman, Irene Chien, Mary Ann Doane, Eric Faden, Kris Fallon, Chris Goetz, Tom Gunning, Ji Sung Kim, Jen Malkowski, Russell Merritt, Sheila C. Murphy, Anne Nesbet, Dan C. O'Neil, and Mark Sandberg. I am particularly grateful to Dan Morgan and Linda Williams for providing detailed feedback on various chapters during the final stages of the manuscript's preparation.

My fabulous and indefatigable graduate student research assistants provided valuable help with locating and procuring resources. My very sincere thanks to Nicholas Baer, Irene Chien, Chris Goetz, Laura Horak, Ji Sung Kim, Jen Malkowski, and Renee Pastel. Renee Pastel also provided copyediting for a late draft of the manuscript. It has been a pleasure and a privilege to work with each of you.

Irene Chien, Jonathan Haynes, Anne Nesbet, Russell Merritt, Mark Sandberg, and Linda Williams accompanied me on some of my weekly trips to the cinema to see a number of the films that I discuss in this book, from *Avatar* and *Splice* to *Melancholia* and *The Tree of Life*. I am grateful for their good moviegoing company and the excellent conversations that followed.

As always, I am most indebted to my husband, Isaac Hager, and my daughter, Isla Hager, who made writing this book and seeing (so many) blockbuster films a delight. Thanks to Isaac for reading and commenting on chapters, fixing my computers, keeping my software updated, and happily going to see any and every film I needed to see. Thanks to Isla for calling everything a movie, for assuming that buses with movie advertisements take passengers directly to the cinema, for writing her own books alongside me, and for explaining (in a loud and serious whisper), "It isn't real, it's just special effects!" when I asked if *Harry Potter and the Deathly Hallows* was becoming too scary to watch. A film scholar couldn't ask for two better collaborators.

INTRODUCTION

Since the late 1970s the cinema has been undergoing a transformation as significant as the transition to recorded synchronous sound in the late 1920s and early 1930s and the shift to widescreen and color film in the 1950s and 1960s. Much as these earlier transitional eras made the cinema's material and technological heterogeneity newly visible and audible to audiences, the cinema's more recent "digital turn" has foregrounded film's ongoing imbrication with other media and has highlighted its status as a synthetic art made up of numerous (and sometimes overlapping) technologies.[1] In the 1920s synchronous sound demanded the integration of phonograph, telephone, and radio technologies with film technology and forced changes in technical personnel as well as in existing production, distribution, and exhibition practices. In the same way, this most recent transition is creating novel relationships between old and new technologies; transforming production and postproduction practices; altering our understanding of acting, performance, and stardom; and affecting exhibition practices and forms of spectatorship.[2] As David Thorburn and Henry Jenkins argue, the cinema's digital turn has involved it in new relationships with both emergent and existing media (such as graphic novels and comics, popular literature, television, and popular music), and these relationships are based on processes of continuity and displacement, renewal and remediation, and reinforcement and destabilization.[3] This

latest era of transition suggests that one of the defining features of the cinema is its historical variability and ongoing transformation.

As during other periods of technological change, this most recent era has given rise to scholarly debates about medium specificity and film's "essential" identity—focusing mostly on questions of film's photographic base and the "indexicality" of the moving image, and whether or not it has ever had such an identity.[4] Digital tools and proprietary software have changed production and postproduction practices, and have made possible the creation of referent-less photorealistic images in a computer with a degree of image manipulation that was impossible with celluloid. But they have also, as Lev Manovich has argued, revived the proto-cinematic practices of painting and animating images by hand, underscoring that production and postproduction practices that appear to be radically new often bear traces of the familiar and old.[5] Indeed, in his important book on digital visual effects, Stephen Prince convincingly argues that although digital tools have made possible a broad range of new creative possibilities for filmmakers and effects artists, such tools nevertheless extend the cinema's historical tendency to rely on composites (previously made with the optical printer) to create credibly realistic or breathtakingly fantastic settings, characters, and action. He notes, "Visual effects in narrative film maintain a continuity of design structures and formal functions from the analog era to the digital one. Digital visual effects build on stylistic traditions established by filmmakers in earlier generations even while providing new and more powerful tools to accomplish these ends."[6]

Despite these important continuities with the past, the rise of computer-generated images in popular cinema has functioned for many critics and scholars as the clearest sign that the cinema has entered its "postcinematic" phase.[7] As many spectators know (thanks in part to the "making of" featurettes available online and as DVD extras), many popular commercial productions are now hybrid forms that combine live-action elements with key frame animation and that synthesize filmed images (often transferred to a digital format, altered, and then transferred back again to film) with computer-generated images that are themselves strikingly photorealistic in appearance. Performances executed in front of studio-bound green screens are often seamlessly composited with digitized background plates shot on location (or created in the computer) to stage, for example, a terrifying and ultimately failed rescue in the Alps or harrowing life-or-death struggles between actors and fantastical crea-

tures that never existed together in space and time. In turn, hyperkinetic, gravity-defying action is often staged in fantastical settings, such as dream-world urban spaces that fold in on themselves or the enchanted grounds of a school of magic. At the same time, motion capture technologies transform an actor's embodied performance into binary code that is then used to bring digital beings to life, while historical figures and deceased actors appear on-screen in new roles with the help of software that superimposes their digitized visages onto the bodies of other performers.[8] The creation of such images requires much of the labor and cost of making popular live-action films to be dedicated to postproduction rather than production, with principal shooting often constituting only a small percentage of a project's time and budget. As Prince has discussed in detail, even those films that do not appear to depend heavily on spectacular computer-generated images nevertheless make extensive use of digital visual effects that may go largely unnoticed by the spectator—such as the compositing of live-action and digital elements, color correction, the removal of unwanted elements from the frame, the use of morphs to transition seamlessly from the image of an actor to his or her digital stunt double, or the addition of motion blur, grain, and the parallax effect to make digital images appear more like filmed images.[9] Even so, the cinema's digital turn and the rise of computer-generated imagery (CGI) are most often associated with the spectacular big-budget digital visual effects that have become a staple of the blockbuster film.[10]

For much of the twentieth century, special and visual effects were relegated to the margins of the study of cinema and, until recently, received little scholarly attention.[11] In the past fifteen years or so, however, scholars have published important monographs, anthologies, and special issues of scholarly journals dedicated to digital visual effects and, sometimes, their analog precursors. This new attention to special and visual effects can be attributed not only to the high visibility and increasing proliferation of spectacular CGI in popular cinema but also to the emergence of New Media as an important area of study within the arts and humanities. Some recent scholarship on special and digital effects focuses on the creation of a specific aesthetic. For example, Scott Bukatman has written about the sublime aesthetic of Douglas Trumbull's effects sequences, while Angela Ndalianis has analyzed the emergence of a neobaroque aesthetic in recent cinema and multimedia immersive rides.[12] In turn, Michele Pierson has discussed the "electronic aesthetic" of digital effects in science fiction

films of the 1990s.[13] Scholars such as Vivian Sobchack, Bob Rehak, and Dan North have focused on a single visual effect, such as the morph, bullet time, or motion capture processes.[14] Prince's book *Digital Visual Effects in Cinema: The Seduction of Reality*—the most comprehensive study of visual effects to this point—provides detailed analysis of how digital tools have been used by filmmakers to craft "synthetic image blends to stand in for worlds, characters, and story situations" in a broad range of films from the late 1970s to the present.[15] And anthologies on individual films, such as *Titanic* (James Cameron, 1997) and the *Lord of the Rings* trilogy (Peter Jackson, 2001, 2002, 2003), feature essays dedicated to the digital visual effects used in the making of those films.[16] Many of these same scholarly works share an interest in affect and the feelings of awe, astonishment, and wonder that special and visual effects are capable of inspiring in spectators, whether the object of analysis is the trick film of the silent era, the big-budget special effects in blockbuster films of the 1970s and 1980s, or the digital effects that appeared in the final decade of the twentieth century.[17] Such scholarship has opened up the study of analog special effects and digital visual effects beyond the realm of science fiction and horror, previously the favored genres for the analysis of effects.

I agree that the production of affective "intensities," moments of sublime apprehension, and feelings of wonder is undoubtedly an important outcome of analog and digital visual effects;[18] however, I would add that it is important to consider the signifying power of digital visual effects. In *Spectacular Digital Effects* I argue that many awe-inspiring, spectacular visual effects articulate a range of complex concepts and thematic concerns that are central both to the narratives of the films in which they appear and to the broader historical contexts in which the films were produced and exhibited. These historical contexts include the experience of new technologies and technological change. Moreover, individual types of effects (such as the morph or the computer-generated creature) often express such themes and concepts in similar formal and aesthetic styles across a broad range of genres and national cinemas and, at times, across different historical eras (indeed, in many instances the sustained use of a particular effect within a film is often itself indicative of the central concepts and themes with which a film is concerned). Special and visual effects have had this capacity throughout film history. Importantly, the domain of digital visual effects has expanded with the development of new technologies and software, such that these effects now appear on-

screen with increasing frequency, duration, detail, and "reality effect." As a result, digital visual effects are deployed with greater integration into and involvement with narrative, plot, setting, and development of character psychology. This expanded domain has made the textual and narrative work accomplished by effects spectacles newly visible; in the process, it reveals the considerable continuity in the expressive, emblematizing functions of spectacular effects from the celluloid to the digital era.

Any discussion of spectacular digital effects and their modes of address and signification requires a brief return to the debate about the status of the cinematic "attraction" — and its relation to narrative — in the cinema of the late twentieth and early twenty-first centuries.[19] Certainly, spectacular visual effects share a number of the features of the early film attraction as defined by Tom Gunning. They are often based on the exhibitionist display of a spectacle (or series of spectacles) that aims to provoke astonishment and directly solicits the attention of, and moves aggressively outward toward, the spectator.[20] These similarities have inspired other scholars to use the concept of the attraction to analyze the spectacular effects featured in big-budget blockbusters. For example, Wanda Strauven has argued that contemporary blockbuster films have brought about the resurgence of the film attraction — a "cinema of attractions reloaded" — that takes up with renewed vigor the early film attraction's tendency to prevail over or arrest narrative. She notes that the phrase the "cinema of attractions" has proven to be "adequate or at least 'attractive,' for the definition of contemporary special effect cinema as well" and argues that *The Matrix* (Wachowski Bros., 1999) "can be conceived of as a reloaded form of cinema of attractions in that it is 'dedicated to presenting discontinuous visual attractions, moments of spectacle rather than narrative.'"[21] While many spectacular effects (such as the use of bullet time in *The Matrix*) bear a striking resemblance to the early film attraction, I think Strauven's argument overstates the structural similarity between the two. In contrast to trick films of the early era, for example, the digital visual effects mentioned here are fully embedded and integrated within feature-length narratives that at times stretch across a trilogy. Many spectacular visual effects are not, therefore, truly discontinuous: they cannot easily be moved from one part of the film to another without destroying narrative continuity. As Thomas Elsaesser explains, a too-ready application of the attractions model to contemporary cinema can lead to the loss of historical specificity: "The notion that the cinema of attractions can ex-

plain post-classical cinema distorts both early cinema and post-classical cinema."[22]

I argue that in the case of certain *types* of spectacular visual effects, the attraction often reappears in an altered form as a computer-generated (or digitally enhanced) image that does not precisely "arrest" or "prevail over" narrative but instead appears at key turning points in a film's narrative to emblematize the major themes, desires, and anxieties with which a film (or a group of films) is obsessed. Therefore another model—one that defines the complex relationship between spectacular effects, story/narrative, and character development—must serve in its place. Much as the attraction provides a model for understanding early cinema's aesthetics, mode of address, and mode of spectatorship in an era when narrative was neither a goal nor a priority for filmmakers, the emblem (as an object and a mode of signification) provides a model for understanding the mode of address of spectacular visual effects, the specificity of their relationship to narrative, the kinds of spectatorship they encourage, and, moreover, their allegorical power. The emblem, in other words, is an exceptionally useful tool for opening up narrative cinema's spectacular visual effects to such critical, analytical scrutiny.

At its most basic level, an "emblem" is defined as a pictorial image that represents or epitomizes a concept, expresses a moral or lesson, or serves as a "representation of an abstract quality, an action, state of things, class of persons, etc."[23] In contemporary cinema, spectacular visual effects often function as "effects emblems." I define the "effects emblem" as a cinematic visual effect that operates as a site of intense signification and gives stunning (and sometimes) allegorical expression to a film's key themes, anxieties, and conceptual obsessions—*even as it provokes feelings of astonishment and wonder.* Effects emblems neither arrest narrative nor prevail over it. Rather, they are continuous with it and appear at major turning points in the plot of a film to represent, in spectacular terms, the very stakes of the narrative. While a longer discussion of the emblem and its various incarnations across centuries is well beyond the scope of this project, the following seeks to identify those features of the emblem—its structure, form, and mode of address to viewers or readers and its emphasis on allegorical signification—that are relevant to the operation of a certain class of spectacular digital effects in contemporary narrative cinema. To be clear: I neither equate digital visual effects with specific emblems or emblematic forms nor suggest that spectacular effects are direct descen-

dants of the emblem as an art form (or, for that matter, that directors and effects artists have been influenced by emblem books). To do so would be misleading. Rather, I use the concept of the emblem throughout as a critical tool for opening up spectacular visual effects to historically specific analysis that aims to define their narrative function, their relationship to the development of character and story, their peculiar mode of signification, and the kinds of spectatorship they make possible or even demand. Most important, though, I make use of the emblem in order to discuss a particular visual effect's spectacular elaboration of the concepts and themes central to the film in which it appears. I regard the spectacular visual effects discussed in this book, as well as the individual emblems I analyze alongside them, as participating in, and therefore belonging to, the very long and diverse history of allegorical images in popular modern culture and media.

In its earliest incarnation the emblem was associated with forms of decorative embellishment that have been attached to an already existing object or text. The historian John Manning notes that the term "emblem" is based on the word *emblema*, from the Greek verb meaning "to set in, or on, to put on, to graft on," and that classically "emblem" might refer to "mosaic tiles, or the grafting of a shoot onto a stock, or detachable decorative ornaments."[24] The understanding of the emblem as "an ornament of inlaid work" that is inserted into some other substance expanded after the first publication of Andrea Alciati's book *Emblematum Liber*, in 1531, which began the production of the type of emblem most familiar to scholars of visual culture: the emblem book.[25] Such emblems often had a tripartite structure that included an image (a woodcut, engraving, or drawing) accompanied by an epigram and a longer verbal text that elucidated both. Emblematists drew from a vast image stock taken from numerous secular and religious sources, including the Bible, classical mythology, hieroglyphics, scientific observation of the natural world, historical narratives, fables, and "fantasy archaeology."[26] Images and text drawn from these normally "discrete traditions" were, according to Manning, "collapsed together in a mutually illuminating flash of understanding."[27] While emblems often conveyed pithy advice of a moralizing nature, they were intended to provoke pleasure as they addressed serious topics (such as the ephemerality of life and the certainty of death, or the dangers of pride, ambition, or lust) in a playful and witty manner.[28] Manning emphasizes that the significance of these allegorical emblems—their meaning,

or the concepts they elucidated—was located in the particular *combination* of image, epigram, and text.[29] Emblems were, in short, allegorical assemblages that directly solicited the eye of a reader or beholder in order to prompt pleasurable interpretation and understanding of the concepts and precepts they addressed. Hence, as Sir Francis Bacon explained in his description of the pedagogical mode of the emblem, the "Embleme reduceth conceits intellectuall to Images sensible, which strike the memory more."[30] Though their most common medium was the book, they have always been intermedial: emblems were also part of festive pageants and celebrations, theatrical performances, and architectural adornments. They were secular and religious, honorific as well as satirical, moralizing as well as bawdy (and sometimes even pornographic).[31] Importantly, emblem books, in particular, were enormously popular and enjoyed mass readership. Andrea Alciati's *Emblematum Liber*, for example, was translated into dozens of languages in more than 150 editions. As John F. Moffitt notes of the emblem book, "The commercial success of the new, as much entertaining as educational, genre initiated by Alciati is unquestionable, and it was comparable in scale (if scarcely in quality) to the postmodernist, pop-culture 'blockbuster.'"[32] While the emblem book was most popular in the sixteenth, seventeenth, and eighteenth centuries, it has endured into the twentieth and twenty-first centuries in books, advertising, and the cinema.[33]

It is worth pausing here to take a closer look at two examples taken from well-known emblem books—Alciati's *Emblematum Liber* and Jacob Cats and Robert Farlie's *Moral Emblems: With Aphorisms, Adages, and Proverbs of All Ages and Nations* (1860)—that enjoyed widespread popularity. I select these examples not only because they are representative of the emblem's typical form but also because their imagery and some of the concepts they illustrate are linked to digital visual effects I discuss in this book. The first and simpler of the two, "About Astrologers" (Emblem 103), comes from a 1608 edition of Alciati's *Emblematum Liber* and features an image of winged Icarus falling headlong from the sky into the sea (fig. Intro.1).[34] This image refers, of course, to the myth of Icarus and Daedalus, in which Daedalus makes wax and feather wings for himself and his son so that they can escape from the island of Crete. Despite his father's warning against doing so, Icarus flies too close to the sun, which melts the wax in the wings, and he plunges from the sky into the sea. The image of Icarus's (down)fall was often used to represent the dan-

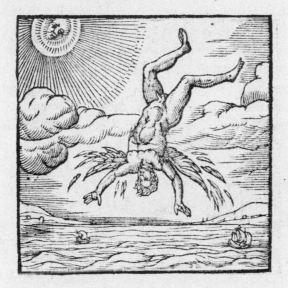

In aſtrologos.

EMBLEMA CIII.

ICARE, per ſuperos qui raptus & aëra, donec
In mare præcipitem cera liquata daret,
Nunc te cera eadem, feruensģ́, reſuſcitat ignis,
Exemplo vt doceas dogmata certa tuo.
Aſtrologus caueat quicquam prædicere: præceps
Nam cadet impoſtor dum ſuper aſtra volat.

Figure Intro.1 Icarus falls from the sky in "About Astrologers," Emblem 103 from Andrea Alciati's *Emblematum Liber* (1608 [1531]). Courtesy of the Bancroft Library, University of California, Berkeley, call no. PN6349 A53 E5 1608.

gers of overweening ambition. The *Emblematum Liber* updated the image for its audience to represent fraudulent knowledge manufactured by astrologers and the notion that the very means used to accomplish (falsely gained) ascendency will bring about inevitable downfall and doom. The text reads: "Oh Icarus, you who ascended through air up into the heaven until the melting wax pitched you into the sea, now this same wax and the same burning fire bring you back to life as an example by which you

will teach us your resolved doctrine. The astrologer must be careful with what he predicts, since the impostor falls head down when he flies above the stars."[35] Taken together, the epigram, image, and text tease out an allegorical meaning that, like a constellation, exceeds the sum of its constitutive parts: Alciati takes a familiar, dynamic, and highly fungible image from classical mythology and uses it to present a broad moral concept (the dangers of hubris or soaring ambition), which he updates for his audience's own historical context (the fraudulent predictions made by charlatan astrologers).

The second emblem is taken from the 1860 edition of Jacob Cats and Robert Farlie's *Moral Emblems*. This emblem, "When the Wolf Comes," addresses the broader theme of unity and the necessity of transcending individual differences and conflict in the face of an external threat. The illustration displays an arresting image of a pack of wolves attacking a herd of cattle (fig. Intro.2).[36] The image is surrounded on all sides by epigrams related to the concept at stake. The reader is advised that "union gives strength," and that "singly we succumb" and "united we conquer." Beneath the image, the title explains that "when the wolf comes, the oxen leave off fighting to unite in self-defence," thereby adding a prologue to the attack depicted in the image: prior to the attack, the cattle fought bitterly among themselves, which, we are told by the narrator of the accompanying text, they often do ("Not long ago, some oxen of our herds upon the moor, / In furious fight among themselves, as oft I've seen before, / Were suddenly surprised to see some wolves, which, crouching low, / Were stealing on the herd to strike an unexpected blow").[37] The text goes on to describe how, once attacked, the cattle instantly transcended their differences to act in collective defense of their lives. On reading the poem, certain details in the image become more meaningful; now we take notice of the wolf being trampled beneath the hooves of one ox, and understand that the wolf airborne above the herd is not attacking it, but has been gored and tossed into the air so that it will be trampled to death upon its fall into the middle of the herd. The illustration represents not just an attack by wolves, but one that will inevitably fail thanks to the collective unity of oxen. The unbroken ring of cattle is duplicated in the circular border around the image to reinforce the idea of a continuous and closed unity that forms, the text indicates, "like magic, all at once" when a threat is spied. The final line of the accompanying text applies the lesson of the cattle's ability to transcend their differences to the political life

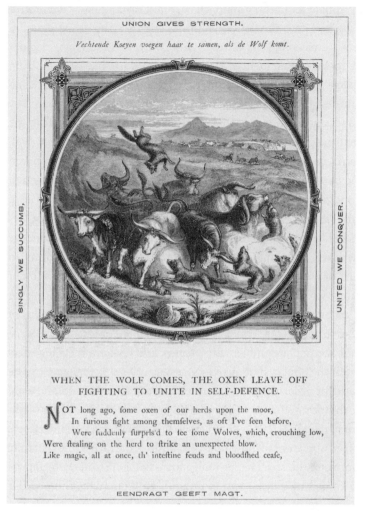

UNION GIVES STRENGTH.

Vechtende Koeyen voegen haar te samen, als de Wolf komt.

SINGLY WE SUCCUMB,

UNITED WE CONQUER.

WHEN THE WOLF COMES, THE OXEN LEAVE OFF
FIGHTING TO UNITE IN SELF-DEFENCE.

NOT long ago, fome oxen of our herds upon the moor,
 In furious fight among themfelves, as oft I've feen before,
 Were fuddenly furpris'd to fee fome Wolves, which, crouching low,
Were ftealing on the herd to ftrike an unexpected blow.
Like magic, all at once, th' inteftine feuds and bloodfhed ceafe,

EENDRAGT GEEFT MAGT.

Figure Intro.2 Jacob Cats and Robert Farlie's "When the Wolf Comes"
from *Moral Emblems* (1860). Courtesy of the Bancroft Library, University
of California, Berkeley, call no. PT5626 E5 P5 1860.

of nations and the need to "hush all inward strife, when from without a
foreign foe assails the Nation's life."[38] Taken together, the image, epigram,
and poem emblematize the concepts of unity, concord, and the subordi-
nation of individual differences to the needs of the collective in times of
crisis (themes expressed by numerous films I discuss in chapter 2).

Both types of emblems discussed here—the inlaid decoration and em-
blems found in books—can be fruitfully brought to bear on the contem-
porary visual effects discussed in this book. At first glance, spectacular

effects may appear as nothing more than inlaid ornaments—decorative spectacles grafted onto the body of a film to enhance the visual pleasure it offers and increase its (box office) value. However, many spectacular effects function as one element of a tripartite structure that, as in emblem books, creates a dynamic, mutually elucidating relationship between stunning attention-seeking spectacles, the longer narrative in which they are embedded, and a cinematic equivalent of an epigram manifest in the dialogue that precedes, follows, or brackets the spectacular effect. Walter Benjamin's description of the relationship between image and language in the baroque emblem is helpful in this respect: "The function of baroque iconography is not so much to unveil material objects as to strip them naked. The emblematist does not present the essence implicitly, 'behind the image.' He drags the essence of what is depicted out before the image, in writing, as a caption, such as, in the emblem-books, forms an intimate part of what is depicted."[39] In the digital effects emblems under consideration here, the dialogue, soliloquies, speeches, and voice-over narration that accompany, immediately precede, or follow the display of a spectacular visual effects sequence function like the epigrams and written texts that accompany emblematic images, and lay bare the allegorical significance of the effects shot or sequence. At times this dialogue can be epigrammatic; at other times it is characterized by heightened and even overblown rhetoric (such as the prebattle speeches delivered throughout the *Lord of the Rings* trilogy that I discuss in chapter 2). While effects emblems often appear at turning points in a film's narrative, the dynamic interplay between the spectacular image and dialogue, and their mutual elucidation (aided by editing and montage), emblematizes the broader themes, desires, and obsessions narrated by the film as a whole. We can say, then, that one of the defining features of (digital) effects emblems is their status as allegorical images. Following Gunning's discussion of emblematic images in silent narrative film, digital effects emblems and the films in which they appear should be thought of as "works that seek to develop images which will be simultaneously intense and . . . legible; images that aspire to writing in pictures, willing to court the artificiality that foregrounds significance over depiction."[40] To paraphrase Manning's definition of the literary emblem, digital effects emblems are attention-seeking spectacles addressed *to* someone, and demand or challenge interpretation.[41]

In *Spectacular Digital Effects* I focus on four types of visual effects ac-

complished with the aid of digital technologies: the illusion of radical, gravity-defying vertical movement; the appearance of massive digital "multitudes"; the animation of photorealistic digital creatures; and the corporeal and spatial "plasmatics" made possible by the morph effect. These effects have appeared repeatedly in numerous films since the late 1980s and early 1990s across a broad range of genres including historical epics, spy thrillers, fantasy and action-adventure films, *wuxia* or martial arts films, romantic and family melodramas, war films, science fiction, horror, and catastrophe films. In the process, they have become recognizable as particular types of computer-generated effects (or, to borrow a phrase from Bob Rehak, as visual effects "micro-genres"[42]) with distinct formal, semantic, stylistic, and aesthetic features. Moreover, contemporary films deploy these effects in surprisingly consistent ways in order to interrogate and emblematize the concepts and themes with which they are concerned, often regardless of genre or nation of origin. Much like emblem books of the seventeenth, eighteenth, and nineteenth centuries, they rely heavily on binary oppositions. Emblems gained allegorical and affective force by contrasting lust with virtue, pride with modesty, gluttony with moderation, or youth with old age;[43] the cinematic effects emblems discussed here gain dramatic effect by contrasting power with powerlessness, the individual with the collective, life with death, and freedom with constraint. The orchestration of spectacular digital effects around such broad, accessible themes and concepts enables the films in which they appear to address and resonate with the heterogeneous and often global audiences for whom they were made. And while these digital visual effects are often perceived as hallmarks of everything that is novel and cutting-edge in the cinema, they also force us to return to past film history as they engage with and expand on earlier effects created by analog technologies, thereby allowing us to see old effects in a new light.

In chapter 1, "The New Verticality," I analyze contemporary cinema's use of the screen's vertical axis such that action, narrative, and character are plotted through radical forms of ascent and descent. Before the digital effects advances of the late 1980s and early 1990s, cinematic being-in-the-world remained, for the most part, anchored on the terrestrial plane of existence, and vertical movement was used rather sparingly to punctuate action, accent narrative climaxes, or intensify dramatic conflict. However, digital processes have given rise to a new film aesthetic based on height, depth, immersion, and the exploitation of the screen's y and z

axes. With the help of green screens, wire-removal software, digital 3D, key frame animation, digital compositing, motion control, and the digital simulation of the parallax effect, digital visual effects have liberated many aspects of filmmaking from (some of) the laws of physics, allowing for much more pronounced and sustained exploitation of the screen's vertical axis.[44] Often characters plunge thousands of feet without bodily injury, displacing the long fall's dramatic effect away from the body and onto story, character, and theme. Struggles between protagonists and antagonists hinge on the degree to which each is able to defy or master the laws of physics, making extreme vertical settings pervasive, almost regardless of genre. And since verticality implies the intersection of two powerful forces—gravity and the drive required to resist, master, or overcome it—it has become an ideal technique for allegorizing power and powerlessness, and for mobilizing various connotative (and sometimes allegorical) meanings implied by ascent and descent. In this chapter I investigate what might be called the "spatial dialectics" of contemporary cinema's vertical imagination—its tendency to map the violent collision of opposed forces onto a vertical axis marked by extreme highs and lows. I show how the digital technologies used to create vertically oriented bodies and narratives simultaneously create breathtaking effects that emblematize struggles for and against historical change, in films such as *Inception* (Christopher Nolan, 2010), *Avatar* (James Cameron, 2009), *Star Trek* (J. J. Abrams, 2009), *Hero* (Zhang Yimou, 2002), *Crouching Tiger, Hidden Dragon* (Ang Lee, 2000), *The Matrix* (1999), and *Titanic* (1997).

In chapter 2, "The Digital Multitude as Effects Emblem," I focus on the various computer-generated hordes, swarms, armies, armadas, and crowds that have appeared in a broad range of popular films in the past fifteen years with the aid of motion capture technologies and software programs such as MASSIVE (Multiple Agent Simulation System in Virtual Environment), Render Man, and Stadium Guy. Crowd animation software has most often been regarded as a tool for creating large group formations at very little cost; for example, writing of the digital processes used in the making of *Forrest Gump* (Robert Zemeckis, 1994), Jean-Pierre Geuens notes, "And, to the delight of cost experts everywhere, a small crowd is magically duplicated to fill an entire stadium."[45] Yet it is important to distinguish digital crowds used to "flesh out" a given space from those whose appearance is calculated to create a sense of overwhelming—and even sublime—force. Rather than function as background elements or as in-

expensive, "empty" spectacle, contemporary cinema's armadas, swarms, and standing armies (numbering in the tens or hundreds of thousands) often emblematize the epic themes at work in contemporary block-busters. In films such as *Independence Day* (Roland Emmerich, 1996), *Starship Troopers* (Paul Verhoeven, 1997), *Star Wars Episode II: Attack of the Clones* (George Lucas, 2002), *The Lord of the Rings: The Two Towers* (Peter Jackson, 2002), *The Lord of the Rings: The Return of the King* (Peter Jackson, 2003), *Troy* (Wolfgang Petersen, 2004), *I, Robot* (Alex Proyas, 2004), *300* (Zack Snyder, 2006), and *Curse of the Golden Flower* (Zhang Yimou, 2006), the multitude's appearance heralds "the End"—the end of freedom, the end of a civilization, the end of an era, or even the end of human time altogether. Though such films span a number of genres, all use the digital multitude to spatialize time and to allegorize their pro-tagonists' relationship to sudden, often apocalyptic, historical change. Moreover, the astonishing numbers that compose the digital multitude make this particular digital effects emblem inseparable from settings de-fined by vast spaces, and its terrifying extensiveness often finds expres-sion through the multitude's occupation of horizontally articulated space. I show how the digital multitude's spatial composition within the frame often amounts to the cinematic emblematization of temporal or historical concepts such as "infinitude," the "historical threshold," and "apocalypse." These same films use their digital multitudes to dramatize the relation-ship between the individual and the aggregate and to challenge the asso-ciation between great numbers and power. And while the use of crowds, flocks, and swarms to represent historical transition has a long history in the cinema, computer-generated effects have exponentially expanded the sheer *quantity* of on-screen hordes and crowds and, in the process, have brought the *qualities* associated with them into sharper focus. In this chapter I analyze digital multitudes alongside those created by opti-cal and analog special effects—with particular attention to the menacing flocks found in Alfred Hitchcock's *The Birds* (1963)—to show how new digital visual effects can make visible previously overlooked aspects of "old" analog visual effects.

In chapter 3, "Vital Figures: The Life and Death of Digital Creatures," I analyze the computer-generated monsters, humanoids, dinosaurs, and other fantastical beings that have populated live-action films with in-creasing frequency since the release of Steven Spielberg's *Jurassic Park* in 1993. Since then, strikingly photorealistic creatures have been brought

to life with the help of 3D modeling, character rigging, and key frame animation, and made credibly lifelike in appearance by software programs that make bodily movement, facial expressions, skin texture, fur, and hair appear persuasively organic. Though digital processes have done much to increase the lifelikeness and photorealism of effects creatures, many of them are, nevertheless, composed of some combination of digital and analog effects (such as animatronics, puppets, and prosthetics). This combination of material and code includes the performance and motion capture processes used to create compelling and even sympathetic "hero" creatures such as Peter Jackson's King Kong and Gollum or James Cameron's Na'vi. Precisely because of this synthesis, films such as *Jurassic Park*, *The Mummy* (Stephen Sommers, 1999), *King Kong* (Peter Jackson, 2005), the *Lord of the Rings* trilogy, *Harry Potter and the Chamber of Secrets* (Chris Columbus, 2002), *The Host* (Bong Joon-ho, 2006), *Avatar*, *Splice* (Vincenzo Natali, 2009), and *Harry Potter and the Deathly Hallows, Part 1* (David Yates, 2010) must overcome the ontological differences between analog special effects and digital visual effects, so that all "life" appears on-screen as equally animate and alive. To produce the on-screen *viability* of effects creatures, filmmakers and effects artists have developed a set of visual and narrative strategies that help produce not just a creature's lifelikeness, but its surplus and even lethal *vitality*. In this chapter I analyze a range of such strategies, including the digital designs that charge creatures with excess life (such that they often seem more fearsomely alive than their live-action counterparts), the "body-building" strategies that help produce the illusory materiality of digital beings and subject them to inexorable laws of physics, and the surrounding discourses that produce compelling physical and psychological interiorities in creatures that are often pure surface. Such strategies work in concert to persuade us that these creatures are animated from within by an ineffable "vitality" and not given "life" from without by numerous old and new technologies. Hence the software and digital designs used to charge effects creatures with photorealistic lifelikeness are often joined to plots that supply those creatures with the power to mediate (and even remediate[46]) life and death in the films in which they appear. While the animation of artificial creatures has been a long-standing practice (and even obsession) in the cinema, the animation of digital creatures in recent cinema has strong links to contemporary concerns surrounding the relationship between human and animal biology and new digital technologies. Hence I discuss

how the (re)mediating function of vital figures in recent cinema allows digital creatures to emblematize a range of fantasies and anxieties surrounding changing definitions of human life and death—and the mediation of both by new (digital) technologies—in an era of scientific change defined in part by the ongoing convergence (and even conflation) of genetic code with computer code.

In chapter 4, "The Morph: Protean Possibility and Algorithmic Control," I focus on the visual and narrative function of the morph, one of the first digital effects to be recognized as a computer-generated effect by audiences and critics alike. Morphing software programs such as MorphPlus and Elastic Reality enable the rapid and seamless transformation of a source image (of a character or object) into a target image (a second character or object) and have made possible a new plasticity of bodily form in live-action film, which, as Scott Bukatman has shown, was previously possible only in animation.[47] I begin by returning to Sergei Eisenstein's concept of "plasmaticness," which he used to theorize the variability of physical form that was characteristic of Walt Disney's animated characters. Eisenstein linked animated images of metamorphosis to the appeal of "the myth of Proteus" and describes the freedom of form exhibited by Disney's drawn characters as "an ability that I'd call 'plasmaticness,' for here we have a being represented in drawing, a being of a definite form, a being which has attained a definite appearance, and which behaves like the primal protoplasm, not yet possessing a 'stable' form, but capable of assuming any form."[48] I update Eisenstein's concept of plasmaticness for the digital era by turning to films such as *Terminator 2: Judgment Day* (James Cameron, 1991), *Dark City* (Alex Proyas, 1998), *The Matrix* (1999), *X-Men* (Bryan Singer, 2000), *Hulk* (Ang Lee, 2003), and *Spider-Man 3* (Sam Raimi, 2007). Vivian Sobchack has argued that the morph's figural freedom indicates its freedom from the constraints of time, space, and the body.[49] I go on to show how the protean quality of the digital image in contemporary cinema mobilizes fantasies of transcendence involving any type of rigid categorization—zoological, behavioral, social, spatial, and historical. This fantasy is significant because the morph tends to be featured most spectacularly in films set in imaginary worlds defined by radically closed, even carceral settings—prisons, mental institutions, isolated camps, secret military bases, or oppressive and confining social milieus—from which there is no escape. This spatial confinement often has a temporal/historical corollary that subjects a film's protagonists to

unavoidable, fated futures over which they have no control. I show how the plasmaticness of the digital morph—whether it is the property of a protagonist or an antagonist—almost always emblematizes a violent conflict between the desire for radical freedom (expressed through story, character, setting, and dialogue) and forces that work in the service of control over space, time, and fate. Hence the morph does not simply embody and exercise the "omnipotence of plasma" in the style of Disney's animated characters.[50] Rather, its transformations are the outcome of a play between freedom (figural, bodily, spatial) and control (physical, spatial, temporal, and algorithmic), which, in turn, provides a structure and a theme for the films in which the morph appears. In order to historicize this effects emblem, I analyze films featuring the digital morph alongside earlier films that use analog special effects and optical effects to create fantastic transformation scenes, particularly *Dr. Jekyll and Mr. Hyde* (Rouben Mamoulian, 1931) and *The Thing* (John Carpenter, 1982).

Much like the emblems found in Alciati's *Emblematum Liber* or Cats and Farlie's *Moral Emblems*, the majority of the films discussed in this book were extremely popular with audiences around the world. More important, much like the baroque emblem discussed by Benjamin, the digital effects emblem often expresses or addresses, in an allegorical and simplified form, the anxieties and trauma stemming from profound historical change and uncertainty. For if there is an overarching concept or concern that unites the four different effects emblems discussed in this book, it is an obsession with mass destruction, catastrophe, apocalypse, or, at the very least, the annihilation of a film's protagonists. Put differently, effects emblems are deployed to give spectacular representation to scenarios and events that strongly imply, or threaten to bring about, "the End." While this is most obviously the chief anxiety addressed by the film I discuss in the conclusion of this book—Lars von Trier's *Melancholia* (2011)—it is also true of the historical epics, science fiction films, melodramas, and fantasy films I analyze throughout. To come to terms with this common theme, it is helpful to turn to Miriam Hansen's definition of the classical cinema as a form of "vernacular modernism." Hansen argued that as "vernacular modernism," the cinema "played a key role in mediating competing cultural discourses on modernity and modernization, because it articulated, multiplied, and globalized a particular historical experience" (including the ways in which it allowed "viewers to confront the constitutive ambivalence of modernity").[51] Similarly, films featuring effects em-

blems can be thought of as a form of "vernacular postmodernism" that addresses, in sensorially pleasurable ways, the experience of late capitalism and its instabilities, processes of globalization (including what Michael Hardt and Antonio Negri call "the global state of war," in which armed conflict becomes the chief organizing principle of society[52]), and the experience of radical scientific and technological change. To think of these films in such terms is to bring together the cinema's ongoing and historically variable "mass production of the senses" with the emblem's historical tendency to address allegorically the uncertainty wrought by social, political, and economic change.[53] Indeed, Benjamin conceived of the baroque emblem as an allegorical form that gave expression to a profound sense of crisis, and he argued that "allegories are, in the realm of thoughts, what ruins are in the realm of things."[54] Precisely because effects emblems express a profound sense of historical crisis, Andreas Huyssen's reformulation of Benjamin's axiom is quite useful here: "Emblems are in the realm of media what ruins are in the realm of architecture."[55] Like the baroque emblem, the effects emblem is a "multimedial mode of representing and interpreting a world out of joint."[56]

The topic of digital visual effects is very broad, and in order to analyze a discrete object of study, I focus on spectacular digital visual effects in live-action films, beginning in 1989 with the release of James Cameron's *The Abyss* and ending in 2011 with the release of *Melancholia*. While many of the films under consideration are Hollywood productions, others were produced in China, South Korea, France, England, and New Zealand, and feature visual effects produced by a number of effects houses, including Weta Digital, Industrial Light and Magic, The Orphanage, and Tippett Studio. Although I discuss certain digital processes or the software used to create a particular effect throughout this work, I do not provide detailed descriptions about how such processes were accomplished. Such information is readily available in periodicals (some of which I cite throughout) such as *Cinefex* and *American Cinematographer*, SIGGRAPH (Special Interest Group on Graphics and Interactive Techniques) publications, and detailed histories of special and digital visual effects processes, such as Prince's *Digital Visual Effects in Cinema* and Richard Rickitt's *Special Effects: The History and Technique*.[57] My analyses are (with one exception) based on the original, theatrically exhibited films and not director's cuts or altered or extended versions available on DVD[58] — not only for consistency's sake but also because the type of expensive, spectacular effects

under discussion here are rarely cut from the final, theatrically distributed version of a film. Finally, although this book addresses the very recent past, it is a historical project. Therefore I make no speculative claims about the future of digital visual effects or the direction that motion picture history, CGI, or digital effects may take; such predictions and prognostications are rarely accurate and often tend toward the utopian or dystopian perspectives I have tried to avoid throughout. Instead, this project considers digital visual effects alongside some of their analog precursors to show how attention to that which seems radically new can shed light on the past, and how attention to the past can, in turn, make spectacularly visible the historical continuities that often slip out of focus in eras of technological change.

THE NEW VERTICALITY

So neither the horizontal nor the vertical proportion of the screen *alone* is ideal for it.

In actual fact, as we saw, in the forms of nature as in the forms of industry, and in the mutual encounters between these forms, we find the struggle, the conflict between both tendencies. And the screen, as a faithful mirror, not only of conflicts emotional and tragic, but equally of conflicts psychological and optically spatial, must be an appropriate battleground for the skirmishes of both these optical-by-view, but profoundly psychological-by-meaning, spatial tendencies on the part of the spectator.
—Sergei Eisenstein, "The Dynamic Square"

Since the early 1990s the directors and effects artists of numerous films—including *Titanic* (James Cameron, 1997), the *Matrix* trilogy (Wachowski Bros., 1999, 2003), *X-Men* and *X2* (Bryan Singer, 2000, 2003), *Crouching Tiger, Hidden Dragon* (Ang Lee, 2000), *Hero* (Zhang Yimou, 2002), *Avatar* (James Cameron, 2009), and *Inception* (Christopher Nolan, 2010)—have made increasing use of the screen's vertical axis with the aid of new digital technologies. Drawing from cultural sources ranging from the narratives and characters featured in comic books, fantasy novels, and television series to the visual logics of video games and virtual reality, recent blockbusters have deployed a broad range of digital visual effects to create composite film bodies that effortlessly defy gravity or tragically succumb to its pull. In keeping with this tendency, these same films create breath-

taking imaginary worlds defined by extreme heights and plunging depths, the stark verticality of which becomes the referential axis of many narrative conflicts. In this chapter I investigate the spatial dialectics and allegorical significance of contemporary cinema's vertical imagination—its tendency to map the violent collision of opposed forces onto a vertical axis marked by extreme highs and lows. Such verticality often functions emblematically to represent an abstract quality or "state of things." As an effects emblem, digitally enhanced verticality facilitates a rather literal naturalization of culture in which the operation and effects of (social, economic, military) power are mapped onto the laws of space and time. Hence, in recent blockbuster films, vertically oriented bodies and objects represent a relation not just to the laws of physics but also to a fictional world's prevailing order. As a result, verticality often functions allegorically to give dynamic, hyperkinetic expression to power and the individual's relation to it—whether defiant, transcendent, or subordinate. The films I focus on—*Titanic, Hero, Crouching Tiger, Hidden Dragon, The Matrix,* and *Avatar*—span a number of genres (including martial arts films, disaster films, science fiction films, action-adventure films, and fantasy films), and though they were produced in the United States, New Zealand, Hong Kong, China, and Taiwan, they share a number of characteristics linked to their insistent deployment of verticality; in each film, digitally enhanced verticality functions emblematically to give dynamic and spectacular articulation to the broader thematic concerns and concepts expressed elsewhere in the film through dialogue, characterization, and story.

This new, digitally enhanced verticality participates in (and extends) a very long pictorial tradition that has made use of the vertical axis of the frame (or page) to emblematize the rise and fall of mythological figures. Before turning to specific examples in contemporary cinema, it is worth returning to Andrea Alciati and his use of myths featuring dynamic, vertically oriented movement to represent or allegorize moral and political states. Alciati's Emblem 56, titled "About Reckless People," draws on the Greek myth of Phaeton's chariot ride and is accompanied by an engraving that shows him plunging headlong from the sky to the earth below (fig. 1.1). In the myth, Phaeton, son of the sun god Helios, wishes to drive his father's sun chariot—a vehicle so difficult to control that even Zeus refuses to pilot it. Despite being warned against doing so, Phaeton attempts to drive the chariot across the heavens, and after losing control of

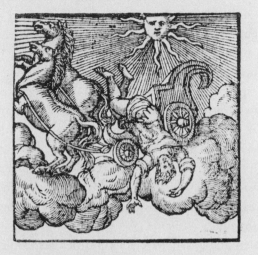

In temerarios.

EMBLEMA LVI.

Aspicis aurigam currus Phaëthonta paterni
 Igniuomos aufum flectere Solis equos;
Maxima qui poftquàm terris incendia fparfit,
 Eft temerè infeffo lapfus ab axe mifer.
Sic plerique rotis fortuna ad fidera Reges
 Euecti, ambitio quos iuuenilis agit;
Poft magnam humani generis cladémq; fuámq;
 Cunctorum pœnas denique dant fcelerum.

Figure 1.1 Phaeton is struck from the sky in "About Reckless People," Emblem 56 from Andrea Alciati's *Emblematum Liber* (1608 [1531]). Courtesy of the Bancroft Library, University of California, Berkeley, call no. PN6349 A53 E5 1608.

the wild, fire-breathing horses that pull the vehicle, he comes too close to the earth and scorches it, forcing Zeus to strike him from the sky. Alciati's "About Reckless People" describes Phaeton as he who "dared to guide the fire-vomiting horses of the Sun," and uses his fall as an allegorical image for the "adolescent ambition" of reckless kings and their misuse of power: "After scattering enormous conflagrations all over the Earth, [Phaeton] fell disgraced from the vehicle which he had so reck-

lessly mounted. Much the same happens to many kings who, driven by adolescent ambition, are carried toward the stars upon the wheels of Fortune. After having provoked much misfortune among the human race, they bring ruin upon themselves and, finally, they pay the penalties due for their crimes."[1] The image represents the dramatic turning point when the ascent into, and flight across, the heavens (linked to generational conflict, rebellion, hubris, and ambition) is converted to its opposite by a sudden reversal in directionality: struck from above by Zeus's lightning bolt, Phaeton is abruptly stripped of the power he seized. His fall presents a striking, dynamic image of the unexpected loss of power, of a body given over entirely to the laws of physics, the laws of the gods, and the prevailing order that he defied through his ascent. Taken together, the text and image update the myth of Phaeton's fateful ride in order to emblematize the power seized and wielded by rulers who, by their actions, upend the order of things and wreak havoc on their subjects, only to suffer the ultimate loss of power in the end.

Much as emblematists and artists have for centuries made allegorical use of dynamic images of verticality, directors and effects artists have created numerous cinematic spectacles of (more or less emblematic) astonishing ascents and breathtaking falls enabled by historically available special and optical effects, from Harold Lloyd's precarious climb up the side of a department store in *Safety Last!* (Fred C. Newmeyer / Sam Taylor, 1923), to Jimmy Stewart's defenestration at the end of *Rear Window* (Alfred Hitchcock, 1954), to Slim Pickens's descent through the atmosphere astride a bomb in *Dr. Strangelove* (Stanley Kubrick, 1964). However, the blockbusters of the 1970s marked a turning point in the history of cinematic verticality as they deployed big-budget special effects to exploit the screen's vertical axis to a degree not seen before. *The Poseidon Adventure* (Ronald Neame, 1972) capsized an ocean liner and forced its protagonists to ascend through a series of inverted sets to find a way out through the ship's upended hull; *The Towering Inferno* (John Guillermin / Irwin Allen, 1974) turned the skyscraper into an upright labyrinth difficult to exit alive; and *King Kong* (John Guillermin, 1976) staged a battle between Kong and the New York Police Department on top of the World Trade Center. Films such as *Star Wars* (George Lucas, 1977), *Superman* (Richard Donner, 1978), *Close Encounters of the Third Kind* (Steven Spielberg, 1977), and *E.T.* (Steven Spielberg, 1982) increasingly used models, miniatures, blue screens, mattes, and motion control to animate their

characters' movements and desires along the screen's vertical axis. Meanwhile *High Anxiety* (Mel Brooks, 1977) parodied the use of the long fall as a device for creating suspense in classical film noir.

The increasing exploitation of the screen's vertical axis continued through the 1980s and became significantly more pronounced at the end of the 1990s with the development and refinement of digital processes, including wire-removal software, motion control, (photorealistic) digital animation, morphs (between actors and their digital stunt doubles), and performance and motion capture techniques. For example, in 1990 wire-removal software created convincing images of bodies and matter in flight in *Back to the Future Part III* (Robert Zemeckis), while in 1993 Industrial Light and Magic helped animate the screen's vertical axis with towering photorealistic dinosaurs in *Jurassic Park* (Steven Spielberg). That same year *Cliffhanger* (Renny Harlin) composited images of its actors (shot against a green screen) with digitized images of mountainous landscapes to stage its action at vertiginous heights, much as the infant protagonist of *Baby's Day Out* (Patrick Read Johnson, 1994) scaled Chicago's soaring skyline thanks to composites of the baby's image with digitized photos of the urban landscape.[2] Such developments continued until 1996, when the three top-grossing films of the year—*Independence Day* (Roland Emmerich), *Twister* (Jan de Bont) (both of which used new particle animation software), and *Mission: Impossible* (Brian De Palma) (for which the Computer Film Company did digital compositing, paintwork, wire removal, and tracking)—suggested that digital technology's ability to polarize action along extreme spatial coordinates would continue to develop into the new millennium.

At its most basic level the new digitally enhanced verticality is a technique for activating polarized extremes: it choreographs the rise and fall of the narratives in which it appears and emblematizes the soaring aspirations and desires, as well as the downfall and doom, of a broad range of protagonists, antagonists, heroes, and antiheroes. Hence verticality's abstract spatial coordinates are those of the zenith and the nadir, and its favorite location is the precipice, regardless of setting. Skyscrapers, chasms, national monuments, elevator shafts, upended ocean liners, high towers, tall (and sometimes ambulatory) trees, and hovering helicopters have all functioned with equal efficiency to polarize conflict, to frame possible outcomes in terms of a devastating fall or a willfully insurgent rise. Even when action returns to terra firma and ordinary horizontality,

the mise-en-scènes of these films help activate and orient vision along the screen's vertical axis: pillared interiors, banners streaming down from high ceilings, floating mountains, cascading waterfalls, and showers of brightly colored petals or spent bullet casings all indicate that actions and events will inevitably follow lines of ascent and descent, thereby compounding the thematic and allegorical significance of vertical movement in these films.

Verticality mobilizes and even codifies various connotative meanings and types of affect attached to ascent and descent. Upward mobility gives dynamic expression to feelings of soaring hope, joy, unbridled desire, aspiration, and even escape; it implies lightness, vitality, freedom, transcendence, defiance, and lofty ideals. And while falling and sinking give expression to dread, doom, and terror and are linked to weighty burdens, inertia, subordination, loss, and the void, the volitional nosedive suggests the thrilling mastery of powerful laws of physics.[3] As a dynamic device for conveying the heightened emotions to which violent conflict gives rise, this new, digitally enhanced verticality draws heavily from the 1950s Hollywood melodrama's use of expressionistic mise-en-scène and takes the genre's association of staircases with rising and falling emotions to new extremes.[4] Not only has the *scale* of the vertical setting expanded exponentially with the development of CGI (to elevator shafts spanning more than one hundred floors, for example, or to mountains that float in the air, high above a forest), but so have the stakes: frequently a struggle for the survival of an entire city (as in *Spider-Man* [Sam Raimi, 2002], *X-Men*, and *Godzilla* [Roland Emmerich, 1998]) or humanity itself (as in *The Matrix*, the *Lord of the Rings* trilogy [Peter Jackson, 2001, 2002, 2003], *The Day after Tomorrow* [Roland Emmerich, 2004], *Armageddon* [Michael Bay, 1998], *Sky Captain and the World of Tomorrow* [Kerry Conran, 2004], and *The War of the Worlds* [Steven Spielberg, 2005]) is played out along spatial coordinates of extreme highs and lows. Because the new verticality vastly expands the terrain on which (and with which) the cinema compels its protagonists to struggle, it logically favors the epic.

Verticality's link to gravity and the laws of space and time make it an ideal technique for dramatizing and emblematizing the individual's relationship to powerful historical forces. Horizontality is an important point of reference that stands for temporal and historical continuity; its rupture by the upsurge or fall of a vertically articulated mass creates a dynamized moment, a temporal/historical break that radically changes the

course of events. Early in *Jurassic Park* the shot of a towering brachiosaur eating leaves from the top of a tree (bracketed by reaction shots of the stunned protagonists) signals the evolutionary past's astonishing eruption into the present, enabling the dinosaur to embody the park owner's plan, as Constance Balides describes it, to appropriate "historical time for profit on a grand scale."[5] In *The Day after Tomorrow*, a towering wall of water crashes into and submerges Manhattan to signal an irreversible shift in the balance of power: the United States' economic and military supremacy comes to an end, initiating a new era in which it is dependent on Mexico. In *Reign of Fire* (Rob Bowman, 2002), *Deep Impact* (Mimi Leder, 1998), and *The War of the Worlds*, digitally rendered danger descends from above and threatens to bring human time to an end. And while *Star Trek* (J. J. Abrams, 2009) plots the demise of the planet Vulcan along expansively polarized spatial coordinates as rogue Klingons drill a hole into the planet's core from a ship located in outerspace, *2012* (Roland Emmerich, 2009) imagines apocalypse on Earth through images of skyscrapers collapsing and plunging into a massive canyon that opens up in the middle of downtown Los Angeles. Later in *2012*, when Yellowstone National Park becomes a volcano that erupts with the power of a nuclear explosion, burning chunks of molten rock rain down on the protagonists and nearly thwart their escape.

When verticality is located in the gravity-defying body of a protagonist in these films, it often implies a crisis inseparable from his or her problematic relation to the historical, familial, and traditional past. Whereas a protagonist's upward verticality is frequently associated with a (rebellious) leap toward a new future, the downward verticality of the long fall is inseparable from the rapid approach of an inevitable end. In some of these films the past is represented as a weighty burden that constrains the protagonist's freedom precisely so that powerful social, class, and political formations may carry on, unchanged, into the future (as in *Titanic* and *Crouching Tiger, Hidden Dragon*). In other cases, the past repeats itself and revives dark forces that promise to annihilate the protagonists in the not-so-distant future (*X-Men*, *The Fifth Element* [Luc Besson, 1997], the *Lord of the Rings* trilogy, *Minority Report* [Steven Spielberg, 2002], *Van Helsing* [Stephen Sommers, 2004], and *Star Trek*). Conversely, in yet another group, historical continuity and a tangible relation to the past provide the conditions of possibility for a historical agency able to overcome forces whose power stems precisely from the ability to manipulate or master

space and time at will (the *Matrix* trilogy, *Dark City* [Alex Proyas, 1998], and *Avatar*). Since extreme forms of vertical movement inevitably imply a violation and reassertion of the laws of physics, vertically oriented bodies and narratives provide the ideal form for abstracting power and representing the struggles of the emergent against the dominant—a concept neatly conveyed by the title of the film *Sky Captain and the World of Tomorrow*.

While the popularity of the blockbusters I consider here can be explained in part by their presentation of astonishing digitally rendered spectacles, the "structure of feeling" (to borrow a term from Raymond Williams)[6] invoked by verticality also allows them to resonate with contemporary audiences. Because verticality lends itself so well to the dynamic elaboration of conflict between opposed forces, it seems remarkably suitable for an era defined by economic polarization and new forms of political, religious, and military extremism, all of which seem to have had the effect (or so we are regularly told) of evacuating previously available middle grounds.[7] The way that such global conflicts played out at the World Trade Center on September 11, 2001, only reinforced the link between verticality and the struggle for power in the popular imaginary. Indeed, verticality allows these films simultaneously to acknowledge extremism, economic polarization, and thwarted upward mobility as significant aspects of their global audience's condition of existence and to charge these crises with new visual pleasures and imaginary resolutions. Even when they purport to represent actual historical events, these films feature mythological characters, breathtaking vertical terrains, and forms of embodiment detached from any referent in the real world onto which international audiences can map their conflicting identifications and emotional affiliations.[8] Precisely by defying verisimilitude, the new verticality lends these films a different sort of emblematic truth able to resonate—strongly and broadly—within the historical context of the late twentieth and early twenty-first centuries.

This is not to say that previous eras have been free of either extremism or cinematic verticality. Indeed, verticality has been used to dramatize violent conflict in the cinema since Gus chased Flora Cameron to the cliff's edge in *The Birth of a Nation* (D. W. Griffith, 1915).[9] However, before 1990, cinematic being-in-the-world remained, for the most part, anchored on a horizontal axis and verticality was used primarily to punctuate action and accent narrative climaxes and dramatic conflict. Recent blockbuster films exponentially extend and expand on the cinema's on-

going exploitation of gravity's dramatic potential. Digital technologies have helped liberate many aspects of production from the laws of physics, allowing for much more pronounced and sustained exploitation of the screen's vertical axis. Indeed, in what is perhaps the most complex example to date, *Inception* uses the slow-motion image of a van falling from a bridge into the water below to organize vertically oriented action taking place simultaneously in four different diegetic dream worlds: the fate of the protagonists depends on their use of gravity (a "kick," or the sensation of falling that jolts one from sleep) to awaken themselves from pharmaceutically induced dreams and dreams-within-dreams once they have completed a required task. Each "kick" must be perfectly timed to allow characters to awaken in the next dream layer (from the deepest layer to the one closest to the surface of unconsciousness) before the van hits the water. The film cuts from the van to Ariadne (Ellen Page) plunging from a skyscraper, to a tower compound as it collapses down the mountainside, to an elevator propelled upward by explosives that jolt the weightless, sleeping protagonists awake upon impact, and, finally, to the van as it hits the water, awakening most of the crew into the collective dream world closest to the real world.

Hence, just as widescreen processes, according to David Cook, "created the functional grounds for a new film aesthetic based upon composition in width and depth" in the 1950s,[10] digital processes have given rise to a new film aesthetic based on height and depth—hence the screen's y and z axes. As a result, verticality is no longer confined to hair-raising stunts and dramatic camera angles but has become a cinematic mode that structures and coordinates setting, action, dialogue, and characterization along radical lines of ascent and descent. Now characters such as Gandalf (Ian McKellen) in *The Lord of the Rings: The Two Towers* (Peter Jackson, 2002) and Jake Sully (Sam Worthington) in *Avatar* plunge thousands of feet without bodily injury, displacing the long fall's dramatic effect away from the body and onto narrative, characterization, and allegorical significance. *Superman Returns* (Bryan Singer, 2006) uses terrifying downward vertical mobility to stage the event to which the film's title refers: when a plane carrying Lois Lane (Kate Bosworth) experiences a catastrophic breakdown and plunges through the air in a terrifying nosedive, Superman (Brandon Routh) stops it from crashing at the last moment, thereby precipitating the love triangle and revenge plot that structure the ensuing narrative. Such films consistently locate their conflicts in ex-

treme vertical settings—such as skyscrapers, deep chasms, and mountain peaks—and organize their plots around scenarios that demand a protagonist's defiance or mastery of the laws of physics. The resulting spatialization of power and time allows the new verticality to map spatial transience onto historical transition, and radical forms of mobility onto the possibilities and perils of change such that the new verticality becomes an emblem for (desired or thwarted, social or political) transformation.

Gravity, Historical Inertia, and Inevitability

I begin with two extremely profitable films—*Titanic* and *Hero*—that use verticality's spatial dialectics to represent mythologized historical pasts defined by the violent opposition of polarized (political, economic) extremes.[11] As an effects emblem, verticality creates an interpretive framework for the rising and falling bodies and matter in these films that goes well beyond their reality effect: by mapping complex struggles for power onto the laws of physics, verticality can make historical change a matter of inertia or inevitability. While *Titanic*'s verticality represents history as a body or force that will remain in motion along a specific trajectory unless displaced by another force, *Hero* uses verticality to make the outcome of imperial history as predictable as the operation of gravity itself. And while verticality loans some support to the "official" histories that these films appear to confirm (i.e., class conflict lies submerged in the United States' distant past; national greatness demands the violent suppression of internal dissent), its bidirectional movement also accommodates the contradictory or ambivalent interpretations that global audiences might bring to it.

Titanic links its ship's forward propulsion to historical inertia and a sense that the early twentieth century was drifting blindly toward disaster. As a number of scholars have argued, *Titanic* depicts 1912 as a moment in history defined by a rigid and punitive class-gender system in which a corrupt and decadent industrial patriarchy (modeled after European aristocracy) greedily pursued wealth and fame at the expense of others.[12] This world is remarkably polarized: there is no middle class (the ship offers only first- and third-class passage), and proper Victorian femininity (contrasted only with images of the French prostitutes seen in Jack's [Leonardo DiCaprio] sketchbook) remains unchallenged by the New Woman. The ship's rigid segregation of classes by deck emphasizes two-tiered hierarchy and subordination from above. Aside from

some minor grumblings about the tendency of first-class passengers to walk their dogs on the third-class deck, and the hushed explanation that women's choices are always difficult, acquiescence to a corrupt industrial patriarchy prevails among the RMS *Titanic*'s female and third-class passengers. Described by one character as "a steamer so grand in scale, and so luxurious in its appointments, that its supremacy would never be challenged," the ship materializes both the decadent excesses of the industrial class and the arrogant presumption that it, like the *Titanic*, is unsinkable. Computer-generated tracking shots emphasize the ship's considerable length, while wide shots display its smooth passage along the ocean's flat, expansive surface, linking the prevailing order with an insistent horizontality and unperturbed stasis. The film thereby turns the *Titanic* into an emblem of historical inertia: unless acted on by another force, the ship/history will continue to move in the direction of an increasing imbalance of power between classes and genders.

Historical inertia is doubled by the inertia that seems to govern the fate of Rose Dewitt Bukater (Kate Winslet), whose impending marriage has been arranged purely for the profit of others: it will enable both her fiancé (Billy Zane) to come into his inheritance and her mother (Frances Fisher) to retain the upper-class lifestyle threatened by her late husband's debts. Her imminent marriage seems to reduce Rose to a mute object, incapable of action. A panning shot of the dining room at teatime shows other women gossiping animatedly about the wedding as Rose sits paralyzed, staring blankly ahead as her voice-over explains, "I felt like I was standing at a great precipice, with no one to pull me back, no one who cared or even noticed." Her later suicide attempt links her plight to a descent into a dark void. When asked by Jack why she tried to jump overboard, she explains, "It was everything. It was my whole world and all the people in it, and the inertia of my life, plunging ahead and me powerless to stop it." To extend the association of marriage with the bride's downfall and social constraints with the inexorable force of gravity, Rose shows Jack her large diamond engagement ring, about which he comments, "God! Look at that thing! You would have gone straight to the bottom."

Verticality intervenes as a spectacular emblem for temporal rupture and violent historical "break." An iceberg's sudden appearance looming high above the ship's upper decks reconfigures the ocean's topography by activating vertical space high above and deep below its surface: the iceberg punctures the ship's hull, causing water to rush in from below and

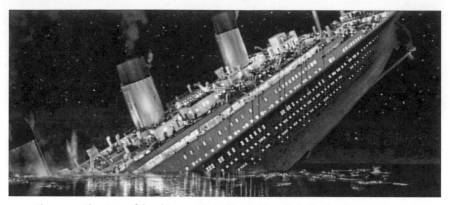

Figure 1.2 The stern of the ship upends in *Titanic* (Twentieth Century Fox, 1997).

chunks of ice to rain onto the deck from above. This reorganization of linear space prepares the way for the astonishing visual effects shots of the ship's stern catapulting high up into the air, converting the ship's magnificent length into a terrifying precipice that spurs the fall of an unjust era (fig. 1.2). Gravity therefore acts as a historical corrective in this film: it violently undoes the flattened hierarchy of the ship's two-tiered class configuration by turning the first- and third-class decks into equivalent parallel lines aligned upright, side by side. Computer-generated long shots and point-of-view shots from the top of the upended stern show hundreds of (digital) passengers—transformed into mere matter by gravity—plummeting the length of the ship to the icy waters far below. All fall to their deaths at the same speed regardless of class or rank as the ship's bow points to its new destination at the bottom of the ocean (fig. 1.3). Social determinism gives way to "mathematical certainties" as the indifferent laws of physics take control of the *Titanic*'s fate, emphasizing the idea that "in the act of falling, history relentlessly marches on to its foregone conclusion."[13] Verticality further emblematizes the notion of a historical break as the ship cleaves in two before upending again and then plummeting downward to the depths of the ocean floor.

That Rose's struggle for survival takes place at the stern is significant, for this site is associated with her earlier desire to give herself over to gravity and dissolution. The ship's sinking ultimately provokes her resistance to the force to which she earlier succumbed: she refuses to stay in the lifeboat (reserved for first-class passengers) that would preserve her identity, and ends up quite literally on a new precipice where, with Jack's help, she resists gravity's previously alluring pull. Verticality inverts the

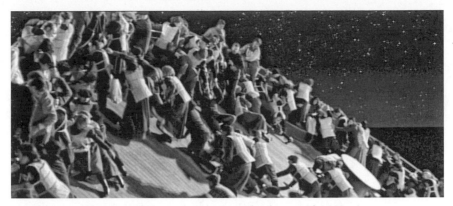

Figure 1.3 Passengers begin falling to their deaths as the ship upends in *Titanic* (Twentieth Century Fox, 1997).

logic of Rose's attempted suicide: rather than Rose escaping an oppressive social order by jumping overboard, the oppressive social order is instead sent plunging into the depths of the ocean. Rose's temporary submersion ultimately dissolves oppressive social/familial ties and consigns Victorian femininity to an obscure past: kicking to the surface, she emerges from disaster as Rose Dawson, New Woman. By simultaneously resisting gravity and succumbing to its corrective forces, Rose bridges verticality's historical break to become the subject of a new history defined not by polarization and inertia, but by the middle ground and hyperkinetic motion. While the frame narrative reveals that Rose went on to get married in the Midwest and progressed into old age as part of California's comfortable middle class, old photographs show a young Rose Dawson standing in front of a biplane and riding a horse in front of a roller coaster.

Critics have argued that Rose's transformation into a penniless third-class passenger who eventually rises to the middle class upholds the American ideology of upward economic mobility.[14] I agree, but I would add that *Titanic* is equally concerned (as its digital visual effects suggest) with downward mobility, and that the film's focus on descent simultaneously addresses a global audience for whom such myths of upward mobility are largely untenable. Verticality is masterfully and profitably deployed in *Titanic* to charge downward mobility with unprecedented visual pleasure: not only are the most astonishing digital visual effects reserved for the ship's near ninety-degree inversion and sinking, but the latter facilitates a decline in Rose's social status that the film argues has only liberating effects. Fantasies of potential and possibility are ultimately

tied to a protagonist who wins by losing. Her ongoing determination to cast off the burdens of the society life she left behind is signaled when the elderly Rose tosses the Heart of the Ocean diamond into the sea—a moment that should remind us that she never was, in fact, poor or lower class. In contrast, Jack, who is the film's primary figure for an irrepressible desire for upward mobility, heroically slips beneath the ocean's surface. Even as the frame narrative makes the myth of upward mobility available to some audiences, the film's tendency to map mobility along a downward trajectory acknowledges that, in the late twentieth century, the middle class may indeed have been accessible only from above. As *Titanic* suggests, verticality's spatial dialectics and bidirectional movement allow it to mobilize extremes, to elaborate and emblematize struggles for and imbalances in power, and to accommodate contradictory interpretations of each. In this way, verticality allegorizes and makes pleasurable the (spectatorial) position of being caught in the middle of fictional violent conflicts between polarized extremes, whatever their outcome.

Like *Titanic*, *Hero* represents a historical shift through verticality in order to emblematize the spectacular end of an era. In this film, verticality finds its most stunning elaboration through the four assassins who attempt to end the King of Qin's (Daoming Chen) bloody conquest of the region's warring kingdoms. Digitally enhanced wire fighting mobilizes their bodies along an expanded vertical axis and works in tandem with a highly stylized mise-en-scène to map complex historical forces onto (spatially) polarized oppositions. *Hero* is organized around three narratives that provide competing versions of the events that have brought the assassin Nameless (Jet Li) within ten paces, and hence striking distance, of the King. Within these narratives, the assassins defy gravity in settings defined by high bookshelves, tall trees, mountains, and desert rock formations, linking their verticality to their plotted obstruction of the King's plans for conquest. From the beginning, an Eisensteinian use of mise-en-scène supplements vertical motion to materialize the idea that history proceeds dialectically from the intersection of directionally opposed forces. When Nameless arrives at the King's court, horizontal and vertical lines clash to create a form of graphic montage within the frame. As Nameless mounts the stairs to the palace, his upright figure cuts sharply against the lines of the broad staircase that span the entire width of the screen. Inside, the interior of the Great Hall is even more starkly defined by linear conflict: in one shot, taken from the King's point of view, Name-

Figure 1.4 Horizontal and vertical elements of the mise-en-scène conflict in *Hero* (Beijing New Picture Film Co., 2002).

less's kneeling figure and the palace's pillars are dwarfed by horizontally aligned ceiling beams and rows of candles that dominate the frame and appear to exert pressure on vertical elements from above and below (fig. 1.4). The graphic montage that creates a conflict between horizontal and vertical elements of the mise-en-scène and the dominance of horizontality in the opening scene is important, for *Hero* concludes with a funeral procession that lionizes the willing demise of the forces of resistance. Analog and digital elements within the film (including set design) thereby work together to enable the screen's x and y axes to be used for emblematic signification. As the narrative unfolds, increasingly graceful images of downward mobility charge the assassins' surrender of power with elegiac beauty. In this respect, verticality aids in the aestheticization of acquiescence, and gravity's inescapable pull lends a sense of inevitability to past (and future) history and to the protagonist's heroic willingness to be leveled by the forward thrust of imperial "progress."

In the first, least truthful narrative, Nameless represents himself as a prefect who defeats the King's enemies—a group of assassins consisting of Sky (Donnie Yen), Broken Sword (Tony Leung), and Flying Snow (Maggie Cheung)—by taking advantage of a love triangle that has bitterly divided them. Here gravity-defiant insurgency is linked to heightened emotions and feuds fueled by jealousy and disloyalty. These connotations are most pronounced in the scene in which Moon (Zhang Ziyi) fights Flying Snow to avenge her master's murder. Throughout the scene, rage fuels vertical mobility as the combatants whirl through the air like tornados, give chase over treetops, and dive from high up in the air toward

grounded targets below. Throughout the fight, bright yellow leaves rain down on the combatants, suggesting that the unbridled passions that propel them upward will ultimately lead to their downfall. Indeed, when Flying Snow fatally wounds Moon, the trees and the falling leaves turn blood red. The mise-en-scène appears to mourn the futility of Moon's death, giving the impression that the natural world bleeds with her. At the end of the tale none but Nameless — the King's loyal prefect — is left standing. Though the King ultimately disproves this story, it serves the broader ideological function of allowing vertically articulated bodies to stand for the warring kingdoms that suffer needlessly by fighting among themselves, making unity through empire appear natural and necessary.

In the second tale, the King narrates events as he imagines they must have transpired, given his knowledge of the assassins' honorable characters. The King correctly surmises that Nameless, too, is an assassin and assumes that unity of purpose among the assassins has allowed Nameless to come within striking distance of the King's throne. In this version of the tale, verticality allows the King's admiration for the assassins' willingness to sacrifice themselves for their cause to be expressed through stunning images of descent. After picturing Flying Snow's heroic death during her staged battle with Nameless (as they fight, she exclaims, "I die willingly for our cause! Please make your move!"), the King imagines a subsequent, more spectacular fight between Nameless and Broken Sword (the vertical orientation of which was made possible by the digital removal of the wires, harnesses, and cranes used to create convincing images of flight). However, this battle unfolds only in their minds as a tribute to Flying Snow, whose body lies nearby on a bier. The imagined fight takes place on a lake, the perfectly still surface of which mirrors the tree-covered mountains in the background, inverting the treetops and peaks so they point to the bottom of the frame. In some shots, only the reflection is visible in the frame, orienting mise-en-scène along a downward trajectory, while in others, the frame is divided between the landscape and its mirror image, between competing images of ascent and descent that match the rising and falling action (fig. 1.5). The camera cuts between images of the fighters skipping across the surface of the water like birds taking flight and wide shots of them plunging headlong toward the lake, using the tips of their swords to rebound off the water's smooth surface. Here ascent (and with it insurgent power) is most beautiful when followed by images of descent that aestheticize the surrender to gravity and the loss of power.

Figure 1.5 Nameless and Broken Sword plunge toward the lake's surface as they fight in *Hero* (Beijing New Picture Film Co., 2002).

Not surprisingly, the King's imagination charges self-sacrifice and surrender with elegiac beauty and foreshadows the film's conclusion, in which Nameless is given a hero's funeral after sacrificing himself and his cause to the King's ostensibly higher goals of empire.

The third and final tale combines elements of the first two: the assassins are divided not by desire and jealousy but by conflicting political ideals. While Snow and Nameless still oppose the King (their families were killed by his army), Broken Sword embraces the vision of "Our Land" and the unification of the warring kingdoms through bloody conquest. Predictably, Broken Sword's decision to succumb to the forward march of progress follows a downward trajectory. In a flashback within the tale, he describes the fight in which he passed up the opportunity to assassinate the King. The fight unfolds in the Great Hall among long green banners that hang from the high ceiling and match the color of Broken Sword's clothing. Here, vertically oriented mis-en-scène aids wire-fighting to give outward expression to Broken Sword's desire to relinquish his part in the struggle and thereby helps to map a shift in power. At a crucial moment Broken Sword has the chance to cut the King's throat but ultimately pulls back. After the King realizes his life has been spared, a long shot shows the massive banners streaming gently to the floor on either side of the combatants. The opposed spatial coordinates of high and low are flattened as opposition gives way to acquiescence, allowing gravity to double for the inexorable force of China's (future) imperial history.

This historical trajectory finds expression through the arrows that slice across the court when the King gives the order to execute Nameless, sac-

rificing him to the ideology of "Our Land." Having taken to heart Broken Sword's argument that only the King has the power to end suffering and "bring peace by uniting our land," Nameless also declines to assassinate the future emperor and therefore forfeits his life. His execution concludes with an image that simultaneously documents the fall of oppositional power and aestheticizes its absence. The camera tracks along the court wall — now transformed by thousands of black arrows that protrude in a thick horizontal mass from its surface — until it reaches the empty, blank space where Nameless once stood. The negative space formed by the assassin's absent upright figure perfectly emblematizes the ideology that national history always demands the noble self-erasure of insurgent forces who resist its forward movement and idealizes (self-)subordination to an oppressive regime.[15]

Walled Cities, Mountaintops, and the Force of Tradition

Crouching Tiger, Hidden Dragon, a *wuxia* film that undoubtedly helped prime *Hero*'s enthusiastic reception by Western audiences, uses digitally enhanced visual effects to melodramatize a dynamic struggle for power by protagonists whose upward verticality is linked to insurgency against ongoing tradition and the past. As in *Hero*, resistance has deadly consequences, and the film ends with a willing fall into a void. At the opening of *Crouching Tiger*, each of the main characters is poised to break from the traditions and institutions that define his or her life. However, the past thwarts each attempt and asserts itself primarily through the obligations of duty (to dead fathers, fiancés, and masters) and revenge, both of which preserve lines of power and maintain past traditions in the present. Jen Yu (Zhang Ziyi) is about to enter into an arranged marriage that is certain to advance her father's career and increase her family's power. Though she appears to be an obedient upper-class daughter, she is, in fact, a powerful fighter trained by the notorious Jade Fox (Pei-Pei Cheng) and is in love with Lo (Chen Chang), an outlaw bandit. Jen wishes to lead a warrior's life, which she mistakenly believes is defined by freedom from duty to others. Li Mu Bai (Chow Yun Fat) wishes to quit his life as a warrior in order to spend it with Yu Shu Lien (Michelle Yeoh); she, in turn, contemplates forgetting her duty to honor the memory of her dead fiancé to be with Li Mu Bai. However, *Yi* (duty to his dead master) binds Mu Bai to the past. At the beginning of the film, he gives away the Green Destiny sword to escape the *jiang hu* underworld, but, as he notes, "the cycle of

bloodshed continues" as Jade Fox's arrival in Peking forces him to avenge his master's murder. In *Crouching Tiger*, vengeance maintains the past in the present by keeping one murder alive, so to speak, until another one consigns it to the past. Though Mu Bai kills Jade Fox, she also slays him with the same poison she used to kill his master. Rather than free Mu Bai to pursue a new future, the act of vengeance gives the past the power to repeat itself and foreclose on the future altogether. As in *Titanic* and *Hero*, the struggle for power between polarized forces takes place on a historical threshold where a younger generation's priorities and desires threaten to overturn long-standing tradition. The film represents the upheaval characteristic of such moments of (generational) conflict and transition through vertical movement.

Mu Bai and Jen are defined in part by their desires to jettison traditional duties to fathers and masters in favor of satisfying individual desires. They also imagine and long for a future that departs from the ongoing order of things. In the first half of the film, Mu Bai plans to abandon his training altogether to be with Shu Lien, but in the second half, he revives his pursuit of Jade Fox and decides to return to Wudan to train a female disciple. In turn, Jen leaves behind the obligations of aristocratic femininity and marriage to roam freely as a rogue warrior unbound by any duty to others—even *Qing* (the duty of consideration of others), which Shu Lien points out is necessary for any warrior's survival. Indeed, by running away from her arranged marriage and having a relationship with Lo, Jen rejects the traditional female virtues of both *Xie* (filial piety) and *Zhen* (female sexual purity), gives way to *Yin* (excessive sexual feeling), and fails to exhibit *Li* (propriety or conformity to accepted standards of social behavior).[16] Not surprisingly, Jen and Mu Bai are the film's primary and secondary agents of verticality, respectively. Ultimately the film is ambivalent about any complete rejection of or acquiescence to the demands of the past and the constraints of tradition, for both the fulfillment of traditional duties and the rejection of them have disastrous consequences for each of the characters.

The first vertically oriented fight scene appears immediately after Jen indicates to Shu Lien her desire to evade the confinement and subordination of her approaching arranged marriage. Hence the dialogue that precedes and follows the extended fight sequence frames the vertical action in a way that allows the sequence to emblematize the characters' resistance against or adherence to duty, tradition, and the past. During

her first meeting with Shu Lien, Jen expresses a desire to live a life free from the constraints that bind her to an unwanted marriage arranged by her father. After finding out that Shu Lien is a warrior, she exclaims, "It must be exciting to be a fighter, to be totally free!" Shu Lien points out Jen's error and explains that in order to survive a warrior's life, one must abide by a code, a set of ethics or rules that binds one by duty to others: "Warriors have rules too: friendship, trust, integrity. Without rules, we wouldn't survive for long." Despite this correction, Jen persists in thinking of the warrior life as defined by freedom from all obligations to others and by fighting as a means of overcoming the barriers to the fulfillment of individual desire. She counters, "I've read all about people like you, roaming wild, beating up anyone who gets in your way." Later, when Shu Lien visits Jen following the theft of the sword, Jen indicates that she resents having to marry for the sake of her father's career and reiterates, "I wish I were like the heroes in the books I read. Like you and Li Mu Bai. I guess I'm happy to be marrying. But to be free to live my own life, to choose whom I love—that is true happiness." Shu Lien again corrects Jen, and reveals that she and Mu Bai have never acted on their love for each other. Shu Lien chides, "I am not an aristocrat as you are, but I must still respect a woman's duties." From her reading of fictional stories about warriors, Jen mistakenly assumes that the jiang hu life confers radical freedom to its warriors, eliminates one's duty to others, and releases the individual from fulfilling his or her duty to the demands of filial piety.

The vertical movement of the fight sequence that these scenes bookend emblematizes these characters' contrasting and even polarized relationships to filial piety and tradition. As Christina Klein argues, the fight enacts "the conflict between the desire to pursue one's self-interest and the sense of obligation to others and to the rules that define one's social role. The two women represent opposite poles of this tension, which finds expression in the very form of their fight."[17] Klein argues that, "like a romantic waltz in a musical, the fights communicate visually what is difficult for the characters to say verbally. The fights express characters' feelings and desires, externalize their inner lives, and give physical shape to their relationships."[18] However, I would argue that verticality spectacularly renders that which has already been expressed in dialogue before (and again after) the fight, such that dialogue and visual effects work together to emblematize the broader conflicts around the themes of desire and duty,

the present and the past, that the film as a whole narrates. Story and dialogue simultaneously produce the meanings to be attached to spectacular images of verticality and (to quote Walter Benjamin) drag "the essence of what is depicted out before the image" to shape the audience's interpretation of them.[19]

Hence, despite Shu Lien's caveat regarding the duties and rules that define a warrior's life and actions, Jen nevertheless commits an act of reckless rebellion that will give her a material connection to the (mythological, fictional) warrior life she desires by stealing the Green Destiny sword from Sir Te. Hearing the raised alarm, Shu Lien pursues the masked thief over the peaked rooftops, which give the chase an undulating rhythm that coordinates Shu Lien's and Jen's contrasting relation to the traditions and duties binding present and future behavior to the past. As Klein notes, whereas the dutiful Shu Lien acts with the force of gravity throughout the scene, Jen defies gravity much as she desires to defy duty and tradition.[20] Hence, throughout the fight scene, Shu Lien counters each of Jen's vertical ascents: she knocks Jen out of the air by throwing bales of hay and pieces of brick at her; she steps on Jen's feet as Jen pushes off the ground to fly away, grabs her clothes before she soars out of reach, and scrambles up a wall to cut off Jen's ascent, demanding, "Get down here!" In another shot, as Jen flits lightly across rooftops, Shu Lien remains earthbound and gives chase below through the labyrinthine streets and alleys of the city.

Indeed, given her function as an anchor working to keep the fight on solid ground, it is significant that throughout much of the film Shu Lien chooses to remain bound by tradition: she exemplifies filial piety by successfully operating the security business her father passed on to her (one client declares her an honor to her father's memory); she protects at all costs the interests and reputation of Sir Te (who regards her as a daughter); and, as she explains to Jen, she and Mu Bai have repressed their desire for one another to remain faithful to the memory of Meng Si Zhao, her deceased fiancé and Li Mu Bai's blood brother. Rather than challenging patriarchy, her role as a warrior and security agent fulfills the principle of Xie, simply because she carries on her father's work in his absence.[21] If the digitally rendered walled city of Beijing is the (horizontally articulated) architectural manifestation of Jen's confinement by ongoing traditions and family histories far more powerful than she, then Shu Lien embodies the structural support of dutiful femininity on which patriarchy

Figure 1.6 Jen Yu and Li Mu Bai fight in the treetops of a bamboo forest in *Crouching Tiger, Hidden Dragon* (Sony Pictures Classics, 2000).

and its traditions depend. Hence, throughout their first fight, tradition and duty—figured as the earth's gravitational pull—exercise themselves through Shu Lien, who acts as a counterweight to Jen's vertical flight.

We can compare the vertical action of this scene with the fight between Mu Bai and Jen in the treetops of a bamboo forest. In contrast to the rigid up-or-down verticality of the first fight (facilitated by the walls and buildings of the city), the choreography of the fight in the forest is defined by the swaying flux of the bamboo trees that yield to the lightness and weight of the fighters' bodies (fig. 1.6). This pliant, bending verticality is a visual manifestation of Jen's wavering position, her suspension between courses of action—she may return to her parents and subordinate herself to her father's wishes, she may become Mu Bai's disciple and subordinate herself to another tradition, or she may roam free as a masterless warrior. Whereas in the first fight scene Jen seems far more weightless than Shu Lien, in this scene Mu Bai floats and balances with far greater ease. Here the forest is an important element of verticality's mise-en-scène: the trees provide a structural support for the weightless body that demands the masterful use of gravity as much as the transcendence or defiance of it. If gravity represents the force of tradition and the past, then Mu Bai's more masterful verticality derives in part from his connection to the traditions, training, and duties of a warrior trained at Wudan Mountain. Hence he is able to use the rise and fall of the branches with far greater skill than Jen, who plunges halfway below the tree line when he shakes her from a branch. His greater utilization of gravity's force thereby implies that without some structural support from past tra-

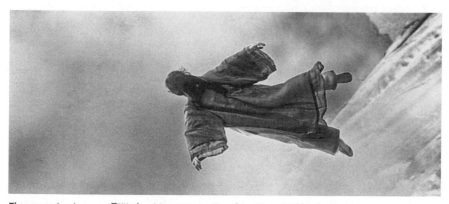

Figure 1.7 Jen jumps off Wudan Mountain in *Crouching Tiger, Hidden Dragon* (Sony Pictures Classics, 2000).

dition, without any master, the future is characterized by a perilous free fall. Yet as an agent of verticality, he is also at odds with tradition. Indeed, at this point in the narrative, Mu Bai chases Jen into the treetops because he wishes simultaneously to carry on tradition and transform it by bringing a female disciple to Wudan Mountain.

In keeping with its ambivalence toward the unconventional future each of the characters longs for, the film ends by suspending its protagonists between old and new worlds. As I mentioned, the past repeats itself in the present when Mu Bai is poisoned by Jade Fox, killing his future. Rather than use his last moments to meditate and enter heaven, Mu Bai chooses instead to remain a ghost that walks the earth by Shu Lien's side. This figurative suspension between two worlds, between heaven and earth, past life and future life, is visually expressed through the film's final image, as Jen jumps off Wudan Mountain (fig. 1.7). Before she jumps, Jen reminds Lo of the legend of Wudan Mountain. Earlier in the film, Lo tells the legend of a boy who jumped from the mountain to save his ill parents from certain death and simply floated away, unhurt, never to return. He tells her, "Anyone who dares to jump from the mountain, God will grant his wish. . . . The elders say, 'A faithful heart makes a wish come true.'" Invoking (and perhaps reenacting) this legend, Jen tells Lo to "make a wish" (he wishes "to be back in the desert, together again") and jumps. On one hand, Jen's descent may be read as an elegiac image of the insurgent figure's fatal acquiescence to the laws of physics and, hence, to the conventions and traditions that govern the social order she had so violently resisted. On the other, her fall might fulfill Lo's wish for them to return

to the desert to lead a life unconstrained by family duty and class differences. Though the path has been cleared for Jen to live a life of freedom and autonomy, the film holds the future at bay, suspending the narrative (and the spectator) between opposing outcomes. Jen's descent through space thereby foregrounds verticality's more general ability to accommodate ambivalence along with the film's specific melodramatic negotiation of—and radical refusal to resolve—conflict between the representatives of the future and the past, the desire for change and the insistent pull of tradition, and the struggle of the emergent against the dominant. *Crouching Tiger*'s open-ended conclusion therefore foregrounds the melodrama's generic refusal to resolve the conflicts emblematized by verticality's spatial dialectics and enacts at the level of action and image what Steve Neale refers to as the "wish structure" of the melodrama, its tendency to provoke spectators to wish, "If only . . ." (i.e., if only Jen had never left the desert; if only she had become Mu Bai's disciple; if only she had arrived in time with Mu Bai's antidote after he is poisoned by Jade Fox, etc.).[22] Indeed, Jen's final words—"Make a wish, Lo"—invoke this structure. Rather than use verticality to provide an easy resolution to complex (generational, gender, and class) conflicts, the film ends with a series of shots that make it difficult to determine whether Jen falls (and therefore succumbs to gravity and the force of tradition) or floats away into the mountains to fulfill Lo's wish and her own desires. By refusing to confirm whether Jen's rebellion against tradition will be rewarded with a return to the desert or punished with her death, this ambivalent, inconclusive image of verticality ultimately works not only to emblematize the (ongoing) desire for historical change but also to accommodate the conflicting identifications, politics, and interpretations of the blockbuster's broadly heterogeneous global audience.

Severed Pasts and Skyscrapers

Science fiction's focus on the nature and experience of time, as well as its tendency to imagine worlds, technologies, and forms of embodiment that defy the laws of physics, has made it another genre ideally suited to exploit the new digital verticality (prime examples include *The Fifth Element, Dark City, Sky Captain and the World of Tomorrow, I, Robot, War of the Worlds, Inception,* and *Avatar*). *The Matrix* is undoubtedly the film that most insistently ties vertically oriented action to the struggle for control over the laws of space and time. In it, humanity has been enslaved by

machines and exists in a state of suspended animation, as nothing more than a power source for artificially intelligent computers. Implicit and explicit in *The Matrix* is the idea that history operates according to horrifying cycles and ironic inversions: while images of the shackled Morpheus (Laurence Fishburne) link the current enslavement of mankind to the transatlantic slave trade, humanity's subordination to machines perverts modernity's equation of historical progress with technological development. Once freed from the matrix, Neo (Keanu Reeves) struggles to rescue humanity from machine-made, simulated space and time. This struggle has evolutionary overtones: while Agent Smith (Hugo Weaving) compares humans to dinosaurs and viruses, Neo will become "the One" (who saves humanity) precisely because he has somehow acquired the characteristics of his captors (Tank [Marcus Chong] refers to him as "a machine"). The film borrows and expands on the vertically oriented action of the martial arts film (Yuen Wo Ping choreographed the fight scenes in both *The Matrix* and *Crouching Tiger*) to spatialize its protagonist's relation to historical time and power. Whereas Neo's powerlessness is emphasized through his fear of heights at the beginning of the film (he is first captured by Agent Smith when too frightened to climb the scaffolding to the top of the Metacortex building), his ascension to his position as the One is marked by his increasing ability to bend the laws of physics and defy gravity. Put differently, Neo's ascension to new ontological heights as the One is marked by his gravity-defying upward mobility; such ascension in turn signals his transformation into an agent and emblem of historical rupture.

As in the other films discussed here, *The Matrix* does not use verticality simply for the sake of spectacle. Rather, verticality is the dynamic, emblematic expression of a desire to change the course of history, to precipitate a new future. Nearly all violent conflict with the Agents takes place along a vertical axis, from the opening scene when bullet-time sequences first display the spectacle of Trinity (Carrie-Anne Moss) suspended in the air as she kicks her way out of a trap, to a later scene in which the rebels flee the hotel by sliding down through its interior walls. The spatialization of power is most evident in the scenes organized around Morpheus's rescue from the Agents, which begins with Neo and Trinity storming the lobby of a skyscraper and engaging in a shoot-out with security guards. The pillars that line the lobby materialize the film's broader theme of imprisonment and structure the vertical mise-en-scène of the fight se-

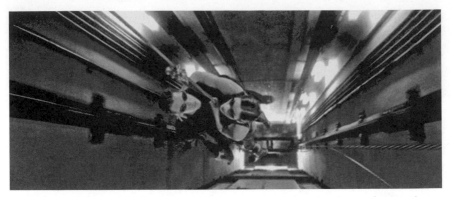

Figure 1.8 Neo and Trinity rise up through an elevator shaft as the elevator drops to the ground floor in *The Matrix* (Warner Bros. Pictures, 1999).

quence. As agents of verticality, Neo and Trinity create a downpour of falling shrapnel, objects, and bodies even as they defy gravity themselves. Fragments of marble and concrete, spent bullet casings, shards of glass, and water from a sprinkler system create a constant stream of downward motion that mimics the descent of the binary code seen falling across computer screens throughout the film. As other bodies drop, Neo and Trinity rise: in one of the rescue scene's many high-angle shots, they propel themselves to the top of the skyscraper by the cables of an elevator car they have sent plunging to the lobby, packed with explosives (fig. 1.8). Later in the rescue, as Trinity and Neo shoot from a hovering helicopter into the office where Morpheus is being held, the camera cuts to a low angle beneath the shower of bullet casings that rains down from above (fig. 1.9).

The bidirectional movement of such shots foregrounds the link between verticality and narratives of emergence. Neo's repeated defiance and bending of the matrix's machine-made gravity (he dodges bullets, runs up walls, dangles over a digitized greenscreen cityscape, and rescues Trinity as she falls from a downed helicopter) ultimately demonstrate that he is the One and present the possibility of humanity's liberation from the matrix. Importantly, the film exploits the skyscraper to do so. While the jagged, burned-out spikes of the real world's city skyline represent the end of human progress, the mirrored postmodern skyscrapers inside the matrix represent an inversion of the principles according to which modern progress was measured. If the upward reach of the twentieth-century skyscraper implied the limitless potential of human

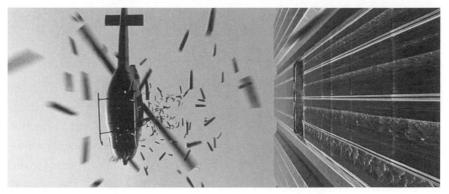

Figure 1.9 Bullet casings fall from a helicopter as Trinity and Neo rescue Morpheus in *The Matrix* (Warner Bros. Pictures, 1999).

endeavor, the simulated skyscrapers of the matrix imply humanity's backward slide, its reduction to nothing more than the energy given off by the body's biological processes. Hence the simulated skyscraper filled with workers in tiny cubicles simply cloaks the real-world skyscrapers of the film's twenty-second century—the massive energy towers that reduce human history to the ahistorical temporality of thermodynamics. Like some of the other films I discuss here, *The Matrix* has a somewhat inconclusive resolution. Whereas *Crouching Tiger* ends with its protagonist's downward fall, *The Matrix* ends with Neo promising a future revolution in voice-over and rocketing upward above the city skyline of the matrix. While we might link this open-endedness with the film's position as the first installation of a trilogy, it is worth noting that the trilogy itself ends not with a triumphant victory of human over machine, but with a truce between polarized forces.

Diving Downward and Looping Back

Like many recent blockbusters, *Avatar* maps (a fictional) historical transition onto spatial transience and sets its narrative at a pivotal moment in history that promises to bring about the return of the past. The film dramatizes a struggle over which past—or, to be more precise, *whose* past—will return in the present to determine the course of the future on the moon Pandora. The "pull" of the past and the drive to manifest it in the present find emblematic expression in the film's emphasis on volitional downward mobility. The film opens onto a violent conflict already under way between the Na'vi (Pandora's native population) and the Sky People

(humans from Earth—here, the invading aliens) for control over space and time on Pandora. It is clear from the outset that this conflict will be played out on a polarized vertical terrain: the Sky People have arrived by spaceship from above to mine a precious metal (called "unobtainium") from deep below the surface of Pandora's rainforest. To gain access to Pandora's unobtainium, the humans first use their avatar program (which allows humans to upload an individual's consciousness, via a computer link, into hybrid Na'vi/human bodies able to endure Pandora's toxic atmosphere) to try to persuade the Na'vi to yield their natural resources to the mining company; when that fails, they use military force. The struggle over the space of the rainforest (and what lies beneath it) is inseparable from a struggle over the historical past and the future. The humans and the Na'vi inhabit structurally similar but conflicting recursive temporalities: while the Na'vi organize life around the cyclical time of nature, tradition, and myth (with an emphasis on renewal and return), the humans fight to incorporate Pandora and the Na'vi into humanity's (or the United States') cyclical history of military-industrial conquest and natural destruction (disguised, of course, as linear progress). Significantly, to reach unobtainium, the mining corporation must dig up and destroy the rainforest, an ecosystem that also functions as a biological, networked database that stores elements of the Na'vi's past (souls, memories, voices of the dead) and makes them accessible in the present. By mining underground deposits of unobtainium, the humans uproot not only the forest but with it the ongoing presence of the historical past in the everyday life of the Na'vi.

The horizontal configuration of this bioluminescent network links its design strongly to the historical past it stores (when the Na'vi attempt to "upload" Grace's [Sigourney Weaver] and Jake's consciousness permanently into their Na'vi avatars through this network, we see it spread, weblike, across the surface of the forest floor); but the violent struggle over its destruction or preservation is fought on a vertical axis. Hence in *Avatar* the ability to occupy the spatial coordinates of the zenith and the nadir is inseparable from the power to control space and time on Pandora. Early on in the film, a hologram in the mining corporation's database maps out the terms of the polarized conflict and its downward directionality. In a key scene, Selfridge (Giovanni Ribisi) and Colonel Quaritch (Stephen Lang) reveal that Home Tree—an immense structure that towers above the rest of the forest and serves as a village for the

Na'vi—rests on top of a massive deposit of unobtainium. To extract the precious metal from deep beneath the village, the mining company must raze Home Tree. Time has nearly run out for the corporation to get the Na'vi to leave voluntarily; efforts at incorporating the Na'vi into the temporality of imperial progress by building schools and roads have failed, making the use of military force increasingly likely. Just as mining leads the alien humans on a downward trajectory, the Na'vi ascend to vertiginous heights that allow them to attack their enemy from above; hence Na'vi verticality is epitomized by the highly controlled nosedive executed from extreme heights—a thrillingly volitional descent that displays their transcendent mastery of gravity through flight. Each Na'vi ascent (usually accomplished by climbing) is thus matched by a spectacularly masterful descent—a joyful drive toward the traditional past that downward mobility emblematizes.

Pandora's fantastical computer-generated landscape makes possible this spatialization of time and power: the opening scenes reveal a topography marked by waterfall-covered cliffs, tall bamboo trees, and branches that span massive chasms to emphasize the verticality of the rainforest's terrain. Moreover, we learn early on in the film that Pandora has low gravity, a notion evidenced by the Hallelujah Mountains—massive rock formations that float high above the rainforest. Even as the floating mountains seem to transcend gravity, hanging vines and waterfalls cascade over their sides to display, in spectacular fashion, an ongoing process of gravitational give-and-take in which gravity appears to yield to some objects just as, elsewhere, they yield to it (fig. 1.10). This same process is evident in the design of the massive stone arches that reach skyward over the Tree of Souls only to bend back down again to the forest floor. In turn, the towering Home Tree twists skyward to loom over the rest of the forest, its spiraling, double-helix design implying simultaneous ascent and descent. If verticality spatializes time by linking upward movement to a new future and downward motion to the pull of the historical past, then the bilateral exertion of gravitational pull and resistance evident in Pandora's landscape emblematizes the notion of a movement toward the future that always returns to the past—a recursive history organized around the cyclical time of nature and tradition. Here computer-generated images are used to present the digital landscape as a Bakhtinian "chronotope" in which "spatial and temporal indicators are fused into one carefully thought-out, concrete whole. Time, as it were, thick-

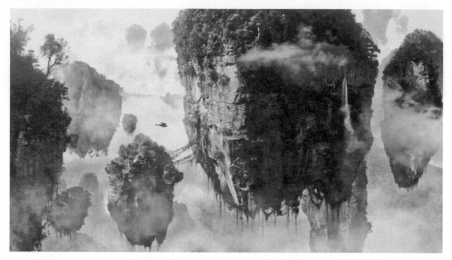

Figure 1.10 Vines and waterfalls plunge over the sides of the floating mountains of Pandora in *Avatar* (Twentieth Century Fox, 2009).

ens, takes on flesh, becomes artistically visible; likewise, space becomes charged and responsive to the movements of time, plot, and history."[23] The design of the Tree of Souls provides an example of the vertical landscape as chronotope: its soaring structure reaches upward only to have its tendril-like, bioluminescent leaves cascade back down to the ground to give the Na'vi access to ancestors from bygone eras. Given the location of the mountains and the Tree of Souls within the "flux vortex" (an area where the laws of physics are attenuated), it is not surprising that much of the violent conflict between the Na'vi and the corporation is staged on a vertical axis in and around the mountains above the Tree of Souls. Hence, upon realizing the impossibility of incorporating the Na'vi into imperialism's progress narrative, Quaritch opts to bomb the Tree of Souls, claiming that doing so "will blast a crater in their racial memory so deep that they won't come within a thousand clicks of this place ever again." When he hears of this plan, Norm (Joel David Moore) exclaims, "If they get to the Tree of Souls, it's over. That's their direct line to Eywa, their ancestors. It'll destroy them," indicating that by severing this connection to the past, Quaritch will foreclose on the Na'vi's future.

Just as the Na'vi are poised on a historical threshold, the film's protagonist, Jake Sully, also teeters on the edge separating his past and a new future, between his role as a spy for the mining company and his emerging identity as the warrior who protects the Na'vi and the rainforest from

annihilation. Jake's development from Quaritch's spy to the leader of the rebellion follows a vertical trajectory so that the ontological heights to which he ascends correspond to his mastery of gravity upon completing a series of astonishing ascents. In a prologue, Jake, a paraplegic ex-marine, is persuaded by representatives from the mining corporation to take his murdered twin brother's place in the mining company's avatar program, promising him "a fresh start in a new world" as he watches his brother's remains being cremated. And while Jake's voice-over states, "One life ends, another begins," suggesting that he has embraced the idea of a new future, moments later he continues, "There's no such thing as an ex-marine. I may be out, but you never lose the attitude," implying that this new life may not entirely reject the past. Indeed, once the Na'vi take in Jake (in his avatar form), he is quickly drafted by Colonel Quaritch to gather intelligence that will prove useful in negotiating the Na'vi's removal, or for using military force against them. If Jake succeeds in his "mission" (persuading the Na'vi to move), Quaritch will arrange to have his spinal injury fixed so that Jake can return to his old life and his old body back on Earth. However, as Jake (via his Na'vi avatar) completes the rituals that will allow him to become "One of the People," he comes to sympathize with the Na'vi way of life and falls in love with Neytiri (Zoe Saldana). If he succeeds in becoming a Na'vi, Jake will begin a new future in a world that is profoundly tied to Na'vi tradition and the rainforest, to the cyclical time of nature. In the end, Jake's violent resistance against the mining company and Quaritch is in the service of preserving a traditional, tribal way of life that remains profoundly connected to the past. Hence his path toward insurgency and becoming "One of the People" follows a vertical trajectory that requires him not just to defy gravity through moments of astonishing ascent but, like the Na'vi, to master gravity through breathtaking moments of controlled descent.

That Jake will master gravity is suggested early on in *Avatar*, when he is chased through the rainforest by a jungle creature and, at precisely the moment escape seems impossible, leaps from a cliff and plunges into the water below, fearlessly using gravity to avoid certain death. Later his training with Neytiri requires him to master gravity far more skillfully, until he is able to convert the deadly long fall (with its connotations of doom and death) into a volitional, controlled dive; he must learn to leap from treetops to the ground far below, using only tree branches and leaves to break his fall. The difference between the dive (or leap) and the fall is

Figure 1.11 Jake climbs up to Oo-rah in *Avatar* (Twentieth Century Fox, 2009).

important, for the former converts the passive, helpless subordination to gravity of the latter into an active appropriation of its power to the ends of survival, preservation, and the mastery of space and time. Jake's training culminates with a final test that takes him to the incredible heights of Oo-rah, which floats at the top of a chain of rocks that stretch skyward, high above the rainforest in the Hallelujah Mountains, so he can claim an ikran (a pterodactyl-like creature used for hunting). As Jake climbs up the hanging vines that tether the mountains loosely together, vertiginous high-angle shots (the astonishing z-depth of which is considerably enhanced by 3D) measure the fearsome distance to the forest below (fig. 1.11) to reveal the all-or-nothing stakes of the trial: should he succeed, Jake will become a new being—a hunter and One of the People; should he fail and fall, his fate is oblivion—a descent into nothingness, a free-fall into the void, and a return to his old, gravity-bound disabled body and his past.

In *Avatar* flight becomes a dynamic device for emblematizing the connection between Jake's aspiration to reach the ontological heights of his new Na'vi being and the imperative to ascend to the dizzying heights (of Oo-rah) where the ikran and possibility for flight are located. Once Jake captures his ikran (only after nearly being thrown over the edge of a cliff), he tentatively commands, "Fly?" and the two plunge downward, ricocheting off the sheer face of the cliff in a struggling, tumbling mass until Jake commands in an authoritative voice, "Shut up and fly straight!" They then

level off and soar through the air, weaving joyfully through the floating mountains as they are joined by an elated Neytiri. The flight sequence culminates with a series of hyperkinetic tracking shots of Neytiri and Jake as they dive down the side of a cliff and then level off to a peaceful, floating glide, with the camera cutting to a position below them. This shared nosedive gives dynamic expression to the broader desire to preserve the Na'vi's past into the future—now shared by Jake. He exclaims in voice-over, "I may not be much of a horse guy, but I was born to do this," linking his mastery of gravity to his "progress" toward becoming a new being. That such becoming is inseparable from the ascent to new heights is confirmed when he leads the Na'vi insurgency against the mining corporation.

Avatar links the apex to power, and so within the fictional world of the film, flight is a means to an end, an enhanced form of vertical mobility that enables one to occupy the highest position in the sky. The scene in which Jake captures the giant ikran, Toruk, allegorizes this connection. Toruk is first introduced in a flight sequence in which Jake exclaims in voice-over, "I was a stone cold aerial hunter. Death from above. Only problem is, you're not the only one" as Toruk attacks and drives Jake and Neytiri from the sky into the rainforest below. Later, when Jake formulates his strategy for becoming Toruk Makto ("rider of Last Shadow"), he explains, "The way I had it figured, Toruk is the baddest cat in the sky. Nothing attacks him. . . . So why would he ever look up?" Sending his ikran into a nosedive from high above Toruk, Jake leaps off and drops onto Toruk's back. This ascent to the highest point in the sky has historical and temporal as well as spatial implications: earlier Neytiri has explained that only five Na'vi have become Toruk Makto, the most recent of whom "brought the clans together in a time of great sorrow." By becoming the sixth rider, Jake inscribes himself into, and becomes an agent and an emblem of, Na'vi cyclical history and oral tradition. As his strategic use of the nosedive and the volitional leap suggest, Jake becomes Toruk Makto to help ensure that the past (all that is stored in and circulates through Pandora's global network) will continue to live on in the future.

In *Avatar*, and in many of the other films I have discussed in this chapter, the new verticality joins the plasticity of the digital image (its radical malleability) to the fungibility of the emblem (its ability to produce an intellectual concept from an image, story, and dialogue) in order to represent a violent struggle over the course of history, the outcome of which will leave one era, one way of life, in ruins. *Avatar* orchestrates the final

battle for control over space and time along lines of radical ascent and descent, with each side using the strategy of "death from above." While Quaritch and his army fly into the flux vortex to bomb the Tree of Souls, hundreds of ikran-riding Na'vi cling to the sides of the Hallelujah Mountains, high above Quaritch's sortie, in order to drive the aliens' bomber into the ground—and the invading humans into the past—before it reaches its target. Each side masters gravity to force the other to succumb to its pull. The mise-en-scène of the battle and the emphasis placed on gravity's link to destiny foreground the new verticality's insistent use of the laws of physics to represent historical change. Much like the emblematic mise-en-scènes of the baroque tragedies discussed by Walter Benjamin, in which "history becomes part of the setting," in *Avatar* "the word 'history' stands written on the countenance of nature in the characters of transience."[24] Thus historical transition finds expression as spatial transience through a mise-en-scène organized around gravity's pull. Each character's death or near defeat (along with that of the civilization for which he or she fights) is represented through a long fall: Neytiri, forced from the sky by a plane, is shot from her ikran and falls to the forest floor; Tsu'tey (Laz Alonso) falls headlong from the bomber's cargo hold to the distant forest floor (only after first hurling several human soldiers into the void). When Trudy's (Michelle Rodriguez) helicopter is shot, it doesn't explode in the sky (as is typical of cinematic firefights) but plunges through the air in a fiery mass, linking the involuntary long fall to loss, doom, and, here, incorporation into humanity's cyclical history of conquest and destruction. In turn, Jake and the bombers race to subject each other to gravity's deadly pull: as soldiers push the bombs to the edge of the cargo hold, Jake leaps from Toruk onto the ship, drops a grenade into an engine, and leaps onto Toruk's back. The ship cants to the side once the grenade explodes, forcing the bombs back into the cargo hold as the ship plunges to the ground and crashes, just before reaching its target. Through these falling bodies—live action, digital, composite—the computer-generated image transcends the laws of physics in order to (re)appropriate them at the level of representation, pressing gravity into the service of allegorical signification so that the natural world and the laws of physics function as emblems of a struggle over the past and the future.

In the end the humans' technological mastery of space and gravity fails to ensure their mastery of historical time, partly because of their failure to fully comprehend their own past. Just as Jake inscribes himself into

Na'vi history by becoming Toruk Makto, he also inscribes his knowledge of the history of humanity's destruction of nature on Earth into Pandora's global network. Earlier in the film Jake brings the dying Grace to the Tree of Souls and asks the Na'vi to upload her soul permanently into her avatar. Precisely because the attempt to save Grace's life fails, her memories become part of Pandora's networked archive of the past. On the eve of battle Jake petitions the Na'vi's deity to search Grace's memories of Earth's destruction, thereby exposing the global stakes of the upcoming fight. Just when defeat seems inevitable, all of the forest creatures join in the battle and attack the invading aliens (the humans), allowing the Na'vi to renew their assault from above.

Much as the film's narrative privileges a future that includes the past, *Avatar*'s concluding shot of Jake "waking" into his avatar body repeats the film's opening, but with significant differences. The film opens with a high-angle shot as the camera flies above the rainforest, then tilts and plunges downward, cutting to black just as it is about to hit the forest canopy. Jake's voice-over states, "When I was lying there in the VA hospital, with a big hole blown through the middle of my life, I started having these dreams of flying. I was free! Sooner or later, though, you always have to wake up." He thereby links downward mobility to the end—the end of (the dream of) freedom from the limitations of a body bound by gravity, of a future unbound by the tragic events of the past. The next shot shows Jake awakening in "cryo" as his spaceship approaches Pandora. By the end of the film, the association of downward mobility with doom has been altered, so that Jake awakens into a new body able to master gravity and, moreover, one that thrills in the nosedive that emblematizes his new relationship to the historical past. However, as this new body (which combines Jarhead Jake with Toruk Makto) suggests, *Avatar* does not simply privilege the past over the future but instead favors a vision of the future that includes the past, one that combines old and new. The final shot of the film invokes, on a far smaller scale, the spatial dialectics *Avatar* uses throughout to emblematize this notion of history: as Jake and his avatar lie on the ground and his soul is uploaded permanently into his avatar, the "camera" moves around the bodies to a higher angle above the avatar, then tilts down and dollies in to a close-up of Jake's face as his eyes open directly into camera. These two looks—Jake's look upward and the "camera's" downward point of view—invoke the vertical coordinates around which the film organizes the protagonists' struggle for control of

space and time. This final, stylistic invocation of old and new, past and present, is relevant to *Avatar*'s position within film history, for while the film developed and deployed new digital technologies (including revolutionary performance capture techniques, stunning key frame animation, and digital 3D) to an unprecedented degree and to astonishing effects, its narrative structure, generic conventions, editing, and story remain well within the conventions of popular, Hollywood-style filmmaking. And while the Na'vi victory can be read as the triumph of "nature" over industrial capital, I think it is more accurate to read it as the triumph of one type of technology (fiber optic networks) over another (heavy industry) simply because the film redefines (and idealizes) the notion of life-as-information that can be stored and networked by the natural world, even after the death of the body. Finally, we might say that this closing image suggests film history's own recursive structure, not just in terms of the ongoing historical remediation of older moving picture technologies by new, but also in terms of the (relatively) recent dominance of film franchises. This image of awakening (an ending that opens the way for a new narrative beginning) portends the cyclical return of Pandora's fictional history in the form of sequels and prequels.

That films defined by their spectacular use of CGI should be so concerned with historical thresholds is not surprising, particularly if we keep in mind the centrality of powerful new (and sometimes alien) technologies to the plots of so many recent blockbusters in which verticality is notable. As theorists and historians have noted, the "remediation" of film by digital technologies frequently provokes critical speculations about the relation of the cinema's (digital) future to its (celluloid) past.[25] Indeed, the vertical bodies under consideration here are composites of old and new, of analog and digital effects, of film and digital media—sometimes visibly so. Put differently, cinematic verticality has its own history, and that history is inscribed on the bodies it mobilizes through space. Sometimes the computer-generated status of the digital stunt doubles, and their corresponding freedom from the laws of physics, becomes too visible in moments of verticality, while at other times the ongoing subjection of upwardly mobile live-action bodies to gravity is evident: though the harnesses and wires that keep the live-action actors airborne (as in *The Matrix*, *Crouching Tiger*, and *Hero*) can be erased from the digitized image, the visual effects of the actual force of gravity on live-

action bodies sometimes cannot. Unless compensated for by some other dynamic motion (kicking, running up a wall), occasionally these vertical bodies retain visible traces of their true condition in space: they exist in a state of suspension between the upward pull of an invisible apparatus and the downward force of gravity. In such instances, gravity's visible trace corresponds, roughly, to the state of suspension in which these characters exist, on one hand, and their association with the new, the historical rupture, or the historically emergent, on the other, within their fictional worlds *as well as* within film history. Digital verticality's occasional lack of transparency foregrounds its association with historical thresholds and transitions (including emergent digital processes and practices, and emerging film histories), as well as the effects emblem's willingness to court artificiality for the sake of (allegorical) signification. Through flying and falling bodies, the new verticality makes visible the position occupied by computer-generated images within the recent past of commercial film history—poised at a historical threshold, between continuity with past tradition and a future defined by aesthetic and technological change.[26]

Yet this particular digital effects emblem (especially in more recent examples) often seems to allegorize broader historical changes taking place in the late twentieth and early twenty-first century. If before September 11, 2001, the new verticality gave expression to a millenialist anxiety over the arrival of a new epoch and the changes it portended (as imagined in the technological dystopias of *The Matrix* or *Jurassic Park*, for example), after that day the new verticality seemed harnessed to a more profound expression of despair over the collapse of twentieth-century civilization (defined by the global dominance of U.S. military power and capitalism) into twenty-first-century ruin (defined by global economic crisis, endless war, and political upheaval). Hence even a film like *Avatar*, which features an ostensibly happy ending for its protagonist, nevertheless imagines the defeat of human civilization (here represented by the militarized corporation) and questions whether it is worth saving at all. After 2001 the now iconic images of the World Trade Center on 9/11 and the (hauntingly vertical) photograph of "The Falling Man" function as the twenty-first-century counterparts to the mythological figures of Phaeton and Icarus that appeared in emblem books—ready to accommodate a range of contradictory and even oppositional meanings.[27] Like the images of Icarus and Phaeton, the stark verticality of such modern images gives

(horrifying) articulation to the violent intersection of opposed forces, emblematizes the individual's relationship to powerful processes of historical change, and functions allegorically to emblematize the fall of an era.

Despite my focus in this chapter on a digital effects emblem that exploits the screen's y axis, it is important to keep in mind the quote from Eisenstein's "Dynamic Square" that opens this chapter and, with it, the cinema's simultaneous exploitation of the screen's x (horizontal) and z (depth) axes. The x axis has been used in recent films to organize the movements of, and allegorical meanings articulated by, the various hordes, swarms, armies, armadas, flocks, and crowds that compose the "digital multitude" in recent popular films. Though the multitude's spatial articulation is profoundly horizontal, like the new verticality it is an "optical-by-view, but profoundly psychological-by-meaning" digital visual effect that appears across a number of films and a range of genres to emblematize imbalances of power as well as radical (and even apocalyptic) historical change.

THE DIGITAL MULTITUDE AS EFFECTS EMBLEM

The City of Lost Children (Marc Caro and Jean-Pierre Jeunet, 1995) opens with a nightmare: a young child stands up in his crib and watches with gleeful fascination as a jolly, fat Santa Claus climbs into his bedroom through an open window. Moments later, another Santa—a perfect replica of the first—climbs through the window in exactly the same manner; he is followed by another replica Santa, and then another. Initially, the child's joy increases as the Santas multiply, but as more and more stream into the room, he bursts into tears; fascination succumbs to horror, and a dream becomes a nightmare as the bedroom becomes crowded with identical, indistinguishable Santas. This scene effectively stages a terrifying scenario that numerous other films would exploit on a grander scale in the years to come: that of being overwhelmed by numbers, of being besieged by a (digital) aggregate in which the multiple is one. Such multitudes have populated a broad range of films since the early 1990s, including *Arachnophobia* (Frank Marshall, 1990), *Independence Day* (Roland Emmerich, 1996), *Starship Troopers* (Paul Verhoeven, 1997), *The Mummy* (Stephen Sommers, 1999), the *Matrix* trilogy (Wachowski Bros., 1999, 2003), the *Lord of the Rings* trilogy (Peter Jackson, 2001, 2002, 2003), *Star Wars Episode II: Attack of the Clones* (George Lucas, 2002), *I, Robot* (Alex Proyas, 2004), *Troy* (Wolfgang Petersen, 2004), *Curse of the Golden Flower* (Zhang Yimou, 2006), *300* (Zack Snyder, 2006), and *The Day the Earth Stood Still* (Scott Derrickson, 2008). Using a number of technologies

(motion capture, 3D animation simulation programs such as MASSIVE [Multiple Agent Simulation System in Virtual Environment], digital split-screen techniques, crowd simulation engines, motion trees and libraries, and particle animation programs such as Dynamation), visual effects houses have created massive computer-generated armies, swarms, armadas, and hordes composed of as many as hundreds of thousands of digital beings—what might be called the "digital multitude."

Recent writing on cinematic digital multitudes tends to focus on the technologies used to create them, the software programs devised to increase their visual complexity and photorealism, and the time and money saved by replacing thousands of live extras with computer-generated substitutes.[1] Less attention has been paid to the way in which, once rendered, the digital multitude has functioned as an effects emblem across a broad range of contemporary films, enabling the compelling articulation of certain thematic obsessions regarding historical time, on one hand, and the nature of collectivities, on the other, through a surprisingly consistent set of formal compositions.[2] Given the grand scale of digital multitudes (numbering in the tens and even hundreds of thousands) and the overwhelming force they imply, they frequently emblematize the epic themes at work in contemporary visual effects films: more often than not, the multitude's appearance heralds "the End"—the end of freedom, the end of a civilization, the end of an era, or even the end of human time altogether. Though the films I consider here (including *Starship Troopers*, *The Mummy*, *Star Wars Episode II: Attack of the Clones*, *The Lord of the Rings: The Two Towers*, *The Matrix: Reloaded*, *Troy*, *I, Robot*, *300*, and *Curse of the Golden Flower*) span a number of genres, including action-adventure films, historical epics, fantasy films, war films, science fiction, and martial arts films, all use the digital multitude to spatialize time and to emblematize their protagonists' relationships to sudden, often apocalyptic, historical change. In the process, these films use their digital multitudes to interrogate the idea that there is great power in numbers, as they explore—in a spectacular fashion—the relationship between the individual and the collective. Hence in this chapter I approach the digital multitude as a visual effect designed to exploit the visual pleasures of power and powerlessness, and in this respect I distinguish the digital multitude from mere digital "crowds" that populate stadiums (as in *Forrest Gump* [Robert Zemeckis, 1994], for example) or city streets (as in *Cloverfield* [Matt Reeves, 2008]) and that are meant to act merely as backdrop. As

conceived here, the digital multitude is a visual effects emblem: it is a computer-generated spectacle that functions allegorically within the narratives in which it appears so as to give spectacular expression to a constellation of concepts concerning historical change and collective action, even as it provokes feelings of astonishment and awe.

Certainly, the use of crowds, armies, and swarms to generate astonishing spectacles and to communicate the arrival of momentous or imminent change has a long history in the cinema. The digital multitude bears relation to numerous other types of spectacular group formations — for example, Siegfried Kracauer's mass ornament, film musical numbers, and the crowds and masses discussed in sociology and political theory — and has its origins in the crowds, armies, and flocks that have populated cinema screens since the 1910s.[3] In the silent era, historical epics such as *Intolerance* (D. W. Griffith, 1916) and *October* (Sergei Eisenstein, 1928) used thousands of extras to flesh out the masses of the eras in which they are set in order to represent historical change on a wide scale. Leni Riefenstahl's documentary *Triumph of the Will* (1935) is replete with panning shots of crowds organized in battalion formations (at times showing upward of 200,000 members of the Nazi Party) to create, as Frank Tomasulo argues, a visual uniformity that suggests "a renewed sense of national identity and unity following a period of economic and political instability" and, along with it, a sense that Hitler and the Nazi Party were ushering Germany into a new historical era.[4] In *El Cid* (1961), Anthony Mann combined these strategic uses of (live action) multitudes by showing massive armies to represent the unification of a previously fragmented people and thereby signify the arrival of a new era of ideological and national consolidation in Spain. The popularization of widescreen processes in the 1950s (preceded by Abel Gance's use of the Polyvision triptych in *Napoléon vu par Abel Gance* [1927]) helped expand the dimensions of crowds, endowing on-screen multitudes with a new lateral extensiveness that underscored their size, uniformity of purpose, or structure of feeling.[5] Hence in 1982 *Gandhi* (Richard Attenborough) featured 250,000 extras in its funeral scene to depict a vast nation bound together in grief over the assassination of a beloved leader and the consequent end of an era.

In contrast to these historical epics and documentaries that rely on thousands of human extras filmed on location or studio lots, disaster films and science fiction films have historically used a variety of visual and optical effects to unleash vast multitudes of insects, birds, or spiders on out-

numbered protagonists. For example, *The Naked Jungle* (Byron Haskin, 1954) used process photography to create a column of army ants "two miles wide and twenty miles long" that threatens to destroy the plantation that Christopher Leiningen (Charlton Heston) has carved out of the South American jungle and, along with it, his new mail-order bride (Eleanor Parker). *The Swarm* (Irwin Allen, 1978) used traveling mattes to represent the arrival of enormous swarms of killer bees in the continental United States. The most compelling example, however, is Alfred Hitchcock's *The Birds* (1963), which used the sodium vapor process, traveling mattes, and rotoscoping to create a series of ultimately apocalyptic bird attacks of increasing frequency, intensity, and magnitude on the small, isolated town of Bodega Bay.[6] As Hitchcock's birds demonstrate, multitudes often function allegorically—as visual effects emblems—so that a large congregation meticulously arranged within the frame can come to represent (real or fantastic) historical change. Hence in *The Birds* the end of modernity's blithe instrumentalization of nature and humanity's supremacy in the food chain is perfectly emblematized by the massive terrestrialized, interspecies flock of birds that occupies the Brenner farm and the landscape that surrounds it in the final shot of the film.

In this chapter I draw from a broad range of films to explore what recent blockbusters reveal about the emblematic mode of representation that characterizes numerous cinematic multitudes—digital or analog—and, in turn, what digital multitudes can tell us about the visual pleasures offered by, and thematic and conceptual obsessions found in, spectacular visual effects emblems.

Occulted Objects and Hidden Histories

Digital effects emblems, much like their Renaissance, baroque, and Victorian counterparts, often exploit a dramatic conflict between binary opposites to allow "images sensible" to give expression to "conceits intellectual" (to paraphrase Francis Bacon).[7] For example, Jacob Cats and Robert Farlie's "When the Wolf Comes" (fig. Intro.2, discussed in the introduction) contrasts the tendency of a herd of cattle to fight among themselves (described in the accompanying text by the narrator) with their sudden unification and common sense of purpose (represented by the unbroken ring of cattle depicted in the image) when threatened by attacking wolves.[8] Films featuring highly visible, spectacularly rendered multitudes of tens of thousands of digital beings similarly exploit the dramatic poten-

tial of polarized opposites and often begin by linking the origins of their astonishing multitudes to individual objects or single characters hidden from view or buried away—occulted and forgotten. Many of the films I consider here open by disclosing the long history of a clandestine object, the surfacing of which sets the narrative in motion. These films thus put into play several meanings of "occult," ranging from the more common-place sense of objects masked or hidden from ordinary perception to acts of occlusion that imply the involvement of "agencies of a secret or myste-rious nature."⁹ Though often benign or ordinary in appearance, such hid-den objects and bodies (for example, a ring [the *Lord of the Rings* trilogy], a mummified priest [*The Mummy*], a dagger [*Constantine*, Francis Law-rence, 2005], and a secretly imprisoned wife [*Curse of the Golden Flower*]) often provide a tangible and ultimately regrettable link to a traumatic past event (a war, a regicide, the crucifixion of Christ, and the faked death and secret imprisonment of a family member, respectively). In a number of films, brief, action-packed prologues set in the distant past disclose the significance of the occulted object or body, which, we are told, has been lost (sometimes for hundreds or even thousands of years) until unearthed by some unwitting character who, in the process, brings the past into the present, often with catastrophic effects. Such objects and characters are tokens of occulted histories and repressed pasts that erupt into the present with violent force via the digital multitude.

For example, the prologue that opens *The Lord of the Rings: The Fellow-ship of the Ring* (Peter Jackson, 2001) links the coming rise of Lord Sauron and his massive armies (seen later in the second and third installments of the trilogy) to the surfacing of a historical fragment obscured for so long it has acquired the status of myth. A voice (Cate Blanchett) issues from the darkened screen to explain that we are entering a world already under-going radical transformation: "The world is changed. I feel it in the water. I feel it in the earth. I smell it in the air. Much that once was is lost. For none now live who remember it." The "it" the voice-over refers to is the "One Ring to rule them all" forged by the evil Lord Sauron three thousand years earlier in order to give himself the power to subject all of Middle-earth to totalitarian rule. After lying hidden at the bottom of the Glad-den River for 2,500 years, the Ring makes its slow (five-hundred-year) progress back to Mount Doom after being stolen and lost by Gollum/Sméagol (Andy Serkis) and brought to the Shire by Bilbo Baggins (Ian Holm). Once Gandalf (Ian McKellen) determines the true nature of the

Ring, it is already too late; Sauron's old plans to annihilate Middle-earth have already been set back into motion. As Saruman (Christopher Lee) explains, Sauron is already in the process of "gathering all evil to him. Very soon, he will have summoned an army great enough to launch an assault upon Middle-earth." Such prologues disclose a bygone act of occultation, the force and duration of which eventually finds expression—with the violence of the return of the repressed—in the appearance of the massive multitude.

Like *The Lord of the Rings*, *The Mummy* opens with a prologue that narrates the brief history of a cursed, hidden figure whose unearthing will unleash a powerful force able to call forth hordes, swarms, and plagues. Set in the year 1290 BC, *The Mummy*'s prologue tells the story of the treacherous Egyptian high priest Imhotep (Arnold Vosloo), who killed Pharoah Seti (Aharon Ipalé) after being discovered with the latter's mistress (Patricia Velasquez), a crime for which he is cursed, mummified alive, and locked in a sarcophagus where he is to remain "undead for all eternity." Aided by the remote desert location of the City of the Dead (the very existence of which is considered a fable), the sarcophagus remains buried until it is unearthed in 1926 by a group of amateur Egyptologists and treasure seekers. After the latter accidentally raise the mummy, he regains his strength and brings about the ten plagues of Egypt (including meteor showers, sandstorms, and swarms of flies and locusts), which threaten to end the world.

In other films historical occultation is associated not with hidden, magical objects and their repressed pasts but rather with the obscuring power of ongoing, evolutionary time. In these films the gradual, hidden development of ostensibly human characteristics (such as the ability to reason) in some (not necessarily organic) form is revealed to the protagonists only after it is too late. For example, in *Arachnophobia* a type of spider that has been "isolated for millions of years" deep in a sinkhole in the rainforests of Venezuela is discovered by scientists who accidentally transport the species' commanding "General" spider to California. When it breeds with a local species, it passes along its ability to strategize and creates a new, deadly arachnid army whose "soldiers" strategically kill off the town's residents and threaten to take over the entire area. Similarly, in *Starship Troopers* insect evolution has for millions of years moved inexorably toward the foreclosure of human history. Though presumed by much of humanity to be without the capacity to reason, Earth's insect

enemies have developed and kept secret new cognitive powers crucial to their efforts to colonize the galaxy and bring human life to extinction. The broader concealment of insect evolution from human view is embodied by a giant "brain bug" that hides in the underground tunnels of Bug City while commanding attacks on Earth's civilians and armed forces by hundreds of thousands of arachnids.

In *I, Robot* and the *Matrix* trilogy the slow development of artificial intelligence in machines places human sovereignty in peril as tens of thousands of NS-5s and sentinels, and multiples of Agent Smith (Hugo Weaving), respectively, work to subordinate humankind to machine control. *The Matrix*, in particular, gains dramatic (and allegorical) force from the revelation that humanity's two-hundred-year enslavement to machines from 1999 to 2199 has been effectively concealed from much of human perception and knowledge by the matrix program. Though the evolutionary changes in these and other films have taken place slowly over extended periods, they are revealed to the protagonists and the spectator with shocking abruptness because they almost always imply, at best, the enslavement of humanity or, at worst, its annihilation. Hence evolutionary changes that have taken decades, centuries, or (as in *Starship Troopers* and *Arachnophobia*) millennia to develop are experienced within the fictional worlds of the film as forms of accelerated, radical historical change that place the immediate future into question as hundreds of thousands of machines or millions of insects wage war against the vastly outnumbered human protagonists.

Star Wars Episode II: Attack of the Clones extends the link between the revelation of an occulted history and the appearance of the digital multitude by making use of the first meaning of the verb "occult": "to hide a celestial body temporarily by moving between it and an observer, or to be hidden in this way."[10] In *Attack of the Clones*, the occultation of the planet Kamino—whose existence, and, along with it, evidence of the massive Clone Army raised there, has been erased from the Jedi Council's computer archives—has helped to keep secret the decade-long prehistory of the Republic's impending demise. Once discovered, the mere existence of the ten-thousand-strong Clone Army makes the coming civil war—and the accompanying end of the Republic—inevitable.

In another variation on this theme, the appearance of the digital multitude is strongly linked to resistance against historical occultation—or the inevitable erasure of an individual's identity and actions by the pass-

ing of time. Hence *Troy* opens with a voice-over narration that reframes its massive armada of a thousand ships less in terms of Helen's (Diane Kruger) famed beauty ("the face that launched a thousand ships") and more in terms of an individual soldier's relationship to history and time. Odysseus (Sean Bean) explains, "Men are haunted by the vastness of eternity. And so we ask ourselves, 'Will our actions echo across the centuries? Will strangers hear our names long after we are gone and wonder who we were, how bravely we fought, how fiercely we loved?'" The ensuing narrative addresses the fate of Achilles (Brad Pitt), who, haunted by the possibility that his actions may not reverberate beyond his own era, sails to Troy with fifty thousand Greek soldiers so that he may distinguish himself in battle and thereby achieve immortality. As these descriptions suggest, once revealed or resisted, occulted histories and repressed pasts materialize in the sudden appearance of a massive multitude that threatens to bring about apocalypse within a very brief period. Hence the concept of historical occultation that organizes these films is millenarian insofar as they all feature at least one massive battle in which a grossly outnumbered minority defends itself against the aggression of an evil, powerful multitude that threatens to bring about "the End."

At the level of story, the suddenness of the multitude's appearance often derives from its mass-produced origins. In *Attack of the Clones*, the ten thousand identical adult soldiers that make up the Clone Army have been grown in a decade using "growth acceleration," without which, Lama Su (Anthony Phelan [voice]) explains, "a mature clone would take a lifetime to grow," but with which, "we can do it in half the time." In the first two installments of *The Lord of the Rings*, the horrifying Uruk-hai soldiers are born fully grown from mud in the caverns of Isengard as fast as the "fires of industry" allow Saruman to produce them. In *Van Helsing* (Stephen Sommers, 2004), a "single birthing" of vampire offspring brought to life by Frankensteinian technology creates thousands of winged, bloodsucking creatures that, moments after birth, fly into a nearby town for their first feeding. This hypergenerative ability signals both the power and the malevolence of the force that authorizes the multitude's manufacture and movements, such as *I, Robot's* VIKI, *Attack of the Clones'* Count Dooku (Christopher Lee), and *Van Helsing's* Count Dracula (Richard Roxburgh).

More often than not, the surfacing of occulted histories in these films has the effect of dramatizing imminence: for the protagonists to thwart the multitude's rapid movements and the dreaded change it represents,

everything must happen at an accelerated pace. There is often an inverse relationship between the long period during which occulted objects, transformations, and bodies have remained hidden and the brief time the protagonists have to prevent their own destruction by the multitude. Indeed, despite its massive size, the digital multitude is always highly mobile, and its swift assault enacts the notion of an impending apocalypse that threatens to overturn an era almost without warning. In *Troy*, King Priam (Peter O'Toole) and the outnumbered Trojans have only three days to prepare for the arrival of Agamemnon's armada and the certain destruction it will bring. In *The Two Towers*, as Gandalf departs for reinforcements for the three hundred men that protect Helm's Deep against a rapidly approaching army of ten thousand Uruk-hai, he exclaims, "Three hundred lives of men I've walked this earth and now I have no time." After the first alien attack in *Independence Day*, General Grey (Robert Loggia) delivers the news to the president that "if you calculate the time it takes to destroy a city and move on, we're looking at the worldwide destruction of every major city in the next thirty-six hours."

By linking multitudes to imminence, these films exploit the temporality inherent in real-life crowds and, as a result, frame their multitudes as emblems of abrupt and catastrophic historical transformation. This association of multitudes with an intensified experience of time on one hand and change on the other is, perhaps, a defining feature of mass group formations in general. Elias Canetti defines crowd formations as profoundly marked by time: the crowd is an uncannily spontaneous and ephemeral phenomenon that appears "suddenly there where there was nothing before."[11] Once formed, Canetti argues, the crowd strains against rapid (and inevitable) disintegration: "For just as suddenly as it originates, the crowd disintegrates. In its spontaneous form it is a sensitive thing. . . . A foreboding of threatening disintegration is always alive in the crowd. It seeks, through rapid increase, to avoid this for as long as it can; it absorbs everyone, and, because it does, must ultimately fall to pieces."[12] At the same time that it enacts suddenness, the crowd and what Canetti calls "crowd symbols" (such as insect swarms or forests) materialize the fantasy of a group's extended duration in time through progeny: crowds, swarms, herds, all imply "large numbers, unbroken succession—a kind of density throughout time—and unity" forged through the "exemplary power of increase."[13] The digital multitude's sudden appearance and its compression of narrative time link it to the overturning of the diegetic worlds in which

it appears, while its "exemplary power of increase" and density within the frame suggest its superior ability to endure in time at the expense of the protagonists, for whom the multitude represents broken succession and sudden, irreversible dissolution. These films thus represent their protagonists' clash with the multitude as a struggle against the swift approach of a terrible new age in which humankind is first outnumbered and then threatened with destruction or enslavement by the subhuman, the human simulation, the anthropomorphized machine, or the undead.

The Multitude's Spatialization of Time

With this in mind, we can say that films featuring digital multitudes derive much of their dramatic force from displaying swarms, hordes, and armadas as spectacular allegorical images of the protagonists' relationship to historical time. They accomplish this formally through the consistent deployment of shot structures that make possible the visual, enframed articulation of temporal and historical concepts through the multitude's transformation or (re)organization of screen space. Such formal compositions are often accompanied by dialogue that supports such interpretations and expands the allegorical significance of the multitudes so that they emblematize concepts linked to time and the experience of overwhelming historical change. For example, in *The Two Towers*, long shots show an Uruk-hai army stream across the open landscape of Middle-earth like a massive black river that engulfs everything in its path, making it an emblem for an unstoppable force of sweeping historical change able to overcome an entire civilization. Once various multitudes reach their destination in these films, their radical visual transformation of diegetic space often signals the imminence of totalizing historical transformation and emblematizes the cusp or threshold between the past and the dreaded future on which the opponents stand. The digital multitude emblematizes such change by making immediately visible the difference between inhabited space and occupied space. In its first appearance on-screen, the digital multitude almost always fills the width of a high-angle wide shot, extends beyond the left and right sides of the screen, and recedes far into the background of the shot, thereby radically altering the appearance of the landscape it occupies. In *Troy* and *300*, open seas are crammed with armadas whose powers appear to include the appropriation of the ocean's quality of limitlessness; once the ships land, the brightly lit, sandy beaches are transformed by swarms of darkly uniformed armies. Toward

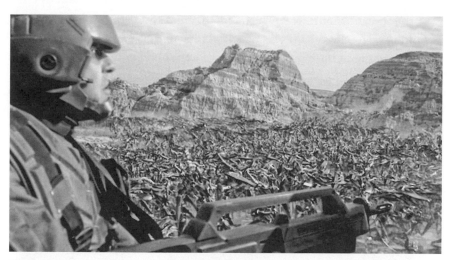

Figure 2.1 Bugs attack a military outpost in *Starship Troopers* (TriStar Pictures, 1997).

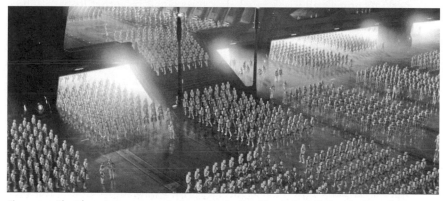

Figure 2.2 The Clone Army appears in formation in *Star Wars Episode II: Attack of the Clones* (LucasFilm, 2002).

the end of *I, Robot*, hundreds of NS-5s scale the exterior U.S. Robotics (USR) corporate headquarters, seeming to transform the forbidding skyscraper into a child's jungle gym. Hence the multitude is inseparable from vast spaces, open (fig. 2.1) or closed (fig. 2.2), and its terrifying (and even sublime) extensiveness finds expression through its near complete occupation of visible space. When revealed to astonished spectators (textual and theatrical), the digital multitude's spatial composition within the frame often amounts to the cinematic figuration of temporal or historical concepts such as "infinitude," the "historical threshold," and "apocalypse." Indeed, many of the films under consideration here give emblematic expression to the notion of apocalypse through the exploitation of

the screen's x and z axes, which link the multitude's spatial articulation to the horizon line and the rising and setting of the sun. Moreover, the relation between the multitude's insistent horizontality and historical time is foregrounded in dialogue, linking the multitude's approach to the dawn of a terrible new age.

Two scenes from *The Two Towers* provide pertinent examples of how spectacular images of multitudes function as emblems of apocalypse. Moreover, these scenes highlight the importance of the effects emblem's integration with dialogue and narrative in charging such spectacles with allegorical significance. Following his banishment from Rohan, Grima Wormtongue (Brad Dourif) returns to Isengard to join Saruman in his efforts to conquer the kingdom. In a sound bridge that connects a shot of an exterior wall of Helm's Deep to a scene taking place in Saruman's tower, we hear Wormtongue explain that "Helm's Deep has one weakness: its outer wall is solid rock, but for a small culvert at its base, which is little more than a drain." The camera cuts from a shot of the culvert to a close-up of a bowl of gunpowder as Wormtongue asks Saruman with incredulity, "How? How can fire undo stone? What kind of device could bring down the wall?" Without answering the question, Saruman states, "If the wall is breached, Helm's Deep will fall," and he moves toward a brightly lit doorway that opens onto a balcony. Wormtongue follows Saruman and protests, "It would take a number beyond reckoning—thousands—to storm the keep!" Saruman replies, "Tens of thousands," to which Wormtongue retorts, "But my lord, there is no such force!" and the two emerge onto the balcony as a horn sounds their arrival. With the camera placed just over Saruman's shoulder, a high wide-angle shot reveals the presence of a massive Uruk-hai army organized into numerous battalions beneath the tower (fig. 2.3). The soldiers chant in unison as the camera quickly pans left to take in the enormity of the multitude, which extends beyond the sides of the frame and into deep space. A reverse shot shows Wormtongue's stunned reaction to the astonishing spectacle arrayed before him as he is left speechless, his mouth agape. With a gesture from Saruman, the army falls quiet as he exclaims, "A new power is rising. Its victory is at hand!" A reverse angle reveals a wide shot of the Uruk-hai marching in place and pounding their spears in a uniformly bloodthirsty response. Saruman continues, "This night, the land will be stained with the blood of Rohan! March to Helm's Deep! Leave none alive!" and a camera flythrough tracks rapidly backward through the army, just above the

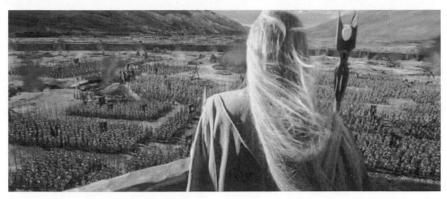

Figure 2.3 Saruman addresses the Uruk-hai army in *The Lord of the Rings: The Two Towers* (New Line Cinema, 2002).

heads of the seemingly endless mass of soldiers and their forest of upright spears. After Saruman concludes his speech with a rousing "To war!," another high-angle shot — this one tighter than the first so that the army fills the space up to and beyond the top, as well as the sides, of the frame — displays the army cheering in unison. Another reverse-angle close-up of Wormtongue shows a tear rolling down his cheek as he comprehends the awesome power of Saruman's army. The scene ends with a close-up of Saruman as he quietly states, "There will be no dawn for men."

Several features of this brief scene are key to understanding the multitude's spatialization of time and its status as an effects emblem. Formally, this particular digital multitude corresponds to what Jeffrey Schnapp calls the "emblematic mass": it is an orderly, geometrically arrayed collective in which the individual units "lose their contours in order to regain them within the confines of a single corporate body."[14] Saruman's speech (delivered in the characteristically overblown rhetoric of the emblem) creates an interpretive framework for the multitude and defines it as an instrument for bringing about the violent end of one age and the bloody dawn of another. Importantly, his reference to a "new power" that is rising to ensure that "there will be no dawn for men" corresponds to the horizontal framing of the computer-generated army, which spans and darkens the horizon line, making the multitude's spatial articulation inseparable from the temporal concept of "apocalypse." If the latter is defined first as "the total destruction or devastation of something" and second as "a revelation made concerning the future," then the multitude's appearance here is quite literally apocalyptic in both meanings of the term.[15] It implies

the imminent destruction of Middle-earth and the emergence by sunrise of a new world in which much of humanity has been killed off. Wormtongue's reaction to the spectacle of the Uruk-hai army—speechless astonishment followed by tearful comprehension—foregrounds the multitude's dramatic impact: for Wormtongue, the protagonists, and even the audience, the multitude's sudden *collective* appearance is (intended to be) abrupt and overwhelming, an experience of the sublime. The sheer numbers on display, along with the high definition of the (digitally enhanced) image, make it difficult to take in and comprehend the astonishing spectacle in a single glance. For this reason, the multitude's first appearance in a horizontally arrayed, high-angle wide shot is almost always followed by reverse-angle reaction shots so that its breathtaking numbers and spatial dimensions (and their historical implications) can be mirrored and perceived in the amazement of diegetic observers and spectators alike.

An ensuing scene taking place at Helm's Deep reinforces the digital multitude's spatialization of historical time and its status as a fearsome emblem of apocalypse. Like the scene taking place between Wormtongue and Saruman, this one begins with dialogue consisting of questions and answers followed by a speech that once again defines the Uruk-hai army as an apocalyptic force. This particular use of dialogue followed by a speech or soliloquy once again provides the opportunity for the kind of heightened rhetoric that overtly marks the image (or, in this case, series of shots) as allegorical. These brief, spectacular sequences simultaneously unveil the stunning image of the digital multitude and, operating in the mode that Walter Benjamin identifies as typical of the emblem, drags "the essence of what is depicted out before the image."[16] As Gamling (Bruce Hopkins) in *The Two Towers* dresses King Theoden (Bernard Hill) for battle, Theoden, stunned by despair, asks, "Who am I, Gamling?" Gamling responds, "You are our King, sire." "And do you trust your king?" Theoden inquires, to which Gamling simply replies, "Your men, my Lord, will follow you to whatever end." This answer reveals Gamling's own understanding of his people's situation: their future is worse than uncertain, and it is likely they have come to the end of their time. This reference to "whatever end" prompts Theoden's "horse and rider" soliloquy: "To whatever end . . . Where is the horse and the rider? Where is the horn that was blowing? They have passed like rain on the mountains, like wind in the meadow. The days have gone down in the west, behind the hills, into shadow. How did it come to this?" Throughout the soliloquy, the film cuts

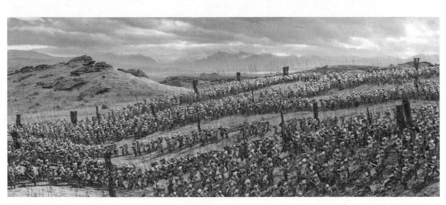

Figure 2.4 Saruman's Uruk-hai army marches to Helm's Deep in *The Lord of the Rings: The Two Towers* (New Line Cinema, 2002).

between Theoden, the Uruk-hai army on the march, and the remaining civilians of Rohan arming for battle in Helm's Deep. Again, editing and dialogue help to define the digital multitude as a historical force, an emblem of the violent displacement of one era by another. After King Theoden repeats "To whatever end," the camera cuts from a close-up of his stunned face to a shot of the Uruk-hai marching swiftly and steadily to Helm's Deep (fig. 2.4). The lost "horse and rider" and the silencing of "the horn that was blowing" refers to the Rohirrim, the mounted army exiled from the kingdom after Saruman spiritually possessed and took control over Theoden's body and mind. Saruman's success in dispersing the king's family and much of Rohan's army seems in turn to guarantee Sauron's success. Indeed, as Theoden utters the lines "They have passed like rain on the mountains, like wind on the meadow," the camera cuts from an old man in Helm's Deep sharpening the dull, nicked blade of a useless sword, to another being handed a spear, to a young boy being fitted with a much-too-large helmet, followed by another shot of a terrified boy being given an ax. Such images of old men and young boys foreground the absence of the more battle-ready Rohirrim and mark Rohan's new army historically: while the old men are part of a past era that can no longer sustain the present moment into the future, the young boys embody a future that the Uruk-hai army intends to kill off prematurely, before it has come of age. It is precisely the Rohirrim's dispersal like wind or rain that has made Rohan's own history equally ephemeral — something that has come and gone much too quickly. Theoden's conclusion that "the days have gone down in the west, behind the hills, into shadow" echoes Saruman's

earlier declaration that "there will be no dawn for men." A medium shot of a single (live-action) Uruk-hai soldier surrounded by others—giant, fanged, fearless, and well armed—followed by a shot of a resigned young boy in a chain-mail hood gives credence to the king's despair. Before cutting back to a close-up of Theoden as he asks himself, "How did it come to this?" a wide shot reveals the Uruk-hai streaming across the screen down a hill like a massive river, followed by another shot showing the multitude blanketing the landscape of Middle-earth in darkness. The density, directionality, and homogeneity (the essential attributes of the crowd formations described by Canetti) of the Uruk-hai army as it streams across the landscape contrast with the fragmented kingdom described by Theoden and suggest that the new order represented by the multitude will endure through time. Indeed, to emphasize that the army's approach heralds Rohan's apocalypse, Theoden is backlit by strong, bright sunlight that streams into the room not from above, but from a position nearly level with the horizon as the sun sets on what the audience and the protagonists fear may very well be Rohan's final day.

While *The Two Towers* deploys the multitude as an emblem of the coming apocalypse, *Troy* uses the digital multitude to give astonishing expression to the concept of "infinitude" that is inseparable from Achilles's pursuit of a glorious death to immortalize his name. Put differently, in *Troy*, dialogue and spectacular digital effects transform the multitude into an emblem for the desire to endure indefinitely in time and to transcend the inevitability of "the End" brought by death. At the beginning of the film, Achilles resists going to battle against Troy for the imperialist tyrant King Agamemnon. When Achilles seeks advice from his mother, Thetis (Julie Christie), she makes it clear that his is not a choice between whether or not to fight for an unworthy king. Rather, as Thetis explains, Achilles must choose between inhabiting the finite, human time that will ensure he is forgotten within a few generations or the infinite time of immortality, which will make his name and actions legendary for millennia. Again, the heightened rhetoric of the dialogue that precedes the spectacular visual effect charges it with allegorical significance. "If you stay in Larissa," Thetis explains, "you will find peace. You will find a wonderful woman. You will have sons and daughters and they will have children. And they will love you. When you are gone, they will remember you. But when your children are dead, and their children after them, your name will be lost. If you go to Troy, glory will be yours. They will write stories

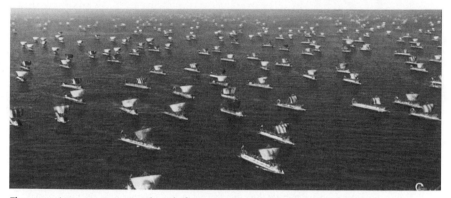

Figure 2.5 Agamemnon's armada sails for Troy in *Troy* (Warner Bros. Pictures, 2004).

about your victories for thousands of years. The world will remember your name. But if you go to Troy, you will never come home, for your glory walks hand in hand with your doom." When she finishes, the camera cuts from Thetis to a close-up of Achilles looking off into the distance toward the sea, before dissolving to a close-up of the bow of a Myrmidon ship as it slices through the water. After the "camera" tilts up to Achilles standing at the ship's bow, still staring into the distance, it pulls back to a high-angle wide shot that reveals the black-sailed ship at the center of a massive armada (fig. 2.5). The sequence of cuts and dissolves that link the content of Thetis's speech to the final, astonishing wide shot of the armada maps Achilles's rejection of historical obscurity, and his pursuit of temporal infinitude, onto the formation of the digital multitude. Both digital camera "movement" and the composition of the frame are central to the multitude's emblematic representation of historical and spatial infinitude: as the camera continues to pull back, it ultimately reveals an impossibly large armada that stretches far into deep space, beyond all four sides of the frame. The armada's astonishing extensiveness (because the ships fade into the distant horizon, we know that we are seeing only a small portion of the fleet) gives allegorical expression to Achilles's desire to lay claim to immortality and eternity through the glory of war. Moreover, as the wide shot of the armada makes clear, Achilles's pursuit of the eternal — or his conquest of time — is simultaneously a conquest of space, for he desires that the entire world, and not just the inhabitants of Larissa, know his name for thousands of years.

As part of their tendency to provide audiences with astonishing emblems of temporal and historical concepts such as apocalypse or infini-

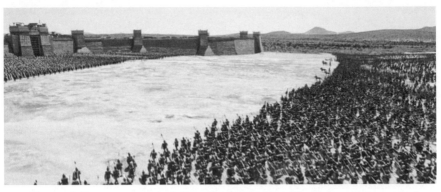

Figure 2.6 Troops amass outside the walls of Troy in *Troy* (Warner Bros. Pictures, 2004).

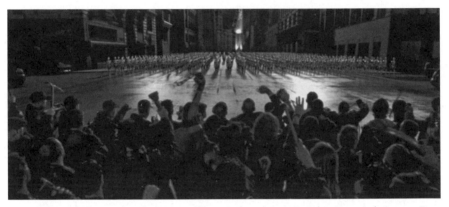

Figure 2.7 An angry mob squares off against the robots in *I, Robot* (Twentieth Century Fox, 2004).

tude, nearly every film under consideration here features at least one scene in which the multitude's spatial composition within the frame neatly emblematizes the idea of a historical threshold. Repeatedly, high-angle wide shots are used to frame multitudes poised at the borders of the civilizations they threaten. For example, in *Troy*, Agamemnon's massive army marches across the beach only to stop a hundred yards or so from the Trojan army, which stands in front of the city's high walls, leaving a stretch of empty sand between the unevenly matched forces (fig. 2.6). This shot echoes several that immediately precede the climactic battle sequences in *The Two Towers*, in which a narrow expanse separates Helm's Deep from the Uruk-hai army that has amassed in front of it. *I, Robot*, in turn, pits a rag-tag mob of citizens who take to the streets of Chicago to resist the army of NS-5 robots that seeks to bring humanity under the control of VIKI (fig. 2.7). The empty space between the unevenly matched

forces marks the historical threshold on which the two formations are poised. This particular arrangement of the multitude within the frame indicates that the ensuing action will either end in apocalypse or usher in a glorious new future.

Multitudes and the Nature of Collectivities

By virtue of its composition, the digital multitude immediately calls into question the relationship between the individual and the mass, the self and the collective. As theorists and historians note, crowds, masses, and group formations have always invoked this dialectic, whether the group formation exists in the same space as a unified mass or is more spatially dispersed but nevertheless connected. For example, in his analysis of real-life digital multitudes organized through the body politic of the "network society," Eugene Thacker notes, "On the ontological plane, the first important observation is that the multitude is neither the individual nor the group. It is positioned somewhere in between, or somewhere else entirely."[17] This complex relationship between the individuals that compose a group formation and its broader unity is central to Canetti's definition of a crowd, which reaches its ideal state at the moment of "discharge," when sheer density causes the differences and distances between individuals to disappear, resulting in a state of absolute equality: "In that density, where there is scarcely any space between, and body presses against body, each man is as near the other as he is to himself; and an immense feeling of relief ensues . . . when no-one is greater or better than another."[18] In the density of the crowd, Canetti argues, "the individual feels that he is transcending the limits of his own person," and at that moment, the multiple becomes singular.[19] In the films I consider here, the digital multitude is a multiplicity that functions as one, a heterogeneous mass that functions homogeneously. In most cases, the digital multitude emblematizes the extreme subordination of the individual to the purpose of a collective. It is no surprise, then, that the multitude's sudden collective appearance often signals a turning point in film narratives profoundly concerned with fragmentation and unity, isolation and alliances. These films polarize their collectivities, such that the digital multitudes always function as radically homogeneous formations, while in contrast, the protagonists function as an aggregate of heterogeneous individuals that fails — at least initially — to act collectively, to function as one.

At the level of the image and sound, the digital multitude often subor-

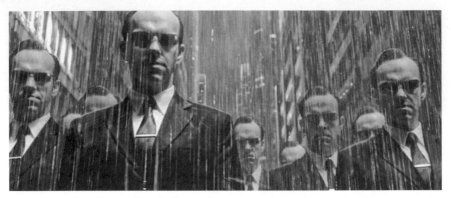

Figure 2.8 Agent Smith multiplies in *The Matrix Revolutions* (Warner Bros. Pictures, 2003).

dinates the individual "units" or "agents" that compose it almost entirely to the group: within various multitudes, soldiers, insects, robots, vampire offspring, sentinels, and Uruk-hai are virtually indistinguishable from one another. In this respect the digital multitude is a cinematic descendant of what Michael Hardt and Antonio Negri call the "demonic multitude" found in literature and the Bible, which similarly conflates the singular and the plural. They cite a parable from the New Testament in which a demon, when asked its name, responds, "My name is Legion; for we are many."[20] Much like the demonic multitude, the digital multitude's conflation of the single and the plural, the multiple and the one, "violates all such numerical distinctions" and in the process threatens radical disorder, the overturning of a world.[21] *The Matrix* and *Attack of the Clones* take this conflation to an extreme and play on the notion of the multitude's homogeneity (and the power that results from it) by featuring multitudes generated from a single character: while Agent Smith's growing power in *The Matrix Reloaded* and *The Matrix Revolutions* (Wachowski Bros., 2003) derives from his ability to multiply himself (fig. 2.8), the entire Clone Army in *Attack of the Clones* is made from a single "prototype," Jango Fett (Temuera Morrison). This radical uniformity of appearance signals the subordination of each individual's actions and desires to a single, shared objective: to facilitate the rise of a new, oppressive power — even if doing so requires self-sacrifice. The singularity of purpose that defines the digital multitude is one of several characteristics that distinguish it from the mass ornament, which, Kracauer argues, is without purpose and is "an *end in itself*."[22] By contrast, the digital multitude exists to realize a single

objective that forecloses on the future: it emblematizes and enacts the arrival of "the End."

Even in films in which the multitude is not made up of clones, there is often a tension between this uniformity of purpose and the degree of differentiation required to ensure that each "agent" appears on-screen as a distinct, autonomous individual. Hence, at the level of design and post-production, animators and software designers have created programs that help ensure that each digital being has a measure of uniqueness (including some variation in size, weight, gait, fighting style, choice of weaponry, costuming, etc.), even when physiognomic similarity is one of the defining features of the group. MASSIVE software allowed animators to control how Orcs and Uruk-hai would behave in various situations, introducing a measure of spontaneity into large battle scenes that allowed the fighting to appear more organic. Joe Letteri, visual effects supervisor for the *Lord of the Rings* trilogy, explains:

> We built a kind of artificial brain which was a system of rules governing how characters might behave or react in various situations. The brains were a network of 7,000 to 8,000 nodes, each node being the equivalent of a decision that had to be made, such as "Do I lift my sword or not?" or "Is this person so strong that I should run away?" Our characters could recognize who to attack, which weapons to use, and how to stand, run, or fall on different types of surface. Warriors even knew how to die in a manner suited to the way they were attacked and where they were standing.[23]

Such variety and spontaneity covers over the status of the multitude as a computer-generated effect: if numerous identical agents executed the same actions identically, the artifice used to create the effect would be too evident. Paradoxically, though, at the level of plot and theme, this measure of autonomy and distribution of variety often works with other visual and sonic signifiers of uniformity to contribute to the idea that whatever individuality and autonomy does exist among the agents has been subordinated to the multitude's pursuit of a shared objective. The affect (awe, terror) provoked by the digital multitude derives in part from its on-screen appearance as a group formation in which each individual has transcended uniqueness, individuality, difference, and distance for the sake of a single goal; in its most terrifying form, the multitude appears

on-screen in a state of "discharge" (radical equality) that Canetti defines as the ideal state of the crowd.[24]

This state is most noticeable in multitudes whose motions mimic self-organizing natural phenomena, such as flocks, stampedes, or swarms, and whose radical singularity resonates on the soundtrack. In *The Matrix Revolutions*, for example, the tens of thousands of sentinels ("squiddies") that invade the outer defenses of the city of Zion buzz on the soundtrack like a massive swarm of bees while they move rapidly through space like tightly packed schools of fish. Early on in *I, Robot*, Del Spooner (Will Smith) and Susan Calvin (Bridget Moynahan) search the warehouse floor of a factory that manufactures networked NS-5s for a rogue robot suspected of committing murder. To distinguish the suspect from the other one thousand identical robots lined up before them, Dr. Calvin commands, "Attention, NS-5s. . . . There is a robot in this formation that does not belong. Identify it." The robots reply in unison, "One of us." When she asks, "Which one?" they again reply, "One of us," reinforcing at the level of sound and image the multitude's tendency to function as a radical singularity in which the multiple *is* one. In other instances, the multitude's visible uniformity is made audible through precisely timed rhythmic sounds (such as chanting, marching feet, or spears rapping against shields) that convey univocality while providing an audible countdown toward the end of human time as the horde draws near. The multitude thereby generates a visual and sonic landscape to match its mass occupation of space and its impending appropriation of the protagonists' future.

The multitude's selflessness and self-sacrifice in these films (i.e., the willingness of its individual units to sacrifice their self-interest and their lives in pursuit of a shared goal) is almost never voluntary. Instead this selflessness is either programmed or "bred" into the multitude (as in *I, Robot*'s NS-5s, *The Matrix*'s squiddies and Agents, *The Two Towers*' Uruk-hai, and *Attack of the Clones*' titular Clone Army), a matter of evolution (the bugs in *Starship Troopers*, the spiders in *Arachnophobia*), or forced into existence by a tyrant who has enslaved the members of his mass (Xerxes's and Agamemnon's respective armies in *300* and *Troy*). Whatever its origins, the multitude's uniformity of purpose and the willingness of its constitutive units to sacrifice themselves for their goal defines its difference from—and hence the danger the multitude poses to—the protagonists. A scene from *Starship Troopers* illustrates this point clearly. After Carmen (Denise Richards), a high school student, expresses disgust

while dissecting an insect in class, her teacher explains, "We humans like to think we are nature's finest achievement. I'm afraid it just isn't true. This Arkellian sand beetle is superior in many ways. It reproduces in vast numbers, has no ego, has no fear—doesn't know about death and, so, it is the perfect, selfless member of society." This description of the insect enemy highlights its function as the chief foil for and greatest threat to humanity, which, the film goes on to make clear, is divided by competing interests and selfish motivations (including reckless competition between branches of the armed forces, love triangles, and professional ambition, as well as fear) that seem to work in the bugs' favor.

Whereas the multitude emblematizes an extreme version of collectivity antithetical to individuation, the protagonists in these films initially inhabit radically atomized republics, kingdoms, or planets fragmented by seemingly irreconcilable ethnic, national, and class differences, conflicting desires, and competing interests.[25] A return to the Cats and Farlie emblem "When the Wolf Comes" is salient here: unlike the fighting cattle that immediately unite in common opposition to an attacking enemy, the protagonists of these films initially fail to transcend their differences even when facing an external threat. For example, in *Curse of the Golden Flower*, the imperial family is hopelessly divided by generational conflict, love triangles, sibling rivalry, and power struggles. The emperor (Chow Yun Fat) has had his first wife imprisoned and is slowly poisoning the empress (Gong Li). The empress, in turn, plots the emperor's overthrow with the help of her eldest son, Prince Jai (Jay Chou). Meanwhile, the emperor's eldest son by his first wife (Liu Ye) betrays his father by sleeping with his stepmother, while having another affair with a young woman (Li Man) who, unbeknownst to him, is his half sister. In addition, the emperor's third-born son (Qin Junjie) attempts to steal the throne by killing his father—a crime for which he is beaten to death.

Likewise, the opening scenes of *Independence Day* define American culture through a series of oppositions and petty conflicts that pit wife against husband, children against parents, the military against civilians, rural America against urban America, the middle classes against the working classes, and white characters against black.[26] In the *Lord of the Rings* trilogy, much is made of the fact that the alliances that once existed between the various kingdoms of Middle-earth no longer stand. A key scene in *The Fellowship of the Ring* foregrounds the idea that Sauron's consolidation of power depends on the fragmentation of Middle-earth: after

the representatives of each kingdom gather in Rivendell, they argue stridently over what is to be done with the Ring. A close-up of the Ring shows their images reflected on its surface as Sauron is heard on the soundtrack voicing pleasure at the bitter acrimony his Ring sows among his enemies. All of this emphasizes that the protagonists' world is vulnerable to the multitude precisely because it is divided by internal power struggles, selfish motivations, and the too-sharp individuation of those who populate it. Indeed, at the level of appearance, the representative members of the Fellowship — Hobbits, Elves, Dwarfs, Wizards, and Men — perfectly embody the variety and differentiation that initially seem to doom Middle-earth. To resist the multitude, the protagonists must aspire to a degree of the unity, singularity of purpose, *and* selflessness that enable the multitude to pursue its destructive force with fearsome singularity of purpose and, in the process, to serve as an emblem of apocalypse.

It is worth pausing here to mention that *The Birds* offers an interesting analog precursor to the digital multitude's interrogation of the relationship between the individual and the collective by pitting a consolidated multitude against an outnumbered, fragmented group of protagonists. Indeed, the birds that attack Bodega Bay ultimately unite a core group of characters initially split by romantic rivalries, Oedipal family relations, and class differences — conflicts that at the outset distract them from the significance of the attacks. In a key scene sandwiched between the crows' attack on the schoolchildren and the seagulls' attack on Bodega Bay's main street, a group of townspeople, along with Melanie (Tippi Hedren), debate the significance of the bird attacks and how best to respond to them. As with other effects emblems and emblem books, the language and dialogue, their tone, and the mode in which they are presented frame and foreground the allegorical significance of the effects sequences of the bird attacks. Importantly, throughout the discussion, characters interrupt one another (each time prompting an abrupt cut to that character), linking the starkly drawn individuation of each to a broader societal fragmentation that will ensure humanity's failure to take action in time. Hence the divergent solutions proposed by different characters offer no course for collective action: whereas a surly traveling salesman (Joe Mantell) improbably suggests, "Get yourselves guns and wipe them off the face of the earth," a panicky mother (Doreen Lang) asks the townspeople, "Why don't you all go home? Lock your doors and windows!" The elderly ornithologist, Mrs. Bundy (Ethel Griffies), explains that the community has

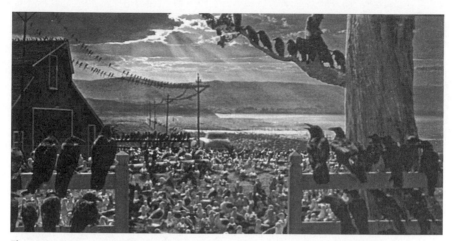

Figure 2.9 An interspecies flock of birds masses on the Brenner farm in *The Birds* (Universal Pictures, 1963).

no recourse to concerted bird attacks. After first insisting, "I have never known birds of different species to flock together. The very concept is unimaginable," she continues, "Why, if that happened, we wouldn't have a chance! How could we possibly hope to fight them?" Mrs. Bundy defines the feature of the avian multitude that makes it a harbinger of apocalypse: it is a radically heterogeneous multiplicity that suddenly functions as one. Hence, though the multitude's astonishing force at times seems purely quantitative (Mrs. Bundy states, "It is estimated that five billion, seven hundred and fifty million birds live in the United States alone. The five continents of the world . . . probably contain more than a hundred billion birds"), it is the multitude's quality of self-sacrificing, radical singularity of purpose that allows it to allegorize "the End." Though the final sequence of shots that constitute the film's conclusion suggests that the core group of protagonists have finally cohered into a collectivity able to subordinate self-interest to the broader interests of group survival, the film's final, highly composited process shot suggests it may already be too late: the birds' mass occupation of terrestrial space confirms the interspecies flocking so feared by Mrs. Bundy (fig. 2.9).[27] As the group drives off toward the rising sun, we sense that this is perhaps the dawn of a new era: the birds' cyclical, coordinated assaults on human targets suggest an overturning of evolutionary history and emblematize the foreclosure on humanity's future.

As with the arrival of Hitchcock's avian multitude, the arrival of the

digital multitude initially exacerbates the divisions and conflicts of interest that fragment the fictional worlds of these films. In *300* the impending arrival of Xerxes's massive army intensifies the internal power struggle in Sparta between King Leonidas (Gerard Butler), Councilman Theron (Dominic West), and the Ephors (who have been bribed by the Persians), forcing Leonidas to break away with his three hundred soldiers to defend the state against invasion. In *Arachnophobia* the first spider-related deaths in the small town of Canaima turn the already standoffish small town against the newly arrived "big city" doctor (Jeff Daniels), making him effectively an outcast. And in *Independence Day* the arrival of alien spaceships provokes pandemonium in the streets of Los Angeles, New York, and Washington, D.C., as panicked citizens desperately try to flee each city and instead end up in traffic jams—a phenomenon that further atomizes and creates conflict among the doomed earthlings. Despite this initial effect, however, the digital multitude ultimately functions as a catalyst that forces the creation of fellowships and alliances that rely on an orchestration of diverse individual talents but demand the temporary subordination of competing interests to the single cause of ensuring the group's survival and sovereignty. In *300* Leonidas heroically sacrifices himself and his three hundred soldiers in order to unite the divided states of Greece into the common defense of their freedom, and in the process he converts his tiny band of soldiers into an army of forty thousand "free Greeks" and Spartans. In *Starship Troopers* the unhealthy competition between the separate branches of the military is embodied by the rivalries (both romantic and professional) that divide former high school friends Carmen, Rico (Caspar Van Dien), and Carl (Neil Patrick Harris). Their self-sacrificing loyalty to one another at the end of the film not only reunites the trio for the film's narrative climax but also results in the discovery and capture of the brain bug, and with it, new hope for humanity's survival. The *Lord of the Rings* trilogy tracks the slow consolidation of the fragmented kingdoms of Middle-earth into a force able to defeat Sauron's vast armies. Hence, just before the final battle in *Return of the King*, Aragorn (Viggo Mortensen) rallies his outnumbered troops by emphasizing the importance of their courageous, self-sacrificing loyalty to Frodo (Elijah Wood) and to one another in their joint effort to destroy the Ring, exclaiming, "A day may come when the courage of Men fails, when we forsake our friends and break all bonds of fellowship, but it is not this day." In *Independence Day*, just before the final battle against the aliens, the U.S.

president (Bill Pullman) delivers the following speech to the motley crew assembled to fight the aliens:

In less than an hour, aircraft from here will join others from around the world, and you will be launching the largest aerial battle in the history of mankind. Mankind. That word should have new meaning for all of us today. We can't be consumed by our petty differences anymore. We will be united in our common interests. Perhaps it's fate that today is the Fourth of July, and you will once again be fighting for our freedom, not from tyranny, oppression, or persecution, but from annihilation. We are fighting for our right to live—to exist. And should we win the day, the Fourth of July will no longer be known as an American holiday, but as the day when the world declared in one voice, we will not go quietly into the night! We will not vanish without a fight! We're going to live on! We're going to survive! Today, we celebrate our Independence Day!

If the digital multitude foregrounds the dark side of collectivity (i.e., extreme uniformity and submission to a single, authoritarian power), then the protagonists' temporary alliances bring into relief the dark counterpart of division: the extreme differentiation, isolation, and self-interest that make civilization more rather than less vulnerable to annihilation by a homogeneous, radically uniform mass. The digital multitude, then, often has the opposite of its intended effect: rather than destroy entirely the heterogeneous and fragmented community, it forces into existence a (temporary) form of collective action able to usher in a new historical era. (Those who fail to cohere—such as most of the fortune hunters in *The Mummy*, the rulers of *Troy*, and the imperial family in *Curse of the Golden Flower*, are doomed.) To become the agents of a new future, the protagonists must temporarily prioritize the collective over the individual and trade self-interest for united, self-sacrificing, bloody engagement with an enemy. For films featuring the digital multitude link notions of historical transition with a rather literal dialecticism that makes historical change inseparable from the violent clash of opposed forces.

It is at this point that we can return to the historical occult, for one unveiling is often the precursor of another. The back-to-the-future logic of these films often requires the protagonists to turn to the past (and not an entirely novel future) to usher in a "new" era of freedom. Opposition to the multitude demands that the protagonists bring to the sur-

face aspects of their historical and ideological origins long buried beneath the fabric of everyday life. In a number of these films the protagonists' occulted history hides in plain view: a more glorious past is embodied in monuments (*Independence Day*, *The Lord of the Rings*), temples (*Troy*, *Curse of the Golden Flower*), statues, and rituals (Fourth of July in *Independence Day*, team sports in *Starship Troopers*, the *agoge* training regime in *300*) that function as substitutes for vaguely defined and largely absent ideals (such as honor, self-sacrifice, unity, courage, and fellowship). Of course, *The Matrix* takes this to an extreme by making the entire perceptible world a veil that covers over the radical absence of human freedom and individual sovereignty. If the digital multitude's astonishing force at times seems purely *quantitative*, the protagonists are ultimately defined in *qualitative* terms that link their power to a recursive historicism that recuperates long-lost founding ideologies. The digital multitude and all it implies is exorcised once these lost ideals are recovered, made operative in the present, and moreover embodied in newly invigorated presidents, restored monarchies, and Christ-like saviors that contrast sharply with the remote and sometimes disembodied rulers that control multitudes from a distance (the brain bug in *Starship Troopers*, VIKI in *I, Robot*, or Lord Sauron in *The Lord of the Rings*). Thus the new futures imagined by these films look astonishingly like the past, updated for a new context should the digital multitude once again pose a threat to the future.

At this point we can consider the cultural imaginary with which the digital multitude engages and to which it contributes, as well as the broader historical contexts in which these films were produced and received. The consistency with which the digital multitude has been used in popular films to represent apocalypse suggests that this particular effects emblem shares more with the baroque forms of culture discussed in the introduction than its allegorical function. Certainly these digital effects deploy, as Angela Ndalianis has shown, a neobaroque aesthetic as they test the boundaries that "separate representation from reality and [confront] viewers with technological *tours de force.*"[28] This is particularly so in those shots that emphasize the immersive qualities of the multitude — both as it extends into deep space and as it moves outward, directly toward the protagonist and the spectator (e.g., computer-generated shots of thousands of arrows soaring through the air toward the camera). At the same time, many of these films give expression to a profound despair that might similarly be described as neobaroque. A return to Benjamin's use of

allegory and emblem in *The Origin of German Tragic Drama* is helpful here. As Bainard Cowan argues, for Benjamin, allegory is a mode of signification linked to experience and to "the expression of . . . sudden intuition" or "apprehension of the world as no longer permanent, as passing out of being: a sense of its transitoriness, an intimation of mortality."[29] The use of multitudes to allegorize sudden and even apocalyptic historical change in recent films can be viewed as the expression of a contemporary "sense of transitoriness, an intimation of mortality."

This sense of transitoriness is, perhaps, inseparable from the suspicion that the twentieth century's prevailing ideologies, ethical codes, and economic organization are inadequate or even irrelevant in the context of the changes that accompanied the approach and arrival of the twenty-first century, such as the failures of neoliberalism, global financial collapse, the fall of long-standing regimes around the world (particularly in the Middle East), and a series of military conflicts framed in the popular press as religious wars. Certainly, themes of sudden, traumatic change reverberated strongly in the years following September 11, 2001, particularly since the events of that day seemed to signal "the End" of an era, while mobilizing inescapable discourses on unity, power, and radical change (including the slogan "United We Stand" and the [very temporary] unification of Americans in red and blue states following 9/11; an era of U.S. foreign policy based on unilateralism and the rejection of former allies; and the global specter of military occupation by a force of overwhelming size and power). Before this watershed geopolitical event, the new millennium figured as a historical threshold, the crossing of which promised to bring about apocalyptic change at the hands of computer technologies potentially at odds with the procession of human time into the year AD 2000 (or, as it was called in the final years of the twentieth century, Y2K). These films thematize anxieties about the relationship between the individual and the community endemic to an era defined by processes of globalization and new digital technologies that create new patterns of migration, dispersal, and diffusion, along with new group formations that link collectivity to the connectivity created by social media (ranging from more or less political "flash mobs" to the revolutionary collective formations of the Occupy Movement and the recent Arab Spring uprisings). In the process, these group formations—enabled, in part, by new digital technologies—make and remake ideas about the relationship between the individual and the community.[30] Finally, in recent years, massive

mass-mediated disasters such as Hurricane Katrina, the 2004 tsunami, and the Sichuan Province and Miyagi earthquakes (in 2008 and 2011, respectively) brought devastating change to entire regions with little or no warning, and demanded, upon arrival, that everything take place at an accelerated pace.

It would be misleading to argue that any of the multitudes I discuss in this chapter directly reference any of these events. Indeed, I would argue that, much like other effects emblems discussed in this book, the digital multitudes' detachment from any direct real world or contemporary referent allows them (quite profitably) to accommodate the conflicting identifications of heterogeneous global audiences. Put differently, precisely by allegorizing or mythologizing what might be interpreted as contemporary relationships (oppositional or otherwise) between various groups (from nation-states to political parties to groups organized around race or religion), the digital multitude enables these films to mediate recent geopolitical realities in a broad, polyvalent, and flexible fashion. Films featuring digital multitudes seem to acknowledge, while at the same time charging with visual and narrative pleasure, the very difficulty of resisting the overwhelming natural, historical, or political forces that promise to bring about sudden, broad-scale change. And much like the sublime special effects discussed by Scott Bukatman, the digital effects emblems used in many of these films provide a sense of mastery over processes of transformation, even as they give expression to anxieties over historical change and the difficulties of collective action.[31] In this respect, digital multitudes are emblems of (historical) transition as much as they are transitional images — computer-generated images that seem to announce the cinema's digital turn.

As important, just as the digital multitude does in fictional film, new digital technologies and image-making practices have often figured as radical historical ruptures, revolutions, surprising returns, or alarming evolutions that promise to bring about "the End" (of celluloid, of medium specificity, of narrative cinema, of entire modes of production and distribution, etc.) in critical and journalistic writing on contemporary popular cinema.[32] Yet although some of the technological means of generating digital multitudes may be new, the films in which they appear draw from the film historical past (the historical epic, the science fiction film, the disaster film, the war film) in order to update allegorical images of, and narratives about, multitudes for a new context. Indeed, at often un-

expected moments, CGI allows us to perceive past film history in new ways — the multitudes in *The Two Towers* or *Starship Troopers* force us to reconsider *The Birds* or *Triumph of the Will*, and thereby provoke what David Edgerton calls "the shock of the old."[33] This "shock of the old" is important, for the digital multitude bears some relation to the crowds that populated cinema screens in the first half of the twentieth century, which, Tony Kaes argues, provided a mirror image of the mass audiences that gazed upon them in the theater.[34] Digital multitudes register the deployment of CGI to draw spectators back to the cinema away from their atomized and isolated viewing positions before small screens. In this respect, digital multitudes can be seen as a mirror image of (and an emblem of the industrial desire for) the massive global audiences that effects-laden blockbuster films are meant to draw back to the cinema en masse to create record-breaking box office revenue.

When certain types of spectacular visual effects are linked to a longer, intermedial tradition of emblematic images, it becomes clear that these effects are sites of intense signification profoundly bound up with the narratives (and historical contexts) in which they are embedded, and for which they provide spectacular elaboration. While this chapter focuses on multitudes of computer-generated creatures and their status as emblematic images of, on one hand, historical change and, on the other, the nature of collectivities, the following chapter focuses on individual digital creatures, or "hero creatures" (including King Kong, Gollum, and the discrete Na'vi characters of *Avatar*), and how they too function as emblems of historical and technological change. Throughout, I discuss how animators and effects artists charge digital creatures with excess vitality in order to produce a degree of lifelikeness, which is increased and intensified by their status as mediators of life and death in the worlds in which they appear. As such, they emblematize contemporary anxieties over, and fantasies about, changing definitions of life and death in an era that has redefined the relationship between bodies and machines, biology and technology.

VITAL FIGURES

The Life and Death of Digital Creatures

Since the release of *Jurassic Park* (Steven Spielberg) in 1993, computer-generated creatures have functioned as spectacular signs of the incursion of digital visual effects into the domain of popular live-action cinema. Many digital creatures begin their lives materially as maquettes, which are scanned into computers and brought to life through digital processes, such as 3D modeling and key frame animation, and made credibly "organic" in appearance by detailed muscle rigs and sub-scatter surfacing techniques. Once on the screen, some creatures are entirely digital, while others are hybrid creatures realized across a number of shots through a combination of digital and analog visual effects that include prosthetics, puppets, and animatronics. The analog-digital hybridity of many contemporary effects creatures extends the dialectic between material and code so crucial to the motion-, performance-, and facial-capture techniques that combine human performance with digital animation to create lifelike Gollums, Kongs, and Na'vi. To make such creatures compelling and credible, animators, editors, directors, effects artists, and actors face a multipronged challenge: they must work in concert to convert the "dead," inanimate matter of analog special effects into animated, pulsing life; transform the immaterial numerical information of digital visual effects into a compellingly embodied diegetic "presence"; and remediate embodied, live-action performances into persuasively vital digital beings.

Hence films featuring digital creatures must overcome the ontological differences between live-action actors, binary code, and inanimate matter to create a range of characters and life-forms that appear on-screen as discrete beings that are equally alive and consistently animate, even—or especially—when audiences arrive at the cinema knowing such creatures are neither real nor alive but rather the highly orchestrated effects of an array of integrated technologies. Filmmakers and effects artists use a range of body-building techniques that help conceal these ontological differences by producing an illusory materiality for effects creatures and endowing them with psychological and physiological interiorities defined by extreme emotional states and uncontrollable impulses or instincts. In the process they charge the "hero" creatures with the over-presence and excessive (and sometimes deadly) vitality that is key to their compelling lifelikeness and on-screen viability. Such deadly vitality, in turn, is central to the ability of digital creatures to emblematize, across numerous films, the unprecedented technological mediation of organic life and death in the late twentieth and early twenty-first century.

Animation has been linked historically to the ability to give and take away the illusion of life. To animate line drawings is to bring them to life through simulated motion, and of course, the stop-motion animation used in silent and classical-era films such as *The Lost World* (Harry O. Hoyt, 1925), *Der Golem, wie er in die Welt kam* (Carl Boese and Paul Wegener, 1920), and *King Kong* (Merian C. Cooper and Ernest B. Schoedsack, 1933) had the propensity to create an uncanny resemblance between the animate and the inanimate, the living and the dead.[1] The increasing photorealism of the digital animation used to bring effects creatures to life, along with the optimization of digital processes used to composite (or "match") them within live-action films, has endowed digital creatures with an extended "life" on the screen: no longer are they confined to brief star turns (however spectacular); instead they can function as emotionally charged protagonists and antagonists that wield the ability to mediate life and death in the fictional worlds in which they appear. When joined by a surprisingly consistent set of designs, narrative strategies, and themes, the mediating function of digital creatures helps to conceal the line that divides animate and inanimate, organic and inorganic, material and code. Moreover, this mediating function is essential both to the "lifelikeness" of digital creatures and to the spectatorial fascination and visual pleasure such creatures provoke. This fascination derives in part from the

tendency of digital creatures to embody the very notion of a "life force" so excessive as to be uncontainable, noncommodifiable, and deadly.

With this in mind, we can say that digital creatures function as "vital figures" in the films in which they appear. Here "vital" is meant to invoke the multiple and even contradictory meanings of the term found in the *Oxford English Dictionary*. In its first few entries, "vital" (adj.) is defined as "consisting in, constituted by, that immaterial force or principle which is present in living beings or organisms and by which they are animated and their functions maintained." This intangible force, defined next as a "vital spark (or flame)," is responsible in living creatures for "maintaining, supporting, or sustaining life" over time. Importantly, just as the term "vital" includes the process of "conferring or imparting life or vigour; invigorating, vitalizing," it also refers to that which is "fatal or destructive to life," thereby yoking connotations of deadliness to vitality. And while things "vital" (noun) include the "part[s] or organ[s]" of a living organism essential to its life, they also comprise "those parts of a machine, ship, etc., essential to its proper working."[2] Hence "vital" is able to encompass concepts associated with organic life and death as well as the optimal functioning of technology so central to the animation of persuasively lifelike digital creatures.

The term "figure" is equally nuanced and encompasses a range of meanings salient to the on-screen appearance of effects creatures following the cinema's digital turn. The most familiar definitions of "figure" are easily applied to an animated character or creature, referring to "the form of anything as determined by the outline; external form; shape generally" and the "proper or distinctive shape or appearance (of a person or thing)," which includes its "appearance and bearing." Importantly, a figure can refer to creatures made from analog as well as digital processes, for the term includes "the image, likeness, or representation of something material or immaterial," as well as "a numerical symbol." Moreover, "figure" also refers to a "represented character" or "part enacted," giving it application to those creatures and effects created with the aid of motion and performance capture processes.[3] The various meanings made available by the phrase "vital figures" therefore correspond to the challenges of creating credible, lifelike creatures from an array of analog and digital technologies, performances, and designs: though compelling vital figures result from the optimal functioning of a complex apparatus of heterogeneous technologies, they must seem, throughout the entirety of their appear-

ance on-screen, to be animated *from within* by a mysterious, ineffable, life-giving, and life-sustaining force or spark, the vitalizing power of which includes, crucially, a capacity for both deadliness and mortality. In films such as *Jurassic Park*, *The Mummy* (Stephen Sommers, 1999), the *Lord of the Rings* trilogy (Peter Jackson, 2001, 2002, 2003), *Harry Potter and the Chamber of Secrets* (Chris Columbus, 2002), *King Kong* (Peter Jackson, 2005), *The Host* (Bong Joon-ho, 2006), *Avatar* (James Cameron, 2009), and *Splice* (Vincenzo Natali, 2009), the creatures whose very ontological status is in question are often the arbiters of matters vital to the protagonists' lives and central to their deaths. As a result, digital creatures themselves often emblematize fantasies about and anxieties over the increasing technological mediation of life and death and the blurring — or even the disappearance — of the lines that separate the organic and the artificial, the biological and the technological, genetic code and binary code.

It is worth pausing here to contrast the vital figures that have appeared in recent blockbuster films with the artificial creatures inaugurated in the Enlightenment with Jacques de Vaucanson's famous defecating duck — a mechanical bird that seemed to simulate animal processes of ingestion and waste elimination.[4] In her analysis of Vaucanson's technologies, Jessica Riskin has argued that Enlightenment-era machines that simulated the processes and functions of organic life helped create an ongoing, developing taxonomy that reconfigured understandings of the human and the machine and, in the process, helped separate "the organic from the mechanical, the intelligent from the rote, with each category crucially defined, as in any taxonomy, by what is excluded from it. . . . Vaucanson's Duck and its companions launched this taxonomic dynamic."[5] Artificial creatures thereby dramatized "not just the reducibility of animals to machines, but also the problem of where the machine ended and the animal began."[6] According to Riskin, the outcome of such projects was "a continual redrawing of the boundary between human and machine and redefinition of the essence of life and intelligence."[7]

Similar to Vaucanson's duck, the computer-generated "vital figures" I analyze here dramatize and emblematize an unstable, transitional moment in this taxonomic dynamic marked by the very difficulty of locating the boundary between the human and machine — an indeterminacy derived from the increasing inseparability of (natural) organism and (artificial) technology, genetic code and binary code. In this respect, digital creatures seem to participate in cultural work that confronts and drama-

tizes not the reinscription of the line separating life from technology but rather the dissolution of that line, such that all life and death seems to be mediated by, and at times inseparable from, technology. A comparison of the assumptions about the relationship between organic life and machines that informed Enlightenment experiments with artificial life (which extended into the mid-twentieth century) and the assumptions at stake in more recent synthesis of biology with digital technologies is helpful here. Riskin argues, "The driving force behind the projects of artificial life was the assumption that life could be simulated and that the simulations would be useful by being analogous to natural life, not by being its antithesis. So these categories [natural life and synthetic life] really redefined one another, not only by opposition, but also by analogy, and the early history of artificial life was driven by two contradictory forces: the impulse to simulate and the conviction that simulation was ultimately impossible."[8] Eugene Thacker's discussion of "biomedia," while evocative of the model described by Riskin, suggests a slight shift in the outcome of the assumptions that subtend inquiries into the relationship between biology and technology. This is less the redrawing or strengthening of the boundary separating the biological from the technological and more its gradual disappearance. Thacker argues that recent developments in biotech "are informed by a single assumption . . . that there exists some fundamental equivalency between genetic 'codes' and computer 'codes,' or between the biological and digital domains, such that they can be rendered interchangeable in terms of materials and functions."[9] The goal of such developments, according to Thacker, "is not simply the use of computer technology in the service of biology, but rather an emphasis on the ways in which an intersection between genetic and computer 'codes' can facilitate a qualitatively different notion of the biological body—one that is technically enhanced, and yet still fully 'biological.'"[10] These intersections are not reducible to mechanical prosthetics or artificial organs, Thacker warns, and should be distinguished from cyborgs on one hand and science fiction fantasies of uploading consciousness into computers on the other. Rather, they result in what Thacker calls "biomedia," or "particular mediations of the body, optimizations of the biological in which 'technology' appears to disappear altogether."[11] It is precisely (the idea of) this disappearance, as well as the fantasies and anxieties that accompany it, that digital creatures emblematize when they appear on-screen as persuasively photorealistic, convincingly "organic" computer-generated life-

forms defined by a deadly vitality that gives them the power to mediate life and death.

Mediating Life and Death

Production companies and effects houses expend considerable resources on previsualization or "pre-viz" research and development of digital creatures, whose designs often feature surplus signs of deadly life and bodily excesses that endow them with hyper-referential physiologies. Like the analog monsters that preceded them historically on-screen, digital creatures are excessive forces of nature aided by the supernatural, the technological, the mystical or magical; they are Nature Plus. Some creatures are oversized, such as King Kong and the giant spiders Shelob (*The Return of the King*) and Aragog (*The Chamber of Secrets*); others are hypercorporealized via surplus limbs and appendages. All the forest creatures on *Avatar*'s Pandora have six limbs (the direhorses, hammerhead titanotheres, hexapedes, etc.), while the massive Mûmakil in the *Lord of the Rings* trilogy sport four tusks (fig. 3.1). In other films, vital figures are given bodies that recall multiple zoological forms in a single creature. *Avatar*'s humanoid Na'vi have leonine eyes and noses and marine-blue, zebra-striped bodies, while the head of the otherwise rhino-like titanothere evokes that of a hammerhead shark. The *Lord of the Rings*' Gollum (Andy Serkis), as Tom Gunning notes, "shows affinities with a range of animal species: a creature that bounds on four feet like a rabbit, carries things in its mouth like a dog, and has the sharpened teeth and ability to spring upon its victims of a predator; while his pale, slimy skin, huge eyes, ridge-like spine, and abilities to navigate in water and creep through rocky crevices evoke a fish or reptile."[12] In *Harry Potter and the Chamber of Secrets*, the snakelike basilisk has the head of a lizard and the bumpy skin of a crocodile, while Dobby, the doe-eyed house elf, evokes simultaneously a Chihuahua and a rodent (fig. 3.2). And although *Jurassic Park*'s dinosaurs were designed and animated to evoke the movements of elephants and hippos, the film's dialogue repeatedly encourages us to perceive their bodies-in-motion as birdlike.[13]

These designs and their supporting discourses help produce what Stephen Prince calls the "perceptual realism" that helps to anchor effects creatures in Newtonian space.[14] Such designs are also key to the creation of vital figures that appear voraciously and (to use Sergei Eisenstein's term) "plasmatically" to appropriate and incorporate the defining fea-

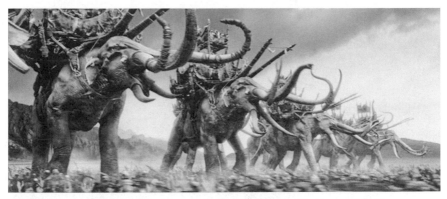

Figure 3.1 Four-tusked Mûmakil advance in *The Lord of the Rings: The Return of the King* (New Line Cinema, 2003).

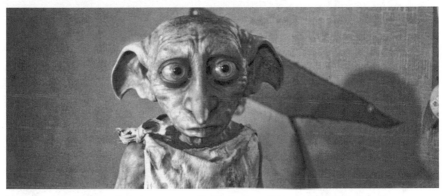

Figure 3.2 The zoologically heterogeneous Dobby in *Harry Potter and the Chamber of Secrets* (1492 Pictures, 2002).

tures of numerous life-forms and, in the process, to recombine a range of life-sustaining characteristics and deadly evolutionary advantages.[15] For example, the design of the zoologically heterogeneous monster in *The Host* enables it to overwhelm its victims and elude capture: having the appearance of an amphibious, freakishly mutated tadpole, the "host" features four-jointed jaws that open flowerlike so that it can consume its large, human prey (fig. 3.3); an anteater's long tongue; and a tail that enables it to hang upside down like an opossum, swing gracefully from the beams of a bridge like a monkey, and grab and carry its victims over long distances. In *Splice* the newborn H-50 (a creature made from combined human and animal DNA with the help of digital technologies) has the head and face of a rabbit, the rear-articulated legs of a bird, and a long scorpion's tail that ends in a stinger filled with toxic venom (fig. 3.4).

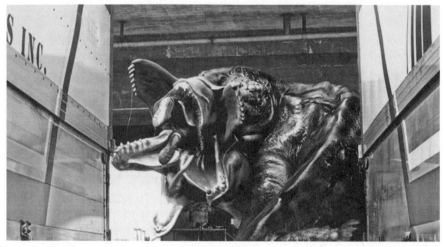

Figure 3.3 The monster consumes a human victim in *The Host* (Showbox Entertainment, 2006).

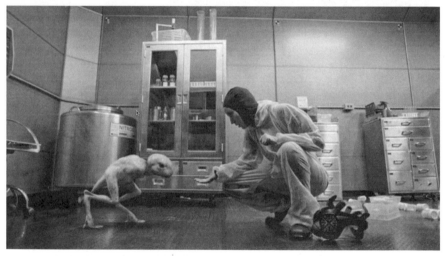

Figure 3.4 The zoologically heterogeneous H-50 in *Splice* (Gaumont, 2009).

These surplus signs of deadly "life" simultaneously cover over and charge with awe (and terror) the vital figure's ontological status, which differs radically from that of the live-action characters with which it inevitably comes into contact. To conceal the ontological differences between the living and the merely "lifelike," contemporary films portray vital figures as excessively and even terrifyingly alive. In order to appear as something beyond inanimate matter or immaterial code (that is, beyond an obvious

computer-generated effect), these vital figures are designed, animated, and presented in a manner that links them ontologically to deadliness.

The vitality of digital creatures thus exists in a dialectical relationship with death; they seem most lifelike when their deadliness and mortality are on display. From the first moment they appear on-screen, it becomes clear to spectators and protagonists alike that computer-generated creatures are mediators of life and death in the fictional worlds in which they appear. Indeed, their mediation of the protagonists' own vitality and mortality contributes to their on-screen *viability* as creatures brought to "life" by an "immaterial force or principle."[16] For example, in *The Lord of the Rings: The Two Towers* (Peter Jackson, 2002), Gollum ambushes Frodo (Elijah Wood) and Sam (Sean Astin) in the first scene in which he is fully visible, biting and strangling his opponents, while in *King Kong* (2005), a thundering, roaring Kong (Andy Serkis) explodes from the jungle to collect his human sacrifice. *Jurassic Park* introduces its dinosaurs with a scene in which a raptor, confined to a steel pen, is being transported by a giant forklift to its paddock in the park. The forklift bursts through the treetops with a degree of force that, along with the anxious appearance of the crew that awaits its arrival, hints at the violence to come. Though we glimpse only the raptor's eye through a small opening in the cage, sound and motion imply the creature's embodied presence, which becomes deadly as the crew attempts to transfer her to a paddock: as soon as the gate is lifted, she forces open a small space between her cage and the paddock gate, causing the gatekeeper to fall into the gap. The raptor devours him alive, allowing the brief action-packed sequence to charge the raptor with a terrifying, voracious vitality that, in turn, creates the narrative demand for the dinosaur's death as the gamekeeper screams, "Shoot her! Shoot her!" That we see so little of the raptor yet are convinced of its lethal, embodied presence is precisely the point: the hyperviolent scene manufactures for the dinosaur an ineffable vitality and vigor so excessive as to be immediately fatal to any other life-form it encounters—even before any raptor appears, fully embodied, on-screen. In this way, Spielberg establishes the dinosaurs' (technological) mediation of the (very narrow) line separating life and death on the island.

Films featuring vital figures often prepare the way for the lethal vitality with which their creatures erupt into the mise-en-scène through a range of discourses that frame them as extraordinary life-forms of legendary

deadliness. The 1933 version of *King Kong* established this practice when it opened with a proverb that defines the central role Kong will play in mediating life and death in the film: "And lo the beast looked upon the face of beauty. And it stayed his hand from killing. And from that day, it was as one dead." While this epigrammatic proverb describes beauty's appearance as fatal (a point discussed by scholars writing about the film),[17] it is also important to note that it is the beast who controls whether she lives or dies; the phrase "as one dead" charges Kong with life precisely by forecasting his death, thereby beginning the vitalizing process long before he appears on-screen. In Jackson's remake of the film, Kong's lethality is signaled far in advance through whispered legends and skull-marked maps; Carl Denham (Jack Black) introduces Kong with a paraphrased version of the proverb before unveiling him for his audience in New York, thereby beginning the final act of the film (which ends with Kong's fatal fall from the Empire State Building) by forecasting the deadly vitality with which he will continue to mediate human life and death until his own violent demise.

The discursive function of this proverb in both versions of *King Kong* is paralleled by dialogue in numerous other films that charges vital figures with significance transforming them from mere visual effects into effects emblems. Hence *Avatar* maintains this tendency to link vitality and lethality in its digital creatures when, in the first few minutes of the film, Colonel Quaritch (Stephen Lang) defines all living creatures on Pandora as both extremely deadly and difficult to terminate. Addressing new recruits in a security briefing, he explains, "Out there, beyond that fence, every living thing that crawls, flies, or squats in the mud wants to kill you and eat your eyes for Jujubes. We have an indigenous population of humanoids called the Na'vi. They're fond of arrows dipped in a neurotoxin that'll stop your heart in one minute. And they have bones reinforced with naturally occurring carbon fiber. They are very hard to kill." Despite this warning, the protagonist, Jake, wanders off into the rainforest the first chance he gets, only to be chased over a cliff's edge by a snarling thanator (an enormous panther-like creature). As Jake struggles to survive the night alone in the forest, the Na'vi Neytiri (Zoe Saldana) watches unseen from a tree above and silently draws her bow to kill him, her hand stayed at the last possible moment by a luminous tree spirit that floats into the frame and comes to rest on the tip of her arrow. Later, when Jake is surrounded by a pack of viperwolves, Neytiri rescues him from cer-

tain death. Upon introduction, then, each of these digital creatures (including the tree spirit, interpreted by Neytiri as a sign to spare Jake's life) is defined as an arbiter of life and death, as a (computer-generated) vital figure that mediates the threshold between the two for the films' human protagonists. Even seemingly meek and sympathetic digital creatures ultimately play an important role in the survival or demise of live-action protagonists: for example, Dobby the house elf's efforts to save Harry (Daniel Radcliffe) from a plot against his life in *Harry Potter and the Chamber of Secrets* are themselves so dangerous that Harry begs him at the end of the film, "Promise me something. . . . Never try to save my life again."

Given the lethal vitality with which contemporary films charge their digital creatures, it should be no surprise that their origins are often identified with places overtly linked to death: while King Kong rules Skull Island, *Jurassic Park*'s dinosaurs inhabit an archipelago called "The Five Deaths," and the Mummy is interred in "Hamunaptra, the City of the Dead." The corporate base camp in *Avatar* is called Hell's Gate and opens onto what Grace (Sigourney Weaver) refers to as "the most hostile environment known to man." And while Gollum/Sméagol hails from a pastoral, Shire-like countryside, he is the only living creature to have found a way through the Dead Marshes (the first place through which he guides Frodo and Sam). Like effects creatures themselves, such spaces are deadly precisely because of the excess vitality they contain. While the rocky, barren side of *King Kong*'s Skull Island is populated by zombielike cannibals, the lush jungle lying beyond the wall teems with voracious life that creeps, drools, and crawls from every crevice, much like the prehistoric life on the Five Deaths in *Jurassic Park*. *The Mummy*'s City of the Dead is a prison for undead, vital forces, which, when released, confuse the boundaries separating the animate from the inanimate and pursue their own bodily regeneration with deadly purpose. And just beneath the surface of the Dead Marshes in *The Two Towers* lie pale corpses that come to life as ethereal specters that try to drag Frodo to a watery death. Simultaneously dead but alive, embodied and immaterial, the corpses help produce the viability of Gollum's own corporeality by making clear that he is neither a soulless body (a mere corpse or an analog puppet) nor a bodiless soul (a spirit or ghost) but rather an embodied being animated from within by the vital spark of desire central to his control over Frodo's — and Middle-earth's — ultimate survival. Hence, after Frodo becomes entranced by the ghoulish corpses and falls into the water, it is Gollum rather than Sam

who rescues him—though not to save the Hobbit, but to save the Ring he loves.

Such deadliness is often inseparable from the notion of a vital figure's mortality and its transcendence of death. While some digital creatures are brought back from the dead or resist death through mystical means (the Mummy, Gollum, the basilisk) or are brought to life by new technologies (*Jurassic Park*'s dinosaurs, *Splice*'s H-50/Dren), others are survivors from a past era (*King Kong*). *Splice*'s H-50/Dren provides perhaps the most extreme example of digital vitality framed (and thereby enhanced) by illusory mortality, for the early days of her "life" are defined by the constant threat of death. Early in the film, while Elsa (Sarah Polley) is monitoring the progress of the H-50 fetus as it develops in an artificial womb (called BETI), its heartbeat suddenly flatlines on the monitor and the ultrasound image of the creature ceases to move, provoking an anxious Elsa to urge, "Come on! Come on!" before it surges back to pulsing life and its vitals once again become audible on the soundtrack. Later the H-50 fetus outgrows its artificial womb, causing its dramatic, premature birth, during which it stings Elsa, nearly killing her, while she tries to deliver it from BETI and save its life. Once born, the H-50 totters even more precariously between deadly vitality and life-giving mortality: on the morning after its birth, Clive (Adrien Brody) awakens and feels ethically compelled to kill the genetically engineered creature to end its probable suffering. However, when Elsa and Clive reach the lab, the H-50 appears to be already dead; moments later, when it becomes clear that it is still alive, Clive attempts to gas the creature to death, only to be stopped by Elsa. She explains that because of the H-50's accelerated growth rate it is "going to die soon anyway," and emphasizes, "She's dying—all by herself." Later Clive once again tries to drown the mortally ill H-50 (now called Dren) (Abigail Chu) in a tub of water, only to find he has saved her life by activating her amphibious lungs. Brought to life (both as an on-screen effect and in the fictional world in which she appears) by digital technologies, H-50/Dren is an extreme life-form (astonishingly viable and lethal) that emblematizes fantasies and fears over the erasure of any distinction between biology and technology, genetic code and computer code.

Like the deadly H-50/Dren (who ultimately survives long enough to kill Clive and, after switching sexes, impregnate Elsa), most of the vital figures discussed in this chapter are brought to life only to be killed off in a most spectacular (and sometimes melodramatic) fashion. Hence at the

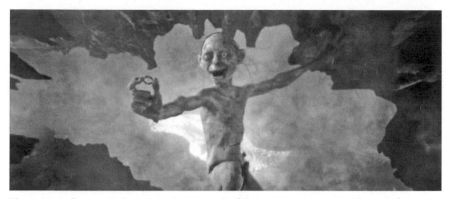

Figure 3.5 Gollum stares lovingly at the Ring as he falls into Mount Doom in *The Lord of the Rings: The Return of the King* (New Line Cinema, 2003).

end of *The Lord of the Rings: The Return of the King* (Peter Jackson, 2003), a joyful Gollum is finally reunited with his "precious" Ring and stares lovingly at it as he falls—obliviously and in slow motion—into the fires of Mount Doom (fig. 3.5). King Kong stares wistfully into Ann Darrow's (Naomi Watts) tear-streaked eyes before plunging to his death from atop the Empire State Building after losing his valiant battle with airplane gunners (from whom he mistakenly attempts to protect Ann, and from whom she, in turn, desperately tries to save him). After Dobby sacrifices himself to save Harry, Ron (Rupert Grint), and Hermione (Emma Watson) from certain death at the hands of Bellatrix Lestrange (Helena Bonham Carter) in *Harry Potter and the Deathly Hallows, Part 1* (David Yates, 2010), he utters, "Such a beautiful place to be with friends. Dobby is happy to be with his friend Harry Potter," just before expiring on a windswept, sunlit beach while cradled in Harry's arms. And the eponymous creature of *The Host* dies only after a protracted struggle with the entire Park family, the U.S. military, and a petrol-toting homeless man. Such examples suggest that nothing is more persuasive in convincing us that a digital creature was "alive" than its spectacularly rendered and temporally protracted death.

That the deaths of digital creatures are often so emotionally charged should come as no surprise, for the creatures themselves are often defined by extreme emotional states, desires, and instincts that constitute the ineffable, "internal" core of their surplus, deadly vitality—the vital figure's equivalent, perhaps, of a death drive. Gollum is defined by an irresistible desire for the Ring, which he lovingly strokes and refers to as his

"precious," and for which he strangles his cousin Déagol (Thomas Robins) and schemes to kill Frodo. Moreover, throughout *The Two Towers* and *The Return of the King*, Gollum/Sméagol passes quickly from one emotional extreme to another, ranging from angry, histrionic tantrums, to unbridled elation, to murderous rage. In *The Mummy*, Imhotep's (Arnold Vosloo) forbidden desire for the Pharoah's lover, Anck Su-Namun (Patricia Velasquez), is so excessive that it leads him to commit regicide, a crime for which he is tortured, mummified alive, and left "undead" for all eternity. "Still in love after three thousand years" (as one character describes Imhotep), the Mummy violently pursues his own physical regeneration and his lover's resurrection only to be returned to endure eternal torment in the underworld. King Kong's desire for Ann is similarly fatal: he battles dinosaurs, giant bats, and warplanes to protect (and possess) her, and ultimately pursues her to his own capture and death. In sharp contrast to scholarly criticism in the early days of CGI that speculated that digital characters' lack of psychological interiority and an unconscious would frustrate spectator identification with them, such beings are often charged with surplus desire, rage, fear, and irresistible greed—all of which are key to their vitalization.[18]

Such expressivity is so important to the viability of digital creatures that motion capture and performance capture processes (along with key frame animation) have been developed precisely to charge hero creatures (such as Gollum, Kong, and the Na'vi) with emotions that produce within them a vital spark or flame. While much scholarship on motion capture focuses on the elimination or abstraction of the performer's body, it is also important to note how motion capture data supplies animators with an actor's performed vitality, which is then made figural in the animation of digital creatures.[19] For example, the animation supervisor on *The Lord of the Rings*, Randall William Cook, explains that the "difference with Gollum [from past creatures] was, instead of simply showing up and performing a star turn, a synthetic character of great complexity was required to interact with humans and display a significant emotional range with a sustained, intense and intricately shaded performance."[20] Andy Serkis's interpretation and affective motion captured performance of Gollum further refined the overall conception of the character from a "monster" to a creature for whom "the Ring had become an addiction."[21] And as is well known, Jackson also used Serkis's motion captured physical and facial performances to animate King Kong. As *Cinefex*'s Joe Ford-

ham explains, *King Kong*'s special project supervisor, Mark Sagar, worked with both primatologists and the psychologist Paul Ekman (the inventor of the human facial action coding system) "to discuss comparisons between human and primate facial behavior, then developed facial poses that translated emotions to gorilla muscles."[22] According to Sagar, "We created a set of equivalent expressions between Andy and Kong . . . then took the motion capture and decomposed it into muscle behavior."[23] For *Avatar* James Cameron used facial cameras, high-definition reference cameras, and automatic facial replacement to transpose actors' emotional facial expressions to the detailed facial rigs of their digital Na'vi counterparts. Cameron notes, "I was on a quest for a holy grail . . . to be able to produce full human emotion in a CG character" while avoiding the "dead-eye effect—the strange disconnect that we have sometimes from CG characters." And while Cameron used a "Simulcam" to allow him to see in real time how an actor's emotive performance translated to digital Na'vi physiognomy during production, key frame animation allowed digital artists to "turbo charge" such performances in postproduction by adding ear and tail movement to indicate fear, anger, sadness, or aggression.[24] Even data clouds created by an actor's larger physical motions vitalize hero creatures by capturing what Stephen Prince calls "the expressive properties of movement" in effects creatures, for, as he notes, "human and animal movement cannot look mechanical and be convincing; it must be expressive of mood and affect."[25]

While the expression of human emotions and impulses is paramount for machine-made hero creatures, the exercise of an unstoppable hunger and a predatory instinct to hunt and feed ("I eat, therefore I am") produces the vitalizing illusion of a physical interiority in digital creatures that are often pure surface—hence the ubiquity in contemporary films of razor-toothed, snapping jaws. To emphasize their mediation of the line separating life and death, digital creatures often eat their prey alive, giving their victims the unique experience of being already dead while still living. For example, early in *Jurassic Park* the paleontologist Alan Grant (Sam Neill) describes the eating habits of the raptor to a contemptuous preteen, who dismisses the appearance of the carnivore's skeleton as that of an "oversized turkey." After explaining that the raptor disables its prey by slicing open its torso, Grant emphasizes, "The point is, you are alive when they start to eat you"—a fact already made clear in the film's opening scene. In *The Mummy Returns* (Stephen Sommers, 2001)

Figure 3.6 The Mummy "assimilates" a victim in *The Mummy Returns* (Universal Pictures, 2001).

Imhotep regenerates his body by "assimilating" the vital organs and bodily fluids of his living, screaming victims through hyperextended jaws, draining them of their life force until they are reduced to shriveled corpses (fig. 3.6). In *The Return of the King* Sam finds a web-wrapped, corpselike Frodo in the lair of the giant spider Shelob, who, Gollum has explained, is "always hungry": "She always needs to feed! She must eat!" Assuming the spider has killed Frodo, Sam hides when Orcs approach and overhears one explain that Shelob uses her venom to paralyze her living victims so she can feed on their "fresh blood." (Not incidentally, Frodo was led to Shelob's lair by Gollum, who prefers to eat his fish "raw and wriggling.") Such predatory orality is also the defining feature of the creatures that populate *King Kong*'s Skull Island—a figuration distilled by the giant "pit slugs" that attack the crew of the *Venture*: nothing more than jaws at the end of an alimentary canal, the slugs' digital design refers to a horrible human-sized digestive interiority (fig. 3.7).

Overwhelming desire and irrepressible instinct give raison d'être to effects creatures, define their figuration, and set their bodies in motion. Hence whereas analog T. rexes and Godzillas were often upright, vertically articulated creatures designed to emphasize their towering heights (figs. 3.8 and 3.9), their digital counterparts are often canted forward horizontally (figs. 3.10, 3.11, and 3.12) so that their snapping jaws are level with their fleeing human prey. Jackson's *King Kong* takes this logic to an extreme: when Kong, Ann, and a family of T. rexes tumble into a deep canyon and become tangled in vines that suspend them in midair, one clever T. rex pushes itself off the canyon wall to swing with increasing

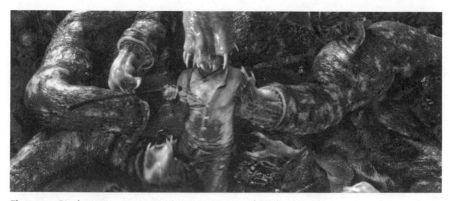

Figure 3.7 Pit slugs eat a victim in *King Kong* (Universal Pictures, 2005).

momentum toward Ann, who dangles helplessly from a vine just beyond the reach of the dinosaur's snapping jaws. Predatory orality and vitality are so closely intertwined on Skull Island that Kong defeats the T. rexes by ripping their jaws apart and then ensures they are dead by opening and closing their mouths (a gesture taken from the original, 1933 version of the film). Staged as dramas of incorporation in which computer-generated images threaten to consume embodied, live-action actors, such moments give terrifying immediacy and diegetic over-presence to absent, immaterial bodies in code.

The shaping of digital creatures' bodily designs toward the expression of excessive internal impulses is a tendency that can be traced back, at least in part, to the beasts and fantastical figures used in emblem books (and the myths on which they are based) to illustrate an internal moral state, such as lust, greed, or gluttony, against which readers were warned. For example, in Andrea Alciati's Emblem 72, titled "Lust," a "goat-footed Faun, his temples covered with colewort, provides a proper symbol for immoderate acts [sexual intercourse provoked] by Venus" (fig. 3.13).[26] Emblem 97, titled "Nature," similarly uses the image of Pan to represent the struggle between reason and lust: after describing the upper, human part of Pan's body as representing the virtue "which is implanted in our heart at birth, [and] has its seat in the lofty citadel of the head" and the lower, goat part of the body as representing lust, the emblem warns, "Some have attributed wisdom to the heart, others to the mind: but neither moderation nor reason will ever rule over the lower parts."[27] In Emblem 115 Alciati uses an image of the Sirens, depicted as "birds without wings, and girls without legs, and fish without a face that, nonetheless, sing through

Figure 3.8 The upright T. rex in *King Kong* (RKO Radio Pictures, 1933).

Figure 3.9 The upright Godzilla in *Godzilla/Gojira* (Toho Film Co., 1954).

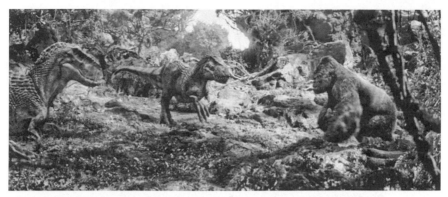

Figure 3.10 The horizontally articulated computer-generated T. rexes in *King Kong* (Universal Pictures, 2005).

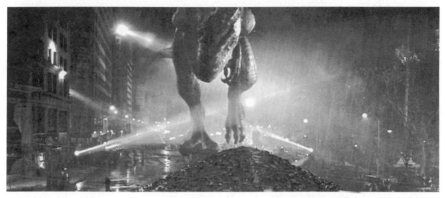

Figure 3.11 The canted-forward computer-generated Godzilla in *Godzilla* (Centropolis Film Productions, 1998).

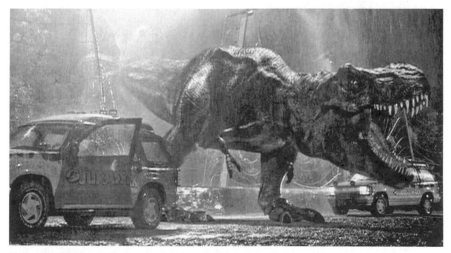

Figure 3.12 The horizontally articulated T. rex of *Jurassic Park* (Universal Pictures, 1993).

Figure 3.13 "Lust," Emblem 72 from Andrea Alciati's *Emblematum Liber* (1608 [1531]). Courtesy of the Bancroft Library, University of California, Berkeley, call no. PN6349 A53 E5 1608.

their lips," as an emblem for "a seductive woman whose lower part is a grayish fish, and that is because lust brings along with it many monsters" (fig. 3.14).[28]

Digital creatures similarly "body forth" their internal drives and desires in order to make visible "the ineffable spark or flame" (so often defined as irrational desire, greed, or insatiable hunger) that produces their excessive vitality. For example, once she reaches adulthood, Dren (Delphine Chaneac) has the upper body of a human woman, the wings and

Sirenes.

EMBLEMA CXV.

ABSQVE *alis volucres, & cruribus abſque puellas,*
 Roſtro abſque & piſces, qui tamen ore canant,
Quis putat eſſe vllos? iungi hæc Natura negauit:
 Sirenes fieri ſed potuiſſe docent.
Illicium eſt mulier quæ in piſcem deſinit atrum,
 Plurima quòd ſecum monſtra libido vehit.
Aſpectu, verbis, animi candore trahuntur,
 Parthenope, Ligia, Leucoſiaq́, viri.
Has Muſæ explumant, has atque illudit Vlyſſes:
 Scilicet eſt doctis cum meretrice nihil.

Figure 3.14 "Sirens," Emblem 115 from Andrea Alciati's *Emblematum Liber* (1608 [1531]). Courtesy of the Bancroft Library, University of California, Berkeley, call no. PN 6349 A53 E5 1608.

legs of a bird, and the tail of a scorpion (fig. 3.15). Defined by her incestuous and ultimately deadly desire for Clive, Dren becomes a modern-day, genetically engineered, nightmare version of Cupid (who often graced the pages of emblem books to advise readers on the pleasures and pitfalls of love and marriage[29]). Dren thus embodies and emblematizes (like the dinosaurs of *Jurassic Park*) the dangers of genetic experiments enabled by computer code, and of the scientific conflation of life with information and information with life. Gollum's distorted body, in turn, corre-

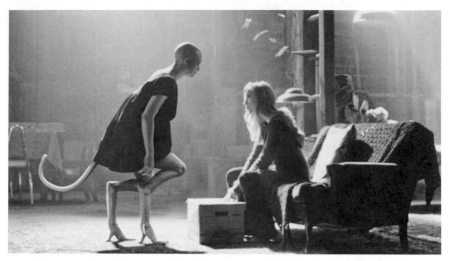

Figure 3.15 The adult Dren in *Splice* (Gaumont, 2009).

sponds best to Alciati's Emblem 90, titled "Gluttony," which features a man "painted with the neck of a crane and a swollen belly" to emblematize human "gluttony for pleasure."[30] Like the glutton, Gollum's body registers his centuries-long physical and moral corruption by the Ring, which has caused his more human, "River Folk," features to become distorted and animal-like, and has transformed him into an updated emblem for irrational desire's triumph over reason. The idea of the addict that informed Serkis's performance also informs Gollum's appearance: he is emaciated, and his bulging, oversized eyes function as the outward expression of his obsessive fascination with, and his desire to possess and gaze endlessly upon, the Ring. While Renaissance and baroque emblems used such bodily designs to create allegorical images of internal moral states against which readers were cautioned, contemporary films go on to make extreme "internal" states the expression of the deadly vitality of their computer-generated creatures—a vitality that is at the heart of their dramatization of (and cautionary tales about) the dissolution of the line separating biology and technology, organism and machine. Some films frame themselves, emblem-like, in moral or ethical terms (for example, after learning about the use of DNA to resurrect dinosaurs in *Jurassic Park*, Ian Malcolm (Jeff Goldblum) warns, "Your scientists were so preoccupied with whether or not they *could* that they didn't stop to think if they *should!*"); others (such as *Avatar*) are fantastical representations of flora and fauna reimagined as biotechnologies.

In addition to saturating their digital creatures with emotion, desire, or insatiable hunger, many of the films I discuss here subject their creatures to various biological processes linked to aging, decay, reproduction, illness, and injury—a strategy that aides the vitalizing effects of other body-building procedures, such as digital processes that layer muscle rigs and "blood" beneath computer-generated skin to enhance the illusion of organic lifelikeness. For example, as Gunning argues, the Ring's unnatural extension of Gollum's life causes him to resemble "simultaneously an infant, an aged person, a fetus, and a corpse" because of a physiognomy that is "in turn too immature (almost fetus-like at points) or too deathly," a figuration of aging and decay gone awry.[31] The Mummy elaborates by reversing the body's decay after death—Imhotep slowly transforms his decomposed, rotting remains into living flesh: with the assimilation of each victim, his body regenerates itself from the inside out, layering muscle over dried bones and desiccated tendons, followed by patches of skin and facial features, giving physiological thickness and internal complexity to the computer-generated Mummy until he is finally embodied by a live-action character. In Splice, because H-50/Dren is born prematurely and develops "like a fetus outside the womb," it initially features a seam that bisects its skull, and this gradually closes as the creature grows into a more recognizably "human" form. Jurassic Park embodies its gentle, herbivore dinosaurs by making them sick: in one scene Ellie (Laura Dern) searches a towering pile of dinosaur waste for a toxin that might have poisoned an ill triceratops, while in another scene a sick brachiosaur sneezes (quite messily) on Lex (Ariana Richards). Meanwhile, some of the ostensibly all-female predators have spontaneously changed sex to male (thanks to their frog DNA), allowing the dinosaurs to lay fertilized eggs and produce offspring. Each of these biological phenomena externalize and visualize internal bodily processes, giving these vital figures a thick biological physiology subject to cyclical time—a crucial vitalizing strategy whether the creature in reference is a material special effect (the brachiosaur and triceratops are both animatronic), digital animation, or a composite of the two.

It is not surprising that as part of this digital body-building project, these films often emphasize a digital creature's status as a perceiving subject, thereby activating and embodying its senses. In Jurassic Park much is made of the T. rex's motion-based vision: as Alan explains to the other characters several times throughout the film, the T. rex cannot see prey that remains perfectly still—a physiological trait that helps vitalize the

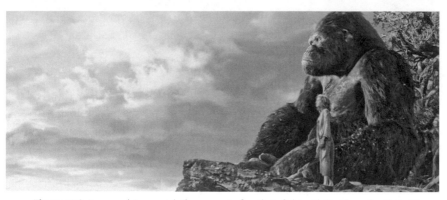

Figure 3.16 Kong and Ann watch the sun set after their fight with the T. rex family in *King Kong* (Universal Pictures, 2005).

dinosaur by embodying its vision. Embodied perception is extended to critical spectatorship in *King Kong*: Kong is a happy spectator of vaudeville (he laughs and jeers at Ann's slapstick routine when she performs for him in his lair) who also finds solace in panoramic views of natural and urban landscapes after bruising encounters with his enemies (fig. 3.16). Such scenes engage the spectator in what Angela Ndalianis describes as "a game of perception that is also about an understood *deception*: a revelation of chimeras";[32] but these scenes are also part of the body-building strategies that films use to anchor their digital creatures in the diegesis and charge their beings with an illusorily corporeal, perceiving presence central to both their visual lifelikeness and their diegetic deadliness. Hence James Cameron uses the scene in which Jake Sully (Sam Worthington) first wakes up in his Na'vi body to activate all five of his (digital) avatar's senses. First, as Jake awakens, we see his blurred vision come into focus through a point-of-view shot as a nurse calls out his name. A reverse angle shows one nurse dilating the avatar's pupils with a penlight as another snaps his fingers next to Jake's ears, causing each to twitch in response. After Jake wiggles his toes with glee and crashes clumsily around the recovery room, he runs out of the room and sprints across the base. When he stops, a close-up shows his toes burrowing into the soil as he enjoys the feeling of the ground beneath his feet. Finally, just after he breathes in the air through his nose with a look of pleasure on his face, Grace throws him a piece of fruit and he bites into it, letting out a sound of pleasure as juice drips down his chin. This sequence neatly completes the on-screen activation of each of the (digital) avatar's five senses—a process covered

over by the spectator's investment in Jake's irrepressible desire to run once again (in human form, Jake is a paraplegic). The digital body of the avatar is in fact more vital, more sensorially and sensuously alive than the (live-action) human body Jake has left behind in the computer link used to upload his consciousness into his avatar. Such strategies participate in recent cinema's broader conversion of the "dead" inanimate matter of special-effects animatronics and puppets and nonbiological, immaterial information into lifelike, vital figures that appear to be animated not from without by the hand of the effects artist but from within by a vital spark or flame that both brings them to life and condemns them to death.

Staging Indexicality: Newtonian and Darwinian Dramas

Recent scholarship on the cinema's digital turn has focused in detail on the ontology of the moving image and, more specifically, on the loss of the indexicality of the film image with the shift from celluloid to digital imaging.[33] I have so far focused on the various ways in which contemporary films address and cover over the ontological differences between digital creatures and live-action protagonists by charging their effects creatures with deadly vitality. Such vitalization processes also include the promotion of a digital creature's embodied (over-)presence in a fictional world through the spectacular display of physical or indexical traces they appear to leave behind. In *King Kong* a massive footprint provides the search party with the first indication of the fearsome size of its quarry. Similarly, in *Godzilla* (Roland Emmerich, 1998) Nick (Matthew Broderick) has been called to an accident site to examine the footprint left behind by the monster. When he (along with the spectator) fails to see it, another character explains, "You're standing in it," and the camera pulls back to reveal the enormous impression left behind by the monster (fig. 3.17).

After such moments of staged indexicality, these same films go on to promote the idea of their digital creatures' photographability by manufacturing encounters between representatives of the cinema's ontologically distinct bases, with digital creatures often threatening to overwhelm live-action photographers even as their cameras charge such creatures with the illusory materiality and vitality they need to make that threat credible and compelling. Often the act of filming or photographing—which requires the photographer's dangerous proximity to his or her subject—provokes anger in digital creatures, further dramatizing their interaction with the live-action characters who attempt to capture their image. In

Figure 3.17 The giant footprint left behind by the monster in *Godzilla* (Centropolis Film Productions, 1998).

The Lost World: Jurassic Park (Steven Spielberg, 1997), the paleontologist Sarah Harding (Julianne Moore) photographs a family of triceratops until the sound of the film rewinding automatically in her camera provokes the startled dinosaurs to attack her. In *Godzilla*, rather than run for safety when the eponymous monster surfaces on a city street, Nick chooses to stay behind to take a close-up shot of the monster with a disposable camera (whose film he winds forward manually), stopping only after the automatic flash causes Godzilla to roar in anger. *Cloverfield* (Matt Reeves, 2008) takes this tendency to its logical extreme by showing its visually uncanny monster only through the lens of a digital video camera held by a single character, who stops filming only after he is chewed in half by the giant monster and dropped to the ground (all of which is caught on camera, of course). And while the above strategies help to establish a digital creature's materiality and presence within its fictional world, they are sometimes used to exploit the photograph's unique relationship to time. Hence in *Avatar*, old photos pinned to the door of a refrigerator in the mobile lab show Grace's avatar with a young Neytiri and other Na'vi children at their school, the yellowed tape that holds them to the door testifying to the past that they document. Such moments play with the difference between the digital image and embodied presence in order to materialize code, to give digital creatures referentiality and being in the fictional worlds in which they reside.

It is worth noting that a number of films engage in self-reflexive moments that acknowledge the immateriality and absence of digital creatures at the time of filming. In *King Kong* Carl shoots 35 mm footage of a

brachiosaur herd just before it stampedes, offering direction to the movie star Bruce Baxter (Kyle Chandler), who asks rather anxiously whether a stand-in might appear in the shot instead. Carl urges Bruce on, explaining, "I need you in the shot or people will say they're fake." This exchange jokingly refers both to the context of 1930s filmmaking, in which Bruce's full immersion in the scene would provide a credible sense of scale and eliminate doubts that it was produced using stop-motion animation and process shots, as well as to the fact that at the time of shooting, the actors performed in front of a green screen, which allowed them to be composited into the prehistoric landscape in postproduction. In *Sky Captain and the World of Tomorrow* (Kerry Conran, 2004), Polly (Gwyneth Paltrow) refuses to use her last two frames to shoot photos of a floating airstrip, astonishing wildlife, or robots loading a rocket ship with animals in case something more amazing should appear later. In the end, she mistakenly shoots the ground and then snaps a photo of Joe (Jude Law)—a joke that acknowledges that the actors are the only photographable elements in this otherwise entirely digital film.

These materializing, body-building strategies are often joined to scenarios that further produce digital diegetic "presence" by placing vital figures in contexts and landscapes that manufacture their fearsome mass and weight. Often the latter is initially created by a creature's earth-shaking approach moments before it is visible on-screen. In *Jumanji* (Joe Johnston, 1995) the ground shakes and books begin to fall off shelves after the protagonists are alerted to the approach of a herd of assorted digital creatures by the nefarious game, which warns them, "Don't be fooled, it isn't thunder, staying put would be a blunder." In *Jurassic Park* the highly anticipated arrival of a T. rex is first signaled to the scientists and children trapped in the park by impact tremors, the force of which are made visible by ripples that appear on the surface of a cup of water and by vibrations that shake a rearview mirror. Such Newtonian strategies of embodiment culminate in the digital stampede, which joins the materializing momentum of aggregate bodies-in-motion to the vitalizing, life-sustaining instinct to flee. In a well-known scene in *Jurassic Park* Alan, Lex, and Tim (Joseph Mazzello) watch with fascination as a computer-generated herd of stampeding gallimimus runs across an open field. The herd becomes deadly once it shifts direction, prompting the protagonists to flee in a panicked mass, mimicking the behavior of the digital creatures that quickly overtake and engulf them.

King Kong rehearses this scenario on a far larger scale: as the crew of the *Venture* rest in a narrow canyon on Skull Island, the ground begins to shake and loosened rocks begin to fall from the canyon walls around them. Carl and Bruce run past, prompting most of the sailors to flee collectively as Herb (John Sumner), the rotund cameraman, lumbers into view, his gait prefiguring that of the ungainly brachiosaurs that appear seconds later as they flee from a pack of hungry raptors. While live-action mimicry of the digital verifies the creatures' instinct to flee danger as a defining feature of (organic) life, the threat that engulfment by the computer-generated stampede poses to the human characters narrows the slim margin that separates life from death and sets it in motion. Immersed within the stampede but not part of it, live-action bodies appear vulnerable to the sheer materiality of the herd (however illusory) once it shifts from distant spectacle to an over-present, engulfing mass. *King Kong* therefore drives its collection of jumbled, colliding bodies and snapping jaws through a narrow, twisting canyon in order to subject its digital creatures to computer-generated laws of physics that manufacture, by appearing to act on, the "materiality" of their bodies. Hence halfway through the thrilling sequence the stampede must turn onto a narrow outcropping running along the edge of a precipice. Unable to overcome the momentum of their own bodies-in-motion, several of the massive dinosaurs fail to turn quickly enough and plunge over the edge, while a few members of the crew plummet to certain death as the outcropping crumbles beneath the weight of the stampede. In the end, stray bullets meant for a raptor bring down the lead brachiosaur, causing a chain reaction of hurtling, rolling, crashing bodies, the deadliness of which is created by a composited over-closeness between beings that never actually existed together in space and time. The digital stampede unfolds on-screen as a biophysical process of fear-driven motion that transforms digital creatures into the antagonists of a Darwinian drama of embodiment based on the advantages and disadvantages of (computer-generated) mass, weight, size, and momentum.

Wild Life

Films featuring digital creatures give further life to code by defining all life as unpredictable, uncontrollable, and beyond containment or confinement; for this reason, digital creatures are more than simply "alive" in such films—they are "wild life." When the small group of protagonists

goes on its fatal tour of the park in *Jurassic Park*, it becomes very clear that the creatures contained within are entirely incompatible with the schedules and display strategies of the commodified spectacle, leaving the visitors to stare into one empty paddock after another with increasing disappointment as the dinosaurs fail to appear for their viewing pleasure, even when the T. rex is baited with a live goat. Unscheduled and untimely appearances become the rule as the narrative unfolds: later the T. rex crashes through the park's failed electrical fences to eat the visitors alive after their vehicles break down. This scene rehearses the basic structure of the film in which computer code, redefined as genetic code, overwhelms the material world—a trope neatly summarized earlier in the film as the protagonists underscore the risks Hammond's (Richard Attenborough) genetic experiments pose to the world. Ellie emphasizes the unknowability and potential uncontrollability of resurrected prehistoric life-forms and observes, "Well, the question is, how can you know anything about an extinct ecosystem? And therefore, how could you ever assume that you can control it?" Alan concurs, noting, "Look, dinosaurs and man, two species separated by sixty-five million years of evolution, have just been suddenly thrown back into the mix together. How can we possibly have the slightest idea what to expect?" In another scene, Ian adds uncontainability to the equation: "If there is one thing the history of evolution has taught us, it's that life will not be contained. Life breaks free, it expands to new territories and crashes through barriers painfully, maybe even dangerously. . . . Life finds a way." Later, after Alan discovers that some of the island's female dinosaurs have spontaneously changed sex and begun reproducing, he follows a set of baby dinosaur tracks leading away from a nest and echoes Ian, exclaiming with wonder, "Life found a way!" He thereby charges the dinosaurs with an astonishing instinctual drive to adapt biologically in order to endure as an engineered species. This scene transforms programmable computer code and the dead matter of analog puppets and animatronics into compelling creatures that pursue life with the same fearsome, unpredictable vitality with which they hunt their prey. In this respect the dinosaurs in *Jurassic Park* play out the tension that Scott Bukatman argues is at the core of animation as an idea and as a mode of production: "Animation as an *idea* speaks to life, autonomy, movement, freedom, while animation as a *mode of production* speaks to division of labor, precision of control, abundances of preplanning, the preclusion of the random."[34] As it imagines the reanimation of

dinosaur DNA, *Jurassic Park* dramatizes the triumph of the life, autonomy, movement, and freedom of the (re)animated being over precision of control and the preclusion of the random that prevailed in the act of its creation—making the category of the "living biological attraction" (as Hammond calls his dinosaurs) untenable within the fictional world of the film.

Similarly emphasizing the refusal by vital figures to be contained, the plot of *Harry Potter and the Chamber of Secrets* revolves around the escape of the deadly basilisk (a giant serpent) from a sealed, hidden chamber at the Hogwarts School, and concludes with the liberation of the computer-generated house elf Dobby from his enslavement by the Malfoy family. In turn, *King Kong* (which opens with shots of bored, live-action animals languishing in their cages in a zoo) suggests that it is precisely the illusory spectacle of unrestrained, excessive vitality—of "life" run amuck—that such computer-generated creatures provide (indeed, the creatures and flora on Skull Island were designed to suggest evolution gone awry in an isolated, prehistoric ecosystem).[35] When asked about Denham's compulsion to see Skull Island, Ben Hayes (Evan Parke) quotes Joseph Conrad's *Heart of Darkness*—"We are accustomed to look upon the shackled form of a conquered monster, but there, there you could look at a thing monstrous and free"—just before starting on the rescue mission that will lead to Kong's disastrous captivity and deadly escape. The notion of Kong's monstrous freedom finds stylized expression through the shaky, handheld "camera," which speeds through the jungle alongside him as he races back to his lair after taking Ann from her sacrificial altar. The camera offers fragmented images of Kong's body hurtling through space intercut with shots of Ann as she is tossed and wrenched about in his grip, at times in slow motion. The cumulative effect of this style is to give Kong fearsome hyperkinesis and to present him as a vital force of nature—one of pure motion, speed, and momentum capable of outstripping any attempt to capture him visually. Kong isn't simply alive: he is wild, untamed, uncontrollable vitality that in its very excess is deadly. Hence *King Kong* erects barriers that contain and separate digital creatures from human beings only so that they can be overcome in the most violent fashion: the massive wall that separates the lush jungle from the gray, rocky beach occupied by cannibals cannot prevent Kong from breaking through in his pursuit of Ann, and later, the shackles that bind Kong to the stage on Broadway do not hold for very long.[36]

The inscription of digital "vitality" as unpredictable and uncontainable

finds support through the depiction of live-action, human life as similarly beyond control. Just as Kong struggles to escape captivity in New York, Ann struggles to escape the bonds the natives use to hold her in place when they offer her to Kong. In addition, she later escapes Kong's lair. In *The Mummy* the monster's desire to break out of the successive enclosures and walls that contain him within the buried City of the Dead is equal to the protagonists' desire to overcome those same barriers to find the treasure buried within. And much as the dinosaurs escape their paddocks in *Jurassic Park*, the protagonists repeatedly leave their designated viewing positions to enter display space throughout the film: in one scene they wrest back the safety bars on their theme park ride so that they can penetrate the barrier that separates spectatorial space from the spectacle of the lab on display; later, despite being warned to remain inside their vehicles, they abandon their jeeps and enter a dinosaur paddock to get a closer look at an ill triceratops. Repeated scenarios of forceful struggle to overcome physical barriers and resist containment not only charge digital bodies with (illusory) diegetic materiality but also endow them with a will to freedom, an internal drive to remain "unshackled" that the film defines as basic to all life.

(Re)mediating Life and Death: *The Host* and *Avatar*

As lifelike machine-made beings defined by excessive and even deadly vitality, digital creatures emblematize and dramatize a range of anxieties concerning changing relationships to, and definitions of, life and death in an era of radical technological change. Two recent films focus quite directly on their digital creatures' mediation—and even remediation—of (human) life and death in ways that evoke the dissolution of the boundary that separates biology and technology: *The Host* and *Avatar*. At the level of story, the eponymous computer-generated creatures of these films are brought to life by technology and function within their fictional worlds as mediums that create, host, redefine, and end (human) life. While contact with the digital creature of *The Host* gives Park Hyunseo (Ko Ah-sung) the status of being dead while still alive, contact with the computer-generated beings of *Avatar*—one of which hosts his human life, or consciousness—gives Jake Sully the opportunity to become more alive, more vital, even after he is dead.

Like the effects creatures discussed earlier, the creature of *The Host* has its origins in a place strongly associated with death—a mortuary on a

U.S. Army base in South Korea. There an obsessive-compulsive army officer, disgusted by a thin layer of dust coating hundreds of bottles of formaldehyde sitting on shelves in his lab, orders his Korean lab assistant to pour the contents of the bottles down the drain and into the Han River.[37] Rather than preserve and fix dead tissue in the confines of a lab, this toxic chemical, once dumped, engenders a highly mobile, freakishly mutated creature that turns the sewer system running along the riverfront into a massive boneyard of human victims. Kyung Hyun Kim argues that the "birth of the monster is a reconstitution of the horror that declares that . . . nature and industry can no longer be distinguished"[38]—a horror that is extended and emblematized by the computer-generated monster's mediation of life and death in the fictional world of the film. The vital spark or flame that animates the creature is an insatiable hunger for human prey, and this creature is distinguished from other digital creatures by its unique digestive interiority: it always takes more victims than it can eat during an attack, carrying one back to the sewers with its tail while partially ingesting others, which it later regurgitates onto the floor of its lair. While some of the partially ingested victims die upon being swallowed alive, Park Hyun-seo, the film's schoolgirl protagonist, survives only to find herself trapped in the monster's hideout with the stockpile of dead bodies it hoards there for later consumption. Her unlikely survival puts her in the strange position of being, in her father's words, "deceased, but . . . not dead."

Hyun-seo's liminal status as deceased but not dead derives from the mass-mediated crisis that emerges from and frames the creature's first, horrific attack on the riverfront, during which it devours people trapped in a food stand, chases down and ingests slower victims, and grabs Hyun-seo with its tail, before leaping into and swimming across the Han River. On the other side, the monster regurgitates the body it had partially ingested and swaps it with Hyun-seo, gobbling her up before diving again into the river while her father, Park Gang-du (Song Kang-ho), and the rest of the crowd watch from a distance in helpless horror. Once the details of Hyun-seo's "death" are reported to the government, it becomes impossible for Gang-du and his family to have her removed from the government's deceased list, even after it becomes evident that she has survived the attack: while quarantined in a government medical center with his family, Gang-du receives a cell-phone call from his daughter, who begs him to rescue her from the sewer. When Gang-du and his family plead

with a government official to trace her call, the official refuses, insisting that Hyun-seo cannot be alive because her name appears on the deceased list. When Gang-du demands that they try to rescue her, the official again refuses to believe that she could have survived being eaten, and counters, "You yourself saw your daughter die. But she called you in the middle of the night. Does that make any sense? That's completely ridiculous." Hyun-seo's life and death have been doubly mediated by the horrifying spectacle of the monster's deadly vitality: not only does the monster ultimately control whether she lives or dies (after being ingested a second time, she does perish), but the official meaning of the monster's incorporation of the little girl becomes fixed within government opinion as unquestionably lethal, thereby guaranteeing that neither the police nor the military will come to her rescue. Having been eaten alive by the monster in a most public, spectacular manner, Hyun-seo awaits certain death in the sewer, where, in inverse proportion to the monster's vitality, her own vital spark or flame will continue to wane as she slowly starves or until she is finally caught and consumed by the creature. Though treated as the ravings of a victim of shock, Gang-du's insistence that Hyun-seo "is deceased, but she is not dead" articulates perfectly the digital creature's persuasive ability to mediate, and thereby blur, the line separating life and death through the horrifying spectacle of its own (technologically manufactured) voracious vitality.

The creature's capacity for mediating life and death expands as it precipitates an international crisis that seems to demand intervention by the U.S. military, which identifies the creature as the host of a new lethal virus that has infected an army sergeant injured by the monster during the riverfront attack. As the Park family and others are transported to the medical facility to be quarantined and tested for the virus, they watch a television news report that explains,

> It now appears that the creature, which disappeared after its attack on surprised park-goers today, is far more dangerous than previously assumed. U.S. Army Sergeant Donald White, who fought bravely with the monster, and lost an arm in the process, is now undergoing treatment at a U.S. Army hospital. After a thorough examination, U.S. Army medical staff have identified an unknown virus, primarily in body parts that came into contact with the creature. The U.S. Army has shipped a sample of the virus to the U.S. Center for Disease Control, which con-

firmed that the creature from the Han River, as with the Chinese civet wildcat and SARS, is the host of this deadly new virus. All military units sent to pursue and capture the creature have been recalled due to the risk of infection. Only special forces trained in biological warfare and disinfectant units are allowed access to the Han River area.

Classified by the U.S. military as the host of a highly infectious contagion, the creature becomes a medium for the viral spread of another lethal life-form. Its capacity to serve *discursively* in this way is part of the over-all function of digital creatures in mediating vital matters: the "host" be-comes a figure for deadly global contagion that produces mass panic and an ensuing demand for quarantine and containment. This new mediating function makes the creature all the more vital (its body hosts a second-ary life-form) and, therefore, deadly, since the quarantine measures im-plemented following its attack make it increasingly difficult for the Park family to find Hyun-seo. Having come into contact with the monster's blood, Gang-du is also classified by the government as a host for the virus. Once the Park family escapes the medical center, they become notori-ous as "the infected family" in television news reports and on wanted posters that pepper the urban landscape of Seoul, making it difficult for them to elude notice. And while later in the film a U.S. Army doctor con-fesses in secret that no traces of the virus have been found anywhere, the monster-as-host continues to serve as a construct—a mass-mediated medium—manufactured to facilitate the deployment of a new, deadly biological weapon (called Agent Yellow) developed by the U.S. military. The host's technologically created surplus life thereby provides an alibi for high-tech militarized death.

Just as the host's death is aided by the use of Agent Yellow, and its ori-gins are linked to the U.S. military, its voracious appetite and its need to accumulate and hoard bodies also function as a metaphor for U.S. global capitalism and neo-imperialism gone awry. Ji Sung Kim has noted that the film references problems with South Korea's entry into the global econ-omy through the financial struggles of the Park family and other charac-ters.[39] While Park Nam-il (Park Hae-il) is chronically unemployed despite having a university degree, his friend from the student protest movement explains that, although he has a job, his salary is equal to his debt, a fact that leads him to betray Nam-il for reward money. Moreover, financial problems define the Parks' family relations: Gang-du seems barely em-

ployable and pilfers change from the tip jar of the family's riverside food stand, and Hyun-seo argues with him over her cell phone, which, she insists, is so cheap she is too embarrassed to use it. Action revolves around the food stand, where Hyun-seo's grandfather supports her and Gang-du by selling traditional Korean fare (such as barbequed squid) along with junk food from around the world—from Coca-Cola and beverages decorated with Disney characters to British biscuits and ramen noodles—to international tourists.

Throughout the film the monster's appearances seem tied to a different type of consumption, *seo-ri* (the right of the hungry to take whatever food they need): just after Gang-du's father confesses that his son had to practice seo-ri as a young child, and that his sleepy, dim-witted nature is probably the result of a lack of protein, the monster appears at the stand and begins an attack that leads to the grandfather's death. Later the monster attacks two homeless brothers as they return to the sewers after practicing seo-ri at the food stand (suggesting that the new economy has left poverty and unemployment in its wake), taking enough food to last a month. And just after Hyun-seo and the younger homeless boy, Se-joo (Lee Dong-ho), longingly discuss all the foods for sale at the Park's stand while trapped in the monster's lair, the monster returns and disgorges the skeletal remains of dozens of its victims on the floor of its lair, tying the monster's spectacularly fascinating vitality to excessive, gluttonous consumption and horrifying death. Hence the host's mediation of life and death functions as a metaphor for economic revitalization that spawns consumption and accumulation run amuck. In this respect the monster is, as Kyung Hyun Kim argues, "the allegory and the emblem of loss."[40] And while the film locates the origins of this monstrous economy in U.S. neo-imperialism (Ji Sung Kim reads the monster's status as a host to a deadly virus as a metaphor for South Korea's status as a host to the U.S. military),[41] it also references its own ambivalent relationship with and (generic) origins in Hollywood cinema. Indeed, as Christina Klein notes, Bong appropriates and reconfigures the generic conventions of the Hollywood monster movie in order to transform them into tools for grappling with questions about Korean sovereignty and its entry into the global economy.[42] Hence, in what is perhaps a nod to the recent power of (mostly American) blockbuster movies to overwhelm domestic box office revenue and to continue to devour international market share thanks to trade agreements and their capacity to spawn sequels, the film's conclu-

sion sets up the beginning of another narrative to come: after Gang-du and the homeless boy whom Hyun-seo saved eat dinner together in the food stand, Gang-du keeps watch over the snowy landscape next to the river, rifle in hand, ready for the next uncannily biological, high-tech creature that will burst violently onto the scene to mediate life and death.

As in *The Host*, digital creatures in *Avatar* mediate and even remediate human life and death. The film opens with an ex-marine, Jake Sully, finding a new life after a combat injury has left him unable to walk. Jake's new life, however, comes at the price of an untimely death: his identical twin brother, Tommy (also portrayed by Sam Worthington), was shot and killed during a robbery just before he was about to depart for Pandora to participate in an avatar program funded by a mining corporation. Tommy's death gives Jake a new life via his (brother's) avatar—a hybrid creature made from combined human and Na'vi DNA that can only be animated by Jake's consciousness. Because Jake's genome is identical to Tommy's, he can "link" to the avatar created for his twin, which will allow him to walk again—at least as a Na'vi avatar on Pandora. Hence when Jake awakens from "cryo" on board a spaceship as it enters Pandora's atmosphere, his voice-over states, "One life ends, another begins." By the end of the film, this phrase refers as much to the end of Jake's life as a human being and the beginning of his new life as a Na'vi as it does to the death of his twin brother, for the genetically engineered (digital) avatar provides him with an entirely new embodied existence.

At the level of both plot and aesthetics, *Avatar* closely associates life and vitality with networked information. Once linked to his Na'vi avatar, Jake becomes part of the teeming life on the forest-covered (and entirely computer-generated) Pandora, which, throughout the film, is defined as a globally networked system of life-as-information and information-as-life, visualized in nighttime scenes in which bioluminescent plants seem to pulse with the internal spark or flame that makes life on Pandora excessively vital. Pandora's networked vitality is described in detail by Grace after Quaritch's team bulldozes the Tree of Voices, leading her to protest to the mining company executive Selfridge (Giovanni Ribisi), "There is some kind of electrochemical communication between the roots of the trees, like the synapses between neurons. . . . It's a global network and the Na'vi can access it. They can upload and download data, memories, at sites like the one you just destroyed." Such data includes the spirits of deceased Na'vi, which, upon death, are uploaded into the network via

the Tree of Souls, an organic, bioluminescent mainframe. Within the fictional world of the film, *Avatar*'s digital flora and fauna do not simply mediate life and death but remediate both by transforming vitality from one medium to another, thereby dramatizing the redefinition of life as networked information that remains vital regardless of the "body" through which it circulates, even after death. Such networked (after)life is even available to the human protagonists via their avatars: when Grace is shot, the Na'vi attempt to save her by uploading "all that she is" through the tree, and then downloading it permanently into her avatar; though the effort fails, she becomes part of Pandora's global network of energy/information.

The networked nature of Pandoran life makes its internal vitality intimately accessible to Jake via the possibility of connectivity between the nervous systems of the Na'vi and Pandoran plant and animal life: the Na'vi can connect to and cognitively command the actions of various creatures (such as the flying ikran or the six-legged direhorses) and access the "living" data of the rainforest through the tentacles that each living creature sports at the end of its braid, mane, or tail. Rather than make such creatures seem machinelike, this connectivity (and the living hardware used to facilitate it) ultimately helps to charge Pandoran wildlife with corporeal thickness and inner vitality: when Jake first bonds with a direhorse, the creature's pupil dilates and it snorts, rearing up in response to the connection. As Neytiri instructs Jake to "feel her heartbeat, her breath," he closes his eyes in concentration and a heartbeat becomes audible on the soundtrack, just as the camera cuts to gill-like organs that vibrate as the horse exhales. The networked connectivity that links all life on Pandora allows Jake (and the audience) to access the creature's vitals, giving sentience and interiority to both digital creatures—for it is clear from the use of subjective sound and Jake's amazed facial expressions that he "feels" the creature's biological processes. In the fictional world of *Avatar*, life and death on Pandora are constituted by and mediated through a dialectic between material (body, avatar, bond) and code (DNA, information, soul, energy, consciousness) that helps produce its creatures as excessively vital figures.

This dialectic between material and code makes possible the fantasy of death-as-becoming that transforms (live-action) Jake into a (digital) Na'vi. Jake is given several new lives throughout the film: first when he takes his brother's place on Pandora (both he and the avatar arrive on

Pandora in cryo chambers that are like high-tech wombs, the avatar "maturing" along the way); he is then reborn into a new Na'vi body (via the "link"); later, after being tutored by Neytiri, Jake progresses from being "like a child," to one of "the People," to Toruk Makto; finally, at the end of the film, his consciousness is uploaded through the Tree of Souls and then permanently downloaded into his Na'vi avatar, eliminating the need for a technological link to his human body. In the film's penultimate scene, Jake signs off on his last entry in his log, stating, "I guess I better go. I don't want to be late for my own party. It's my birthday after all." Importantly, his mediated (re)birth is simultaneously a death, for Jake must leave behind his human body and life in order to become fully Na'vi. The film closes with a close-up of the Na'vi Jake's eyes as they open suddenly and look directly into the camera, a shot that transforms the operative metaphor for the human-avatar relation from driver and remotely controlled machine to a fanciful cinematic inscription of "biomedia": "novel configurations of biologies and technologies that take us beyond the familiar tropes of technology-as-tool or the human-machine interface" in which the body's "inherent informatic quality enables a cross-platform compatibility." Indeed, *Avatar*'s digital imagination is based on the premise that "there exists some fundamental equivalency between genetic 'codes' and computer 'codes,' or between the biological and digital domains, such that they can be rendered interchangeable in terms of materials and functions."[43] With this in mind, we might productively read this conclusion as one that stages and complicates Peter Greenaway's declamation regarding the digital, "Cinema is dead, long live cinema."[44] In the film's final scene, *Avatar*'s digital creatures do not simply mediate life and death; they remediate both, thereby dramatizing and emblematizing the redefinition of embodied, biological life as an effect of technology, as data or networked information that remains vital regardless of the body (engineered or otherwise) it animates.

It is not surprising that vital figures continue to appear on cinema screens with increasing frequency, profitability, and photorealistic persuasiveness (or lifelikeness) in an era during which new technologies mediate life and death to an unprecedented and often controversial degree. As electronically and digitally reproduced figurations of wild life—of excessively vital Nature—digital creatures represent, to borrow a phrase from the late Miriam Hansen, "the last gasp of the dialectic of Enlightenment," in which the technological and rational reappear under the sign

of nature, myth, and the fantastic.[45] Digital creatures' mediation of life and death in the films in which they appear correlates to the layers of high-tech mediation required to bring them to life and charge them with excessive vitality. And precisely because they are lifelike, machine-made creatures-in-code, vital figures emblematize the ambivalence surrounding changing relationships to, and definitions of, (human) life and death in an era of technological change in which human life and machine life have become increasingly intertwined, even conflated. Such technologies include, for example, stem cell research that uses the building blocks of human life to cure debilitating and fatal diseases; assistive reproductive technologies that make new life possible in instances where infertility previously made it impossible; medical technologies that prolong life and, along with life-support systems, spark strident national debates (as in the case of Terri Schiavo, for example) over what it means to be alive or (brain) dead; the mapping of the human genome, which depends on the conflation of genetic code and computer code; the technologies used to clone mammals (no longer the stuff of science fiction); and the ongoing threat of bioterrorism. Within this historical context, vital figures emblematize the waning (and, in some instances, disappearance altogether) of the boundaries that once separated the living from the machine, biology from technology, the organic from the inorganic, and embodied materiality from code, as well as emblematizing the ambivalence with which such change has always been greeted. While digital creatures are emblems for the disappearance of technology into biology and vice versa, the narratives in which they are embedded often allegorize the consequences of this disappearance.

Because the processes used to bring digital creatures to life often blur the boundary between live-action performance and digital animation, material and code, digital creatures certainly enact and render spectacularly visible the technological changes under way in the cinema. At the same time that their photorealistic lifelikeness inspires terror and delight, dread and visual pleasure in audiences, vital figures also provoke (perhaps more so than other effects) the desire to find the "seam" that reveals these effects emblems to be "fake"—not terrifyingly alive, but mere machine-made spectacles. Thus in *Avatar*'s final shot, in which Jake awakens in his new avatar body and looks directly into the camera, it is important that the ontological status of the being represented and the image that represents it is uncertain, hybrid, composite—a synthesis of human and

Na'vi genomes and of live-action, embodied performance transformed into digital animation. The shot is, in short, a nonindexical but partially referential signifier for the history and body of the cinema as it is transformed by new digital technologies.

Just as new intersections between digital technologies and human performance have given rise to fantastical vital figures of unprecedented lifelikeness and photorealism, they have also made possible the cinematic representation of metamorphic bodies that seem to defy zoological classification, evolutionary history, and the laws of nature. The next chapter turns to digital and analog metamorphosis and the ways in which the morph has historically appeared in films concerned with freedom and control to emblematize a desire for sovereignty and a demand to control the direction of individual fate and (human) history.

THE MORPH

Protean Possibility and Algorithmic Control

The "morph" was one of the first digital effects to be recognized by film critics and audiences alike as a computer-generated spectacle that seemed to herald the beginning of a new era in the history of cinematic visual effects.[1] Using software programs developed by Industrial Light and Magic and Pacific Data Images to cross-dissolve and warp images, visual effects artists created digital morphs in *Willow* (Ron Howard, 1988) and *The Abyss* (James Cameron, 1989) to allow characters and creatures to shape-shift their surface appearances from a source image into a target image in single scenes organized around the display of instantaneous transformation. In later films, particularly *Terminator 2: Judgment Day* (James Cameron, 1991), *Star Trek VI: The Undiscovered Country* (Nicholas Meyer, 1991), *The Matrix* (Wachowski Bros., 1999), *X-Men* (Bryan Singer, 2000), and *Hulk* (Ang Lee, 2003), the ability to morph extended well beyond the display of spectacle to emblematize a range of concepts related to history and time and to define the fictional worlds in which metamorphosis is possible and, at times, imperative. In addition to giving live-action bodies the illusory capacity for instantaneous change and (within their narratives) near-perfect mimicry, the morph also allowed natural landscapes and cityscapes to transform with fluid ease in films such as *Heavenly Creatures* (Peter Jackson, 1994) and *Dark City* (Alex Proyas, 1998). In films such

as *The Mask* (Chuck Russell, 1994) and *The Nutty Professor* (Tom Shadyac, 1996) the morph gave the human body comic plasticity that allowed it to stretch, bulge, and bend in cartoonish fashion.

The morph's cultural and aesthetic precursors are numerous, yet within the history of the cinema its chief forerunner is the overlapping dissolve, which originated in nineteenth-century magic lantern shows.[2] This effect was a staple of early trick films (particularly those of Georges Méliès) and was an important optical effect for creating monstrous metamorphoses in classical films such as *Dr. Jekyll and Mr. Hyde* (Rouben Mamoulian, 1931). The smooth seamlessness and rapidity of the digital morph's transformations and its exaggeration and acceleration of everyday perceptions of continuity and discontinuity also places its origins, Scott Bukatman argues, in time-lapse photography.[3] Perhaps most important, though, is the digital morph's relation to film animation. Lev Manovich has argued that digital practices such as the morph, which make it possible to "cut, bend, stretch and stitch digitized film images into something with perfect photographic credibility," represent a return to the hand-painted and hand-animated proto-cinematic practices of the nineteenth century. According to Manovich, at the turn of the twentieth century "cinema delegated these manual techniques to animation and defined itself as a recording medium. As cinema enters the digital age, these techniques are again becoming commonplace in the filmmaking process. Consequently, cinema can no longer be clearly distinguished from animation."[4] Manovich's arguments about cinema's return to its origins in animation are apt for thinking about the photorealistic digital morph's relationship to the pliant and fluid graphic transformations that have always been the province of animation. As Vivian Sobchack has argued, the digital morph exploits the computer-generated image's relative liberation from some of the laws of physics to which the photographic film image is subject in order to transcend the fixed categories and oppositions that define our experience of the world, such as animate and inanimate, alive and dead, male and female, human and machine.[5] This liberation was the focus of Sergei Eisenstein's critical writings on Disney's animation (first published in 1941), which provide an important conceptual framework for thinking about how cinematic metamorphosis (analog and digital) functions emblematically in many of the films in which it appears. Many of Eisenstein's observations about the animated metamorphic image's allegorical figuration of concepts concerning freedom and control remain important

for understanding how the digital morph and its analog precursors often function as a visual effects emblem in popular live-action cinema.

Eisenstein begins his analysis of Disney's animated shape-shifting creatures by describing the sheer joy he experiences while watching the figural transformations undergone by sea creatures in *The Merbabies* (1938). He cites as "an unforgettable symbol" of Disney's "whole creative work" the image of "a family of octopuses on four legs, with a fifth serving as a tail, and a sixth — a trunk," and exclaims, "How much (imaginary) divine omnipotence there is in this!"[6] Eisenstein argues that such images display a sustained "mockery of form" that exploits the appeal of "the myth of Proteus" — that is, the ability physically to assume any form without restriction or restraint. He gives this protean power the name "plasmaticness" and explains, "For here we have a being represented in drawing, a being of definite form, a being which has attained a definite appearance, and which behaves like the primal protoplasm, not yet possessing a 'stable' form, but capable of assuming any form and which, skipping along the rungs of the evolutionary ladder, attaches itself to any and all forms of animal existence."[7]

For Eisenstein, Disney's plasmatic images provoke delight not simply because of their inventive playfulness or potential as a "flashy trick" (indeed, Eisenstein rejects the latter); rather, they fascinate precisely because they violate standardized forms of classification. Hence, he continues, "in *The Merbabies*, a striped fish in a cage is transformed into a tiger and roars with the voice of a lion or panther. Octopuses turn into elephants. A fish — into a donkey. A departure from one's self. From once and forever prescribed norms of nomenclature, form and behavior."[8] Plasmaticness mobilizes the fantasy of transcending any type of categorization or boundary — zoological, behavioral, social, spatial, and temporal. Hence it is not simply the physical boundaries of the body that plasmaticness transcends, but all of the attending categories or forms of classification that attach themselves to any being. The quality of plasmaticness enables the physio-temporal dream of "skipping along the . . . evolutionary ladder," making a leap forward (in time) as possible and as pleasurable as a regression back to a more "primal" state of being — even that of "originary plasma" itself. Hence *The Merbabies'* plasmaticness brings to life a delightful, upended world that collapses distinctions and violates systems of classification and laws that prescribe, delimit, hierarchize, and confine. Indeed, Eisenstein arrives at the conclusion that "a single, common

prerequisite of attractiveness shows through in all these examples: a rejection of once-and-forever allotted form, freedom from ossification, the ability dynamically to assume any form."[9]

Just as Bukatman has linked the digital morph to cultural fantasies surrounding its "promise of endless transformation and the opportunity to freely make, unmake, and remake oneself,"[10] Eisenstein earlier argued that delightful images of plasmaticness were particularly valuable and appealing in the context of technological modernity's regimentation and regulation of every aspect of life. In this regard, Eisenstein explains, "metamorphosis is a direct protest against the standardly immutable" and enacts a "triumph over *all* fetters, over *everything* that binds."[11] Standardization, hyper-rationalization, and fetters—these are the defining features of modern life that call forth both Disney's playfully metamorphic characters and his audience's gleeful response to them. Indeed, Eisenstein claimed that in "a country and social order with such a mercilessly standardized and mechanically measured existence, which is difficult to call life, the sight of such 'omnipotence' (that is, the ability to become 'whatever you wish'), cannot but hold a sharp degree of attractiveness."[12] Hence the plasmatic merbabies provide audiences with "a momentary, imaginary, comical liberation from the timelock mechanism of American life."[13]

Throughout his treatise on animation and plasmatics, Eisenstein refers to "the appeal of the myth of Proteus," and it is important to turn to this foundational myth, for while Eisenstein focuses on Proteus's figural freedom and transcendence of the "standardly immutable," the myths and emblems in which Proteus has historically appeared place emphasis on his relationship to time and even suggest that the latter is inseparable from his shape-shifting. Proteus, the sea god, is a prophet who knows everything about the past and present and can foretell the future to anyone able to capture him. Sir Francis Bacon described him as a prophet "who has knowledge of all things—whatever was, whatever is, and all that is to come."[14] He is, however, a reluctant oracle, and only the seeker able to bind and hold Proteus throughout all of his transformations can learn the sought-after truth about the past and future. In Homer's *The Odyssey* Menelaus tells the story of his encounter with the metamorphic Proteus when he was prevented from returning home after the Trojan War. Menelaus learns that if he can capture Proteus, the sea god will be forced to reveal what Menelaus has done in the past to anger the gods and how he can

pacify them and eventually pursue a new future. After Menelaus struggles with and captures Proteus, he learns the source of his bad fortune, and even learns the (sad) fates of Agamemnon, Ajax, and Odysseus.[15] In Virgil, Aristaeus the beekeeper approaches Proteus after disease kills all his bees. Like Menelaus, Aristaeus seizes Proteus and refuses to let go despite his terrifying transformations. Proteus then instructs him how to make an animal sacrifice to the gods to appease them; Aristaeus does so, and three days later finds a new hive of bees in the carcass of one of the sacrificed animals.[16]

The heroic effort required to maintain one's grip on the shape-shifting god suggests in these myths the considerable epistemological challenges to grasping (or knowing and understanding) the past and present, let alone the future. A return to Andrea Alciati's *Emblematum Liber* is helpful here, for films featuring the morph link shape-shifting not only to a drive for freedom but also to a desire to know and therefore shape the future. Proteus's complex relationship to knowledge of the past was the subject of Alciati's Emblem 182, titled "Whatever Is Most Ancient Is Imaginary." This emblem featured an image of Proteus (one of the earliest, according to Peter Pesic[17]) to represent the elusive nature — or the unknowability — of the past from the position of the present (fig. 4.1).[18] The text that accompanies the image is presented as a dialogue between the narrator and Proteus: "'Old man from Pallenia, oh Proteus, you have as many shapes as an actor has roles. Why are your members sometimes that of a man, and sometimes that of an animal? Come on, tell me, what can be the reason for you to change into all manner of shapes, and yet you have no fixed figure of your own?' 'I reveal the signs belonging to the most remote ages, ancient and prehistoric, and each man imagines them according to his whimsy.'"[19] As Pesic notes, Alciati uses the figure of Proteus to treat the "remnants of antiquity as 'fabrications' that reflect our dreams more closely than the unknowable reality of the distant past. In this view, all we know of the ancients is a shifting, protean palimpsest."[20] For Alciati's readers, Proteus's shape-shifting is meant to emblematize the very difficulty of transcending the present in order to know and understand the historical past.

Three points regarding the myth of Proteus and Alciati's emblem are important for understanding the digital morph as an effects emblem. First, in the myths, Proteus's transformations are prompted by captivity; hence figural freedom is an effect of confinement (an idea that returns

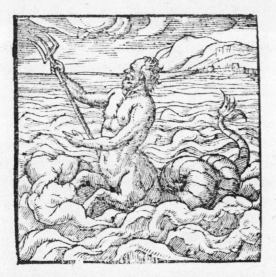

Antiquiſſima quæque commentitia.

EMBLEMA CLXXXII.

PALLENÆE ſenex, cui forma eſt hiſtrica, Proteu,
 Qui modò membra viri fers, modò membra feri:
Dic age, quæ ſpecies ratio te vertit in omnes,
 Nulla ſit vt vario certa figura tibi?
Signa vetuſtatis, primæui & præfero ſecli,
 De quo quiſque ſuo ſomniat arbitrio.

Figure 4.1 Proteus in "Whatever Is Most Ancient Is Imaginary," Emblem 182 from Andrea Alciati's *Emblematum Liber* (1608 [1531]). Courtesy of the Bancroft Library, University of California, Berkeley, call no. PN 6349 A53 E5 1608.

us, rather literally, to Eisenstein and the plasmatic figure's transcendence of "everything that binds"). Second, Proteus embodies the idea of already known, foretold (or foretellable) futures while simultaneously representing the elusive nature of (knowledge of) the past to those who desire to know it. Third, the seeker's desperate desire both to know and to understand the past and to glimpse what will be is, in each myth, presented as the effect of a crisis inseparable from foreclosed futures: without knowl-

edge of the past, the protagonists cannot transcend their current, dire circumstances and move into, or exercise control over, their futures. The emphasis placed on knowledge of the past in the myth of Proteus and in emblems that feature him is important, for the digital effects emblem of the morph tends to be deployed regularly and spectacularly in films that not only place their protagonists in closed or carceral settings (such that the idea of captivity that Proteus evokes is displaced onto location and mise-en-scène) but also burden them with problematic relationships to time and history. In many films the sought-after past is elusive (irrecoverable, unknowable, repressed, suppressed), or the (dreadful) future is foretold—predetermined and therefore seemingly inescapable.

In this chapter I consider the way in which the morph elaborates Eisenstein's dialectic between the "omnipotence of plasma"[21] and "everything that binds" while giving emblematic expression to the desire for (and violent struggle over) knowledge and control of "whatever was, whatever is, and all that is to come." It is precisely the struggle between an ossified, standardized existence that imprisons and enslaves and the dynamic freedom implied by metamorphosis that is at stake in a number of films that feature analog and digital morphs, particularly in *Dr. Jekyll and Mr. Hyde* (1931), *The Thing* (John Carpenter, 1982), *Terminator 2: Judgment Day*, *Star Trek VI: The Undiscovered Country*, *Dark City*, *The Matrix*, *Hulk*, and *X-Men*. In these films metamorphosis enacts and emblematizes this narrative struggle even as it functions as an astonishing optical, special, or digital effect. This dual function should be no surprise, for, as Eisenstein argues of animated films featuring plasmatic metamorphosis, "It's natural to expect that such a strong tendency of the transformation of stable forms into forms of mobility could not be confined solely to means of form: this tendency exceeds the boundaries of form and extends to subject and theme."[22] This strong relation between a film's subject and theme and the visual figuration of plasmaticness is important, for so many films that use metamorphosis as a central (digital, special, or optical) effect emblematize the idea of the struggle for liberation from various forms of constraint or confinement. They do so according to two different models. A number of the films under consideration here take place in radically closed or carceral settings that impose varying degrees of restraint on the protagonists, ranging from seemingly inescapable prison worlds (*Terminator 2*, *The Matrix*, *Dark City*, *Star Trek VI*) to radically isolated landscapes (*The Thing*) to rule-bound, conventional, social worlds that delimit and re-

strict behavior, desire, and individual free will through the imposition of rigid codes, traditions, and timetables (*Dr. Jekyll and Mr. Hyde*, *Heavenly Creatures*). As a (protean) corollary to such closed settings, the theme of Fate, along with a demand to know the past and to control one's future, resonate strongly in these films. Other films, such as *Hulk*, displace the trope of the closed world onto the concept of psychological repression: the mind of the protagonist functions as a container that locks away dangerous memories, past histories, and desires, which, when set free, provoke radical metamorphosis in the protagonist.

Before turning to a more detailed discussion of these films, it is necessary to distinguish the digital effects emblem of the morph (and its analog cinematic precursors) from Alciati's Proteus emblem and other types of visual culture that emphasize "quick change."[23] As Pesic argues, though Proteus is a fungible figure able to stand for a broad range of concepts, he (and, we can add, all things protean) historically posed a challenge to visual representation precisely because his profoundly temporal transformations could not be depicted in emblems, illustrations, engravings, or paintings.[24] In emblems that made use of Proteus, such as Alciati's, his shape-shifting could only be described in the accompanying text and implied in the image through Proteus's figural zoological heterogeneity. Cinematic morphs make good on a promise that emblem books could not fulfill: they represent the metamorphic transformations that are at the core of concepts concerning (knowledge of) the past and the future as well as the concepts of freedom and constraint that Proteus was to emblematize. The digital effects emblem (like some of its optical effects precursors) saturates transformation scenes with significance precisely by mediating them thoroughly, so that the impression left by the morph is less one of a virtuoso performance and more the translation of, in Bacon's words, "conceits intellectuall to Images sensible."[25] Matthew Solomon notes that live forms of metamorphic performance popular at the end of the nineteenth century, such as quick-change artistry, "made human physiognomy, the perceived guarantor of individuality, into a constantly mutating function of performance."[26] In the films under consideration in this chapter, optical and digital morphs displace metamorphic transformation from the realm of performance to the domain of technology and visual effects. In the process the morph makes physiognomy—"the perceived guarantor of individuality"—into a constantly mutating emblem of the desire for sovereignty and freedom from confinement, repression,

and predetermined futures; instantaneous transformation thus becomes an allegorical image for the demand for liberation from a "standardly immutable" existence and "everything that binds."

The transformation scenes in Mamoulian's *Dr. Jekyll and Mr. Hyde* are helpful here, for they demonstrate how such scenes functioned as effects emblems long before the advent of digital effects. While Frederic March's performance in the title role is significant, it is mediated by special effects technologies in a manner that asks us to read metamorphosis emblematically. Seven years before the release of *The Merbabies*, *Dr. Jekyll and Mr. Hyde* used optical and special effects (red and green colored makeup and filters, overlapping dissolves, and double exposure) to create the metamorphic transformations that give expression to Dr. Jekyll's desire to transcend the "prescribed norms of nomenclature, form and behavior" that obtain in the upper-class world of Victorian London. This claustrophobic setting is defined by strictly enforced social conventions and identities, professional boundaries, family traditions, and a sharp class-based segregation of space, all of which conspire to delay Jekyll's marriage (and, most important, its consummation) to his fiancée, Muriel (Rose Hobart), and prevent him from enjoying the "amusements" offered by the sexually available Champagne Ivy (Miriam Hopkins) in London's seedy East End. Muriel's father, the overbearing General Carew (Halliwell Hobbes), forces Jekyll to wait ten months to marry his daughter so that the wedding will coincide with the anniversary of his own marriage. When Jekyll asks that they be allowed to marry much sooner, Carew asks, "Why this impatience? It isn't done!"; he later calls this request "positively indecent." Jekyll's status as an upper-class gentleman and a famous scientist prevent him from soliciting the affections of Ivy, whom he rescues from her abusive lover while taking a shortcut through the East End with his older colleague, Dr. Lanyon (Holmes Herbert). When Lanyon catches Jekyll embracing the unclothed Ivy, he chides Jekyll for his "disgusting" conduct. Lanyon also warns Jekyll against pursuing his scientific inquiries into the duality of the human soul, insisting that "there are bounds beyond which one should not go." To transcend the "fetters" that bind his sexual and scientific curiosity (which are inseparable in the film), Jekyll concocts a potion that will liberate his evil self from his good self and allow the former free expression and satiation.

When Jekyll first consumes the potion that calls forth the hypersexual, sadistic Hyde, he looks into a mirror to watch his violent physi-

cal and moral transformation. After he drinks the potion, he gasps and clutches his throat as he chokes and struggles to breathe. Through the use of colored filters and red and green makeup, Jekyll begins to change on-screen: his skin and lips darken and his features become marked with harsh lines, while the hair on his arms and hands thickens (fig. 4.2). Still gasping for air, Jekyll falls to the floor out of the frame. In an extended and complex point-of-view shot, the camera whirls around in 360-degree pans, against which a series of dissolves repeats earlier moments in the film when female characters sexually entice Jekyll and older, authoritative male characters rebuke him for his improper behavior and ostensible indecency, thereby crystallizing *Dr. Jekyll and Mr. Hyde*'s broader concern with the conflict between Jekyll's desires and the prohibitions placed on them. As the camera spins around, a two-shot of Jekyll with Muriel as he pleads, "Marry me now, I can't wait any longer!" (fig. 4.3) dissolves to Carew's emphatic "Positively indecent!" This shot then dissolves to one from an earlier scene in which Ivy disrobes in front of Jekyll to allow him to examine her, with a close-up of Ivy's legs as she points to a bruise on her naked thigh and, referring to the man who hit her, asks, "See what he done to me?" This image dissolves to a shot of Lanyon reproving Jekyll for his familiarity with the naked Ivy and barking, "Your conduct was disgusting!," which is rapidly followed by Carew's severe "It isn't done!" (fig. 4.4), then Jekyll exclaiming about Carew, "I could have strangled him," and Carew shouting, "Indecent! Indecent!" An image of Jekyll asking, "Can a man dying of thirst forget water?" (a line he utters earlier in reference to his unabated desire for Muriel) dissolves to Lanyon's "Disgusting!" The series of overlapping dissolves ends with a final shot of Ivy on her bed, her bare leg swinging back and forth as she pleads, "Come back soon, won't you? Come back! Come back!" Hyde's spinning point of view finally comes to a standstill, and the camera moves to the mirror to reveal the image of the bestial, evolutionarily regressive Hyde.

In this extended sequence, epigrammatic dialogue and narrative work with optical and visual effects to emblematize the idea that Jekyll's visible metamorphosis into Hyde is the outcome of his desire to transcend the constraints and fetters that regiment time and delay sexual gratification (his "Marry me now!" versus Carew's "It isn't done!"), circumscribe behavior (Lanyon's "Your conduct was disgusting!") and restrain impulse ("Can a man dying of thirst forget water?"). Hence after the second transformation scene, which focuses more directly on the metamorphosis of

Figure 4.2 Jekyll is transformed into Hyde with the help of optical effects in *Dr. Jekyll and Mr. Hyde* (Paramount Pictures, 1931).

Figure 4.3 Jekyll pleads with Muriel to marry him immediately in his potion-induced flashback during the transformation scene in *Dr. Jekyll and Mr. Hyde* (Paramount Pictures, 1931).

Figure 4.4 General Carew rebukes Jekyll in a brief flashback during the transformation scene in *Dr. Jekyll and Mr. Hyde* (Paramount Pictures, 1931).

Hyde's body, Hyde runs out of the laboratory into the rainy night and, turning his face upward into the rain, breathes in deeply and exclaims, "Ahhhhhhh! Free! Free at last!" Though March's virtuoso performance as he struggles through the violent physical changes wrought by the potion helps naturalize the transformation scenes, it is the deployment of effects technologies (the orchestration of dissolves, double exposures, colored makeup and filters, and so on) that charges the spectacle with emblematic significance and asks us to read it allegorically. And while metamorphosis into Hyde gives Jekyll temporary freedom from (sexual) repression and control, he ultimately loses control over the process of transformation itself as Hyde later begins to materialize at the slightest provocation, without the aid of chemistry. Temporary freedom from constraint devolves into the nightmare of a total loss of control that leads to murder and, in the end, Jekyll's death.

Much like *Dr. Jekyll and Mr. Hyde*, the films under consideration in this chapter use a range of technologies and techniques (though mostly digital) to create effects emblems that give spectacular, compelling expression both to their protagonists' and antagonists' desires for liberation from onerous, oppressive constraint and to the potential horror of such freedom when unleashed entirely from everything that fetters and binds. Indeed, even morphing characters that have been associated with unlimited protean possibility—such as *Terminator 2*'s T-1000—are ultimately defined within their fictional worlds as the outcome of the dialectic between freedom of becoming and the constraint of algorithms, rules, and protocol. Much as Jekyll's transformation is the outcome of his resistance against the burdens of (family and scholarly) tradition and the past and a desire to leap, unrestrained, into the future, the digital morph similarly emblematizes a violent struggle over past histories and (control of) the future.

Prison Worlds and Plasmatics

Spatial confinement, ossified identities, and the control of the past and the future by outside forces are all themes that resonate strongly in films featuring the digital morph, such that, much like the optical morph, this effect seems inseparable from questions of freedom and control. In the radically closed settings—prisons, asylums, concentration camps, military bases, research outposts, stifling family homes—in which these films often unfold, the protagonists struggle to take control over their

destinies, identities, and future histories from some antagonistic force. For example, *Star Trek VI* uses the morph as a key figure in its representation of a broad struggle over time (the future) and the drive for freedom from confinement. Early on in the film, Captain Kirk (William Shatner) and Dr. McCoy (DeForest Kelley) are framed for the assassination of a Klingon ambassador by characters that wish to prevent a peace summit between the Federation and the Klingons out of fear of what the future (the film's "undiscovered country") will bring once the neutral zone that segregates the former enemies disappears. Put differently, the antagonists in these films work to maintain the hierarchies, ossified identities, and predetermined outcomes that will prevent history from moving forward into an unknowable future. Though innocent of the crimes for which he has been imprisoned, Kirk nevertheless makes himself vulnerable to his antagonists by expressing the same fears that motivate them. Just after meeting with the Klingons on board the Enterprise, Kirk confesses in his captain's log (which is played back at his trial), "I've never trusted Klingons, and I never will. I could never forgive them for the death of my boy. It seems to me our mission to escort the chancellor of the Klingon High Council to a peace summit is problematic at best. Spock says this could be an historic occasion, and I'd like to believe him, but how on earth can history get past people like me?"

As in the myths and emblems of Proteus, metamorphosis and the violent struggle to determine "what was" (who killed the ambassador) and "whatever will be" (the undiscovered country of the future) converge in a narrative of historical crisis elaborated in a carceral setting. Once wrongfully convicted, Kirk and McCoy are sentenced to life in prison on the gulag planet Rura Penthe, a Klingon labor camp known as "the alien graveyard." Rura Penthe is an arctic prison without walls from which escape is virtually impossible: the warden explains to the new prisoners as they enter a mining camp lying deep beneath the surface of the ice-covered planet, "There is no stockade, no guard tower, no electronic frontier. Only a magnetic shield prevents beaming. Punishment means exile from prison to the surface. On the surface, nothing can survive." As in many of the films discussed here, the radically closed setting seems to call forth the figural freedom of metamorphosis: once they are on the gulag, a beautiful "chameloid" named Marta (Iman) helps Kirk and McCoy escape by using her ability to morph. When their escape route takes them through areas where only men work, she morphs into a massive wookie-

like creature so they can pass through without notice; when they must climb up a ladder through a narrow hatch, she morphs into a slight little girl, then she changes back into her earlier disguise so they can slip out of the prison without drawing the attention of the guards. However, in keeping with the morph's tendency to emblematize themes of liberation and confinement, the freedom she seems both to embody and to facilitate is ultimately revealed to be a trap: Marta has been bribed to lead Kirk and McCoy out of the prison so that they can be justifiably killed for attempting to escape.

In the same year that *Star Trek VI* was released, *Terminator 2: Judgment Day*'s groundbreaking T-1000 appeared in a world defined by radically closed, carceral settings in which human history moves inexorably toward control by machines. At the beginning of *Terminator 2* the fate of humanity seems predetermined: the film opens in the midst of a battle in the year 2029; Sarah Connor's (Linda Hamilton) voice-over narration confirms that Judgment Day has come and gone, that the war against the machines is well under way, and that SkyNet has sent a second terminator to the past to eliminate her son, John Connor (Edward Furlong), the leader of the human resistance. The film takes us back in time to when John is still a boy and Sarah is imprisoned in the maximum-security wing of a mental hospital, where she dreams repeatedly of the impending moment when SkyNet will launch the nuclear strike that will kill three billion people on Earth. The film's flashback structure and the content of Sarah's voice-over represent the arrival of Judgment Day as a historical fait accompli. And while history functions like a "timelock mechanism" (to use Eisenstein's phrase) that moves inexorably toward human annihilation,[27] space in *Terminator 2* is locked down and hierarchized, surrounded by prison gates, chain-link fences, armed guards, and high-tech surveillance, such that the protagonists cannot simply pass through it; rather, they must break through formidable barriers that segment, restrict, and confine.

To protect John and change the future, Sarah must escape from the asylum and destroy the hand and chip of the T-100, which is protected behind layers of high-tech security at Cyberdyne headquarters. The spaces through which the protagonists flee throughout much of the film—the hallways of the asylum, L.A.'s aqueducts and freeways, the corridors running behind stores in a mall, and the steel plant where the film ends—are like mazes through which the T-1000 (Robert Patrick), and the dreaded

future it represents, relentlessly pursues them, morphing with a horrifying plasmaticness that allows it to simulate perfectly any being with which it comes into contact. Even in Sarah's dreams, all escape routes lead directly to the spatio-temporal dead end of Judgment Day: after she is beaten by hospital orderlies, Sarah dreams of Kyle (Michael Beihn), who leads her out of the asylum through doors that open onto the perimeter of a fenced-in playground moments before the blinding flash from SkyNet's nuclear strike, which awakens her from her too-real nightmare. Throughout *Terminator 2*, the chain-link fence—which Sarah rattles while screaming silent warnings to parents and children on the other side—materializes the historical impasse Judgment Day imposes on future human history.

Two scenes linked by crosscutting are particularly important to the connection the film makes between Sarah's incarceration and the inevitable arrival of Judgment Day. The camera cuts from Sarah as she awakens from her nightmare to the room where she undergoes her review. A close-up of a monitor shows a video recording of Sarah narrating the same nightmare from which we have just seen her awaken. The shot dollies out from the monitor to reveal windows caged by chain-link fencing, and later a Steadicam shot pulls back even further into an observation room behind a large pane of one-way glass where med students videotape the interview. As the multiply framed layers of security and surveillance suggest, this review will not lead to the new freedom Sarah desires (transfer to minimum security and a better chance for escape), without which her fate—along with humanity's—is sealed (fig. 4.5). To emphasize this idea, halfway through the interview the camera cuts to Cyberdyne headquarters and Miles Dyson (Joe Morton) as he moves through layers of security to retrieve the T-100's CPU and arm—the very technology that will enable him to invent SkyNet. Hence all the elements that keep history moving toward nuclear Armageddon—Sarah, the chip, and the cybernetic arm—are locked down in high-security spaces. Though Sarah initially disavows the nightmare she has just watched herself narrate on-screen, the present-day interview ultimately ends in the same manner as the previous one: she hysterically warns Dr. Silberman (Early Boen) about Judgment Day and is violently restrained, sedated, and confined to her cell. The repeated motif of the nightmare—dreamed, recounted, disavowed, then reaffirmed—defines the present purely in relation to the coming Judgment Day.

Like *Star Trek VI* and *Terminator 2*, *Dark City* and *The Matrix* feature

Figure 4.5 Sarah Connor is interviewed in the high-security wing of a mental asylum in *Terminator 2: Judgment Day* (Carolco Pictures, 1991).

spectacular morphs elaborated within prison worlds populated by characters that have little control over their own identities or fate. The eponymous Dark City, for example, is populated by a group of humans stolen from Earth by a race of aliens who experiment on them in order to find the "secrets" of the individual human soul. Doing so will allow the aliens to move backward in evolutionary time so that they can avoid impending extinction caused by their possession of a collective soul. The Dark City that serves as the laboratory for these experiments is a discrete, isolated cityscape enclosed by a brick wall that, when pierced, opens onto the void of outer space. Here the architectural body of the cityscape (rather than the body of a character) is plasmatic: each midnight the Strangers morph the city's skyline. As they "tune" the city, buildings expand or shrink, tenements become stately mansions, staircases stretch upward or contract, doorways appear and disappear, and skyscrapers sprout from the ground and twist toward the night sky. The Dark City is a simultaneously closed and variable setting—a prison with plasmatic walls—from which the protagonists cannot escape.

The plasmaticness of the urban landscape in *Dark City* corresponds to the plasmaticness of human identity and history: each midnight as the cityscape morphs, the Strangers force their human captives to sleep so they can inject them with new pasts, memories, and identities in the hope that doing so will reveal what gives each human a unique soul. This process of transformation robs the humans of their individual pasts and takes away any ability to shape their own identities and to act as agents of their individual and collective futures: the residents of the Dark City live in

a perpetual present tense that is a collocation of variable pasts formed and reformed in different combinations. Only after John Murdoch (Rufus Sewell) awakens during a "tuning" does he understand the radically ahistorical, immaterial context in which he and his fellow citizens exist as he watches the city transform around him. Eddie (Colin Friels), a cop who has also come to realize he is the subject of a cruel experiment, wails as he later observes Murdoch trying to find the express train that will take him out of the city to Shell Beach: "There's no way out you know! There's no way out of the city—believe me, I've tried!" The spiral Eddie draws obsessively in his notebooks and the maze in which another character, Dr. Schreber (Kiefer Sutherland), sets loose his lab rats invoke the topography and function of the city as a whole. Though the film waits until the end to disclose the true nature of its setting as a prison-laboratory floating in space, it hints at the truth of its inhabitants' enslavement throughout.

The Matrix, too, links plasmatics to prison worlds and the desire for liberation: both the digital world of the matrix and the real world function as carceral spaces that keep humanity effectively enslaved by machines and digital Agents able to morph into and out of any body. When Morpheus (Laurence Fishburne) first meets Neo (Keanu Reeves), he defines the matrix in a now well-known exchange:

> MORPHEUS: The matrix is everywhere. It is all around us. Even now, in this very room. You can see it when you look out your window or when you turn on your television. You can feel it when you go to work, when you go to church, when you pay your taxes. It is the world that has been pulled over your eyes to blind you from the truth.
> NEO: What truth?
> MORPHEUS: That you are a slave, Neo. That like everyone else, you were born into bondage, born into a prison that you cannot smell or taste or touch. A prison for your mind. Unfortunately, no one can be told what the matrix is. You have to see it for yourself. This is your last chance. After this, there is no turning back. If you take the blue pill, the story ends and you wake up in your bed believing what you want to believe. You take the red pill, you stay in Wonderland and I show you how deep the rabbit hole goes.

In The Matrix the real world–as–prison is veiled over by a machine-made, digital illusion that enables humans to experience enslavement as freedom. It is not incidental that Morpheus alludes to Alice in Wonderland as

he explains to Neo the (pharmaceutical) options at hand, for in doing so he refers both to the protagonists' adventures in an alternate world that subtends the real one, and to the plasmatics of bodily form that both Alice and Neo experience in those worlds (indeed, Eisenstein cites illustrations of Alice's transformations as she grows and shrinks as one of the precursors to Disney's animated plasmatics). The strong relation between plasmatics and prisons (here the former seems a response to or the outcome of the brute fact of the latter) is made clear when Neo, preparing to have his consciousness returned to his real body and the tiny plastic cell where it is held, touches the reflective surface of a cracked mirror only to have it ripple like a pool of liquid metal that slowly begins to engulf him. Once in the real world, such liquidity refers not to the "omnipotence of plasma" but instead to the final form taken by each prisoner, who, upon death, is liquefied and fed to the living. And while the carceral existence of humanity is invisible inside the matrix, wide shots of the battery towers offer a terrifying glimpse of the real world–as–prison: tens of thousands of inert bodies occupy transparent, coffin-sized cells arranged on massive towers that recede into deep space, giving credence to Morpheus's later assertion that "as long as the matrix exists, the human race will never be free."

As in *Terminator 2*, *Dark City*, and *The Matrix*, digital plasmaticness in *X-Men* mediates the clash between two violently opposed forces—one associated with oppression, subordination, and the violent denial of autonomy, the other with an unyielding desire for liberty, free will, and freedom from oppression. *X-Men* locates its narrative origins in the Holocaust to provide a historical framework for imagining the future persecution of genetic mutants, many of whom embody the "omnipotence of plasma." The film opens in 1944 as German soldiers imprison the teenage Eric Lensherr/Magneto (Brett Morris) and his parents (Kenneth McGregor and Rhona Shekter) in a concentration camp. As the Lensherrs are herded with other Jews into the camp, point-of-view shots reveal Eric's focus on the tattooed forearms of emaciated concentration camp victims to establish the principal anxiety of the film: the classification, imprisonment, and destruction of an overpowered minority by a dominant majority. As guards drag Eric away from his screaming parents, he reaches toward the prison gates that separate them and they begin to pull apart, creaking and groaning as they bend toward Eric's outstretched arms. Only by knocking Eric/Magneto unconscious are the guards able to stop his newly emergent

powers. In this way the internal process of genetic mutation finds external expression through—and becomes defined as—the potential power to break down structures (ideological and physiological as well as material) that classify, hierarchize, and confine.

When the film flashes forward to the "not too distant future," it is clear that history is about to repeat itself in a new, twenty-first-century holocaust. The narrative proper unfolds on the eve of a congressional vote on the Mutant Registration Act. After Jean Grey (Famke Janssen) addresses Congress to argue against mutant registration, the mutants' chief antagonist (and registration's chief proponent), Senator Kelly (Bruce Davison), counters,

> I have here a list of names of identified mutants living right here in the United States. Now here's a girl in Illinois who can walk through walls. Now what's to stop her from walking into a bank vault, or into the White House, or their houses [points to audience in the gallery]? And there are even rumors of mutants so powerful they can enter our minds and control our thoughts, taking away our God-given free will. Now I think the American people deserve the right to decide if they want their children to be in school with mutants, to be taught by mutants. Ladies and gentlemen, the truth is that mutants are very real and they are among us. We must know who they are, and above all, we must know what they can do.

Senator Kelly broadly defines the mutant "threat" as the imminent breakdown of formerly impenetrable barriers (walls, gates, craniums) that separate inside and outside, self and other. For Kelly, to be a mutant is to enjoy radical freedom from any boundary (material, physical, legal), and in X-Men, the concept of genetic mutation is inseparable from the morph's figural freedom. Echoing Eisenstein's definition of plasmaticness, morphological genetic mutation in X-Men moves humanity "back and forth along the evolutionary ladder" and functions as a rejection of "once and forever prescribed norms of [human] nomenclature, form and behavior." Some mutants, such as Sabretooth (Tyler Mane), Wolverine (Hugh Jackman), and Toad (Ray Park), embody the breakdown—in Merbabies fashion—of discrete zoological categories that separate human and animal species. Other mutants have the ability to transcend the physiological barriers that separate different bodies and individual consciousness: Charles Xavier (Patrick Stewart) can access and control anyone's mind,

while Rogue (Anna Paquin) can absorb the vital energy or powers of those she touches—a variation on the concept of the "omnipotence of plasma" represented by a morph that raises the veins on her skin and her victim's while draining the latter of color. Mutation's inherent plasmaticness—its tendency to call forth protean possibility—is sometimes doubled by bodily plasmaticness: Toad's tongue can stretch to great lengths, while Wolverine's regenerative flesh heals instantaneously (much in the manner of the T-1000) as wounds morph back to smooth skin in seconds. And if the figural and physiological freedom emblematized by mutant plasmaticness exists in a dialectical relationship with the threat of imprisonment, then it is not surprising that Magneto (Ian McKellen) is aided by his sidekick, Mystique (Rebecca Romijn), who is the only mutant metamorph able to transform her body into a replica of any other. Together, Magneto and Mystique embody the fantasy of a mutant existence in which the material world and the human body are utterly malleable and subordinate to individual will.

Senator Kelly's solution to the problem of mutant plasmaticness is the creation of new systems of identification and classification in the service of discrimination, segregation, and even imprisonment (following the hearings, Magneto warns Xavier, "Let them pass that law and they'll have you in chains with a number burned onto your forehead!"). Registration will have the effect of identifying mutants principally as such in order to convert "mutant" into a reductive, limiting identity category able to counter the protean possibilities of mutation itself. Moreover, the determination of what mutants can do, it seems, would be in the service of either harnessing mutant power for nefarious purposes (Wolverine's adamantium skeleton, X2 [Bryan Singer, 2003] reveals, is the result of military experiments on mutants that, we learn in X-Men Origins: Wolverine [Gavin Hood, 2009], arose from efforts to create mutant super soldiers) or eliminating the omnipotence of plasma altogether by transforming "mutation" back into a more "standardly immutable" form of the human species. Indeed, the third film of the franchise, X-Men: The Last Stand (Brett Ratner, 2006), sees the emergence of a medical "cure" for mutation.

Other films combine the trope of the world-as-prison with the concept of psychological repression such that, much as in Dr. Jekyll and Mr. Hyde, the unconscious functions as a container that locks away dangerous memories and desires, which, when set free, provoke radical metamor-

phosis. Ang Lee's *Hulk* provides an exceptional example. *Hulk* opens on a military base where David Banner (Nick Nolte) studies the human immune system and animal regeneration in order to create a super soldier that cannot be killed on the battlefield. When denied human subjects for his experiments, he runs his tests on himself and accidentally passes along a genetic mutation to his infant son, Bruce—a mistake that eventually makes his son's body into a coveted military secret and a potentially valuable commodity. When the military shuts down David's experiments in the midst of his search for an antidote, he sabotages the laboratory. David later attempts to kill Bruce (to spare him the experience of becoming a monster), accidentally killing Bruce's mother (Cara Buono) instead—an act that the four-year-old witnesses. The murder transforms Bruce, whose mutation had already made him, in his mother's words, "bottled up," into the embodiment of repressed memories and rage. Though he has nightmares of the day of his mother's murder, he is unable to remember them upon awakening. After his ex-girlfriend Betty (Jennifer Connelly) asks about his birth parents, the adult Bruce (Eric Bana) asks why she always returns to that topic; she replies, "Don't know. I guess I figure there's more to you than you like to show. I guess there couldn't be any less." Bruce's body and mind house terrible secrets that, when released, cause his monstrous transformation. When Betty asks Bruce what it feels like when he transforms into the Hulk, he explains that it is like a dream about "rage and power and freedom." Significantly, imprisonment functions alongside repression to keep Bruce's past, his mother's death, and his genetic mutation well-hidden secrets: Bruce's long period of repression coincides with David Banner's thirty-year prison sentence. Once David is released from military prison, everything associated with Bruce's traumatic, repressed past comes to the surface: after an accident at his lab, Bruce morphs into the monstrous Hulk whenever he becomes enraged, leading to his own imprisonment at the very same military base where his father first began his experiments.

These thoroughly closed fictional worlds and "bottled up" characters thus call forth plasmatic figures that possess the power to transcend carceral spaces, predetermined futures, and "ossified" identities. At times such figures serve to emphasize the protagonists' lack of freedom; in other instances they give emblematic expression to the narrative drive toward liberation. For example, in *Terminator 2* the liquid metal man's radical figural and spatio-temporal freedom contrasts sharply with Sarah's im-

prisonment and her powerlessness to thwart the arrival of Judgment Day. The T-1000 is able to move back in time to change the course of history, and even before it appears on-screen it demonstrates its ability to transcend the material barriers that confine Sarah: the film signals the terminator's arrival from the future by a large circle burned through the same kind of chain-link fence that defines the mise-en-scènes of the asylum and Sarah's nightmares. The T-1000's ability to morph gives dramatic and even terrifying elaboration to the violent conflict the film stages between the protagonists' desire for freedom and the machines' drive for complete control. Logically, then, the T-1000's most spectacular morphs take place in scenes in which the protagonists struggle to escape locked-down spaces and, in the process, their foretold futures.

Early in the film, the T-1000 arrives at the asylum just after Sarah sees surveillance images of the T-101 (which she assumes has been sent back in time by SkyNet to terminate John) and her desire to escape becomes most acute. Indeed, Sarah's efforts to break out of the asylum parallel the T-1000's efforts to break in, and the physical force she must use contrasts sharply with the plasmatic ease with which the T-1000 transcends all obstacles (for example, Sarah's use of Liquid Rooter, which she threatens to inject into Dr. Silberman, is a low-tech version of the digital plasmaticness that allows the T-1000 simply to ooze past the prison bars that stand in his way). The spectacular morphs that take place in these scenes emblematize and charge with visual pleasure this conflict between freedom and "fetters," possibility and fate. Hence the film's most astonishing transformation—the T-1000's floor-to-guard morph—takes place immediately after the T-1000 enters the asylum. After asking a receptionist for Sarah's location, the T-1000 disappears when Silberman and a group of detectives and security guards walk out of maximum security toward the reception area. After the security guard locks the door behind the departing detectives, a close-up shows his shoe strike the linoleum floor as he walks back toward reception, and the T-1000 slowly begins to rise out of the floor. The camera cuts to the guard at a coffee vending machine as the T-1000 continues to rise up and morph behind him, still covered with the floor's checkerboard pattern (fig. 4.6). The noise of the pouring coffee as it fills and takes the shape of the cup provides an apt sound effect for the liquid metal man as it "pours" itself into the form of the guard. As the T-1000 morphs into a perfect simulation of the guard, the latter announces to the receptionist that the vending machine has dispensed a coffee cup (printed

Figure 4.6 The T-1000 morphs from the checkerboard floor of the asylum in *Terminator 2: Judgment Day* (Carolco Pictures, 1991).

with playing cards) with a full house; this seems like an inside joke between the two machines, for the two pairs of jacks visible on the side of the cup match the two of a kind (of decidedly different suits) now standing in the hallway. When the guard turns around, his double quickly terminates him and the T-1000 is buzzed into the maximum-security wing. By perfectly mimicking the security system it must bypass, the T-1000 inscribes the morph as the ideal emblem for representing the desire to, in Eisenstein's words, "triumph over *all* fetters, over *everything* that binds." Hence the morph allows the T-1000 to embody an extreme and deadly version of everything Sarah desires for herself and humanity: freedom of mobility through space and time and the radical freedom to become, to make and remake one's self and one's future.

In *The Matrix*, as in *Terminator 2*, the morph emblematizes the protagonists' desire for radical freedom from settings and situations defined by incarceration and enslavement. Indeed, the origins of the matrix are associated with the human exploitation of digital plasmaticness as a means for liberating humanity from bondage. Morpheus tells Neo, "When the matrix was first built, there was a man born inside who had the ability to change whatever he wanted, to remake the matrix as he saw fit. It was he who freed the first of us, taught us the truth," suggesting that the digital prison gave birth to the morph. Hence the characters most strongly linked to the morph—the Agents—exercise this power within the digital prison of the matrix. Throughout the film we see the Agents morph into and out of the bodies of a range of minor characters—a helicopter pilot, several military policemen, and a homeless man asleep on a subway plat-

Figure 4.7 Agent Smith morphs Neo's mouth shut in *The Matrix* (Warner Bros. Pictures, 1999).

form. As Morpheus explains, the Agents "can move into and out of any software still hardwired to their system. That means anyone we haven't unplugged is potentially an Agent. Inside the matrix, they are everyone and they are no one." This ability to morph through any digital body gives the Agents an alarming ubiquity that allows them not only to be anyone but also to be anywhere. Morpheus continues, "We survived inside by hiding from them and running from them. But they are the gatekeepers. They're guarding all the doors and holding all the keys." Here Morpheus links the Agents' power to morph to their broader function within the matrix: they police the thresholds that separate the real and digital worlds, the material prison and the machine-made illusion that keeps humanity enslaved.

Given this strong link between the morph and the protagonists' drive for liberation, it is not surprising that the greatest displays of digital plasmaticness occur during violent struggles organized around scenarios of confinement and escape inside the matrix. The first spectacular, emblematic morphs in the film take place inside a police station when Agent Smith (Hugo Weaving) interrogates Tom Anderson/Neo for information on Morpheus's location. When Neo refuses to cooperate and, citing his rights, asks for his phone call, Smith morphs Neo's mouth shut (fig. 4.7). The other Agents then pin Neo to a table as Smith holds up an electronic bugging device that morphs into a wriggling, crawling electronic insect and burrows into Neo's body through his navel. In this scene the morph provides a high-tech, spectacular demonstration of the fact that Neo's body is not his own, and that like any other slave he is not a subject but an

object to be controlled and exploited. Importantly, the morph that seals Neo's mouth stifles his demand for his phone call (Agent Smith asks, "Tell me, Mr. Anderson, what good is a phone call if you are unable to speak?") and thereby hints at the true conditions of Neo's existence: he has no rights, and the self and free will he experiences in his everyday "life" are merely computer-generated illusions. Moreover, both transformations suggest that Neo's body has no physical integrity and that the boundaries that normally separate inside and out (skin, orifices) to distinguish the self from the rest of the world are myths drawn from a human past that no longer exists (hence while Smith digitally seals Neo's mouth in the matrix, in the real world the machines have imposed new openings into the bodies of their captives in order to harvest their energy and control their neurological functions). Moreover, the quick cut from the interview room to Neo's bedroom hints at the truth that will later be revealed: in this dream world there is no "outside" of the prison.

In *The Matrix* the morph charges scenarios of freedom and confinement with emotion and suspense by endowing the "gatekeepers" with a degree of plasmatic mobility and power that exacerbates and emphasizes the protagonists' ongoing status as cornered quarry. In this respect *The Matrix* inverts the traditional use of metamorphosis in Greek mythology, which Elias Canetti links not to captors but to the desire to elude captivity, noting that in the myth of Proteus, "what is important in each case is the victim's feeling of the physical proximity of the superior power, its immediate grip on him. Everything he does, and especially every metamorphosis he achieves, has as its aim the loosening of the grip."[28] In a terrifying reversal, the forces of captivity in *The Matrix* shape-shift in order to increase their capacity for physical proximity and superior power and hence the possibility of once again imposing their grip on the elusive protagonists. The Agents often morph into a scene at the moment when the protagonists are about to exit the matrix, transforming each departure into a flight for life and liberty. For example, as soon as a cop locates the crew of the Nebuchadnezzar climbing through the wall of the digitally sealed Heart o' the City Hotel, Smith morphs into his body to prevent Morpheus's escape from the matrix. Later, as Neo and Trinity rescue the captive Morpheus from Smith, another Agent morphs into the digital body of a helicopter pilot on the scene. And when Smith is shot during the extended fight sequence, he morphs out of the digital body of the dying policeman and into the body of another cop and continues his pur-

suit of Morpheus. Later, as Trinity, Neo, and Morpheus try to escape the matrix through a payphone in a subway station (phones are an exit point for the humans), Smith morphs into the body of a homeless man lying on the platform and shoots the phone's receiver, thereby destroying Neo's means for escape. At the same time that the morph collapses the distinction between bodies and identities and between humans and machines, it also functions as a weapon used to keep humanity imprisoned, mind and body, both inside the matrix and in the real world.[29]

X-Men similarly dramatizes the dialectic of imprisonment and liberation, power and powerlessness emblematized by the morph; indeed, the act of bodily metamorphosis instantly transforms freedom and power into their opposites in the scene when Toad and Mystique kidnap Senator Kelly for Magneto. The kidnapping begins with a shot of Kelly getting into his helicopter with his congressional aide. After trying to convince another legislator to vote for the registration act on his cell phone as the helicopter takes off, Kelly remarks to his aide, "You know, this situation, these mutants, people like this Jean Grey, if it were up to me, I'd lock them all away. It's a war. It's the reason people like me exist." Moments after Kelly gives voice to the threat he poses to mutant freedom, we see his aide morph (back) into Mystique—an image of digital plasmaticness that implies a transformative power that extends beyond the change in Mystique's surface appearance. As the morph ripples across Mystique's body, the associations of power, freedom, and privileged mobility initially conveyed by setting, mise-en-scène, and dialogue as the senator peddles influence in his helicopter are immediately converted into their opposite. In a single smooth movement, the morph transforms the helicopter into a claustrophobic, isolated trap that strips the senator of his authority and makes him vulnerable, even helpless. Kicking the senator into unconsciousness, Mystique retorts, "It's people like you who made me afraid to go to school as a child." Consistent with the link between the mutant drive for freedom and the looming threat of registration, the morph that shape-shifts the surface appearance of a nonmutant into that of a mutant provides visual shorthand for Senator Kelly's ultimate fate: Magneto has kidnapped him in order to transform him into a mutant, thereby forcing the senator to embody the genetic plasmaticness that he opposes politically and ideologically.

Once Kelly's technologically induced mutation is complete, his body becomes quite literally plasmatic: the digital morph allows his rubbery

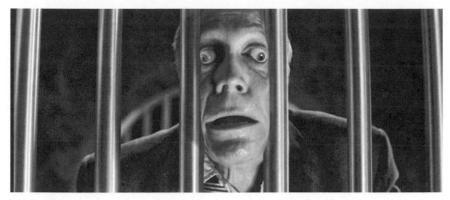

Figure 4.8 The mutant Senator Kelly squeezes through prison bars in *X-Men* (Twentieth Century Fox, 2000).

form to stretch with comic elasticity (when Magneto visits Kelly's cell he asks, "How are we feeling, Senator? Relaxed, I hope"), thereby linking binary code to genetic code in this struggle over identity, difference, and power. At precisely the moment Magneto endows the senator with bodily plasmaticness, he burdens him with a new self, threatened by the loss of liberty that mutant registration entails. Hence Kelly's new mutant plasmaticness becomes the means by which he escapes his cell: first he oozes his rubbery head through the bars on his window (fig. 4.8), then he eludes Sabretooth's attempt to pull him back into the prison cell as his arm stretches and slips from Sabretooth's grasp. After swimming from Magneto's island hideout to shore, Kelly emerges from the ocean and walks along the beach, his body morphing from a gelatinous mass back into recognizable human form. He passes by a young boy who pokes a jellyfish with a stick as his sister pleads, "Let it go, Tommy! Let it go!" This child's play recapitulates the captivity and torture that will be the fate of all mutants, including Kelly, should the Mutant Registration Act pass. Yet Kelly's future will not entail enduring all that registration implies; instead he ultimately comes to embody Eisenstein's "originary plasma" stripped entirely of omnipotence: lying on a gurney, he dies in the infirmary at Xavier's school as his body liquefies into a primordial ooze.

It is worth remembering that Senator Kelly's transformation is simply a test case for Magneto's larger plot to transform world leaders into mutants so that, as he explains, when they return home from a United Nations summit in New York, "our [mutant] cause will be theirs." That he carries out his plan from the top of the Statue of Liberty is no coinci-

dence. Historically, of course, the statue is symbolic of the idea of free-dom and heralds the United States as a place where self-determination, unrestricted becoming, and escape from imposed limitations is possible; however, the form this icon takes—an ossified and unchanging copper statue—conflicts with the notion of bodily plasmaticness that *X-Men* links so strongly to (the desire for) freedom. Indeed, the use of the statue for the final fight sequence provides an ideal setting for violent conflict between the X-Men and Magneto. On one hand, the fight sequence fea-tures the greatest display of mutation's protean possibilities, thereby re-affirming the site's association with liberty and the transcendence of bar-riers and boundaries. On the other, Magneto changes the meaning of the statue by temporarily transforming it into an instrument for confining other mutants and exploiting their powers: he shackles the X-Men and handcuffs Rogue to his mutation machine so he can use her to mutate the members of the UN summit. Magneto argues that this transformation, which will kill Rogue, is necessary because the statue itself has become a hollow, empty promise of freedom cast in metal. The world's leaders must be changed into mutants precisely because, he explains, "there is no land of tolerance, there is no peace—not here or anywhere else." By attempt-ing this mass mutation from the top of the statue, he effectively seeks to change and update the meaning of the statue for a new era poised on the threshold between mutant freedom and mutant registration. His drive to refashion the symbolic resonance of the statue is best represented when a replica of it in the gift shop is ultimately revealed to be Mystique, who has morphed her form into a simulation of this seemingly immutable symbol of sovereignty. Hence in *X-Men* the digital morph is an effects emblem of the struggle for freedom from control.

Finally, in *Hulk* the morph that transforms Bruce into the Hulk gives emblematic expression to the violent conflict between forces of confine-ment and repression and those of freedom in a scene in which Bruce es-capes from the military base where Betty's father (Sam Elliott) and Talbot (Josh Lucas) hold him captive. The underground bunker, with its series of enclosures and long narrow passages that burrow deep below the earth's surface, provides an exaggerated representation of imprisonment and ma-terializes the notion of psychological repression within setting and mise-en-scène. In turn, the formal strategies Lee uses to represent Bruce's im-prisonment, including multiple frames and a computer-generated map of the entire structure, stylize the theme of enclosure, hierarchy, and seg-

mentation. At first the bunker seems an effective container for preventing the Hulk from reaching the surface above, much like Bruce's determined, rational control over his rage prevents the Hulk from emerging. After Talbot takes over Bruce's imprisonment, he tries to harvest Bruce's DNA so the Atheon Corporation can exploit it commercially by patenting and weaponizing it. However, he must do so while Bruce is the Hulk. When Talbot's attempt to provoke Bruce into changing by shocking him with a Taser fails, Talbot sedates Bruce and confines him to a sensory deprivation tank; when the memory of his mother's murder is finally released, emotions take physical form as Bruce transforms into the Hulk. The morph becomes the process that exposes Bruce's genetic mutation and internal psychological state directly to perception. Once transformed, Bruce's body no longer contains and hides internal secrets but functions as a spectacular emblematic manifestation of both his hidden identity as a monster and a family history marked by military and family secrets, unethical scientific experimentation, and violent death.

Freedom in Control, Control in Freedom

The morph's astonishing figural freedom, as well as its ability to emblematize and even enact a desire for freedom from (spatial, social, political, or psychological) constraints, is often joined by the morphing character's omnipresence, his or her ability to become anyone and therefore be (or seem to belong) anywhere. Much as the optical morph allows Dr. Jekyll to indulge in new sexual freedoms and mobility once transformed into Hyde (not only can he enjoy "amusements" on offer in London's East End without fear of being recognized, but once he is changed, his movements become hyperkinetic as he bounds over walls and leaps from staircases), the digital morph endows the characters it transforms with the ability to be where they appear not to be. In *The Matrix* the Agents can morph into and out of any digital "being" inside the matrix, giving them virtually instantaneous presence in any populated space. In *Terminator 2* the T-1000 can simulate the appearance of any human (and some surfaces) he "samples" by touch, allowing him to hide in plain sight as John Connor's foster mother and as a security guard, thereby increasing the potential ubiquity made possible by his ability to ooze past any physical barrier that stands in his way. In *X-Men* and *X2* the digital morph allows Mystique to shapeshift her appearance into that of a teenage boy, a congressional aide, a middle-age senator, Charles Xavier, Wolverine, and a replica of the Statue

of Liberty — thereby giving her undetected passage into otherwise secure spaces. And while his metamorphosis into the Hulk makes Bruce Banner anything but inconspicuous, as the Hulk he enjoys astonishing physical mobility, bounding across vast spaces in moments. Even in comedies such as *The Mask* and *The Nutty Professor*, the morph has the effect of giving its "loser" protagonists entry into the exclusive social worlds (trendy nightclubs, especially) and romantic relationships from which they have always been barred while giving them hyperkinetic physicality and sexual dynamism their original selves lack. In *The Nutty Professor* a chemical formula transforms the overweight, bumbling, and sexually repressed professor Sherman Klump (Eddie Murphy) into the physically buff, sports car–driving sexual dynamo Buddy Love, while *The Mask*'s magical mask morphs its protagonist Stanley Ipkiss (Jim Carrey) — a shy, repressed, passive victim of street thugs, petty criminals, and mean landladies — into, in Bukatman's words, a cartoonish, sexually charged, "green-skinned, zoot-suited parody of African American performer Cab Calloway" who "bounces off walls, floors, and ceilings."[30] Hence the plasmaticness of the morph endows characters with access to just about any (formerly closed) space, giving them a potential ubiquity or new presence that contributes to the association of freedom with the optical and digital morph.

Yet while morphing characters enjoy a broad range of seemingly limitless freedoms — freedom to become, freedom from boundaries and categories, freedom from repression or confinement, and so on — the figural freedom of the morph is often an effect of control, a paradox neatly suggested by the default persona the T-1000 assumes in *Terminator 2*: that of a clean-cut white cop in the L.A. Police Department. On one hand, as the scenes detailing the T-1000's arrival at the asylum demonstrate, the terminator's cop persona, combined with its ability to morph, gives it the potential to be anybody, anywhere, without raising suspicion (which contrasts sharply with the T-101, whose appearance alarms most who see him) — that is, the morph gives the T-1000 extraordinary freedom from the laws (of physics, of the state, etc.) that govern human existence. On the other, the cop persona is also an outward sign of the T-1000's subjection to another set of (algorithmic) commands and laws — those that govern machine and, especially, computer-generated existence. By invoking the law, the T-1000's cop persona is emblematic of the freedom *and* the control to which it is subject, for the T-1000's consistent return to this surface appearance contextualizes its radical plasmaticness to remind us

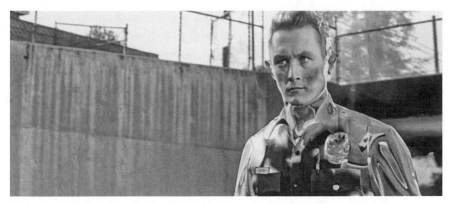

Figure 4.9 The T-1000 morphs from liquid metal man to his cop persona in *Terminator 2: Judgment Day* (Carolco Pictures, 1991).

that it is a machine programmed to complete a single mission. Importantly, the idea that a software program controls the T-1000's morphs is built into the astonishing spectacle of its various transformations. In some of the morphs, an intermediate stage of transformation makes aspects of both the liquid metal man and the cop uniform momentarily visible in a single figure, thereby emphasizing the dialectic between freedom and control that defines the T-1000's existence (fig. 4.9). And as Patrick Crogan argues of the floor-to-guard morph I discussed earlier, the black-and-white checkerboard pattern that covers the surface of the T-1000 as it morphs refers to the "standard surface rendering option in 3D computer imaging software packages" used to create morphs before T2, and thereby functions as a moment of self-reflexivity.[31] Moreover, Crogan argues that the checkerboard pattern "schematizes the computer screen's field of pixels and, more fundamentally still, the simple alternatives of the binary code — 'off' or 'on,' 'o' or '1' — that are the building blocks of digital circuitry in computer chips."[32] The references to software programs and binary code as the sources of the T-1000's figural freedom foreground the idea that the T-1000 cannot deviate from its program, question it, change it, or stop it. Indeed, as the T-101 explains to John, any time a terminator is sent to the past, SkyNet sets its CPU to "read only." Hence all of the T-1000's actions — including its spectacular morphs — are harnessed to a single, inescapable objective. We can say, then, that at the level of character, concept, and spectacular visual effects, the T-1000 elaborates and emblematizes the dialectic between radical freedom and control, boundaries and their transcendence, that structures the entire film: the radical

plasmaticness enacted by the morph is the effect of an algorithmically based program that has been designed to help SkyNet eliminate John Connor, the last threat to machine sovereignty over humans and the only hope for future human sovereignty over machines.

In *The Matrix* the digital morph also emblematizes the struggle for freedom from control in each of its spectacular transformations. While the radical mobility that Agent Smith enjoys thanks to the digital morph is a sign of the Agents' freedom of movement and power, it is also a sign of the control that the machines exert over the Agents. Like the T-1000's morph, the Agents' morph is a sign of their rule-bound existence, for they are sentient programs that must carry out a mission. Indeed, at the level of characterization, the morph simultaneously provides evidence of Smith's relative power within the matrix and his control by machines as it gives emblematic expression to his own violent pursuit of freedom from confinement. This becomes clear in the scene in which Smith tries to break into Morpheus's mind to obtain the codes for the mainframe in Zion, the last real-world city where free humans reside. As he tortures the shackled Morpheus (an image that links humanity's enslavement in the real world to the transatlantic slave trade), he explains, "I hate this place—this zoo, this prison, this reality—whatever you want to call it. I can't stand it any longer. . . . I must get out of here. I must get free. And in this mind is the key. My key. Once Zion is destroyed there is no need for me to be here." Whereas earlier Morpheus defined the Agents as gatekeepers to humanity's prison, here Smith defines Morpheus as the gatekeeper to his own prison. Through Smith, the morph becomes a visual effects emblem for the (unfulfilled) desire for freedom from constraint that drives the entire narrative forward. Hence rather than simply indicate their liberation from the laws of physics, the digital plasmaticness that gives the Agents their figural freedom, radical mobility, and speed is simultaneously the perfect expression of their subjection to algorithmic control. As Morpheus explains to Neo, "I've seen an Agent punch through a concrete wall. Men have emptied entire clips at them and hit nothing but air. Yet their strength and their speed are still based on a world built on rules. Because of that they will never be as strong or as fast as you can be." Each time the Agents morph, they simply confirm that the entire world of the matrix (and hence their own power) is defined and delimited by a program—an idea reinforced by the green binary code that becomes

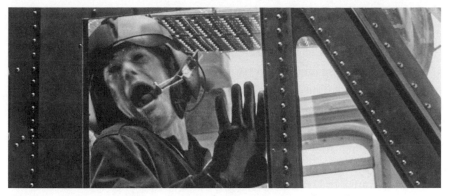

Figure 4.10 An Agent morphs into the body of a helicopter pilot in *The Matrix* (Warner Bros. Pictures, 1999).

momentarily visible each time an Agent morphs into or out of a "human" body (fig. 4.10).

While the plasmaticness of Agent Smith and the T-1000 is an effect of computer control and programming, films such as *Hulk*, *X-Men*, and *The Nutty Professor* link the morph to the (sometimes horrifying) *loss* of control over emotions, desires, or powers that have long been dormant or repressed. In *X-Men* mutant powers are first triggered by an acute emotional experience in adolescence: whereas the teenage Rogue's powers manifest themselves when she first kisses her boyfriend, the teenage Magneto's emerge when he is taken from his parents in a concentration camp. Because they are volatile, such emotions/powers must be harnessed or else the initial freedom emblematized by the morph ultimately develops, Hyde-like, into a nightmarish loss of control, such that the protagonists are no longer able to restrain either their transformations or, once changed, their behavior. *Hulk* provides the extreme version of this tendency, in which the morph implies the protagonist's pleasurable loss of control over an irrepressible, unstable force that is all the more volatile for having been fettered for too long. In this respect, Bruce's metamorphosis into the Hulk is the outcome of a clash between radical repression and radical expression as well as between the other binary oppositions that structure his character (control/volatility, powerlessness/power, dispassion/rage, pure rationality/extreme physicality) that function as opposed forces housed in (and expressed by) the same self or body, however transformed.

The conclusions of many of the films discussed here foreground the films' narrative drive toward freedom from control—including endings that are less than open ended. If, as Sobchack argues, the morph's end is "in its beginning (and vice versa)," it should come as no surprise that the conclusions of films featuring the morph often take the shape of new beginnings.[33] *Terminator 2* links the T-1000's plasmaticness to its potential mechanization of time such that the course of human history can potentially be made and unmade (much like the T-1000's body) by computers and shaped toward a single end—the destruction of humanity. Hence the narrative of *Terminator 2* sways between radically opposed relationships to historical time that can be summed up by two phrases uttered by Sarah in relation to Judgment Day: "You're already dead—you, me, everyone!" and "The future is not set. There is no fate but what we make for ourselves." While the locked-down spaces of the first half of the film work in the service of the fatalist model, the open road becomes the spatial figuration of the second model. Indeed, as Sarah, John, Dyson, and the T-101 drive to Cyberdyne headquarters to destroy the technological remains of the T-100, Sarah's voice-over remarks, "The future, always so clear to me, had become like a black highway at night. We were in unchartered territory now, making up history as we went along." Significantly, the open road becomes a structuring metaphor for the possibility of changing humanity's fate only after Sarah and John change the T-101's CPU from "read only," in the process changing humanity's future from "read only" as well. Once the T-1000 is itself terminated in a vat of molten steel and the T-101 sacrifices itself in order to eliminate that last trace of the technology that will make the future invention of SkyNet possible, the film returns to the motif of the open road.

Dark City uses the metaphor of the open sea, rather than the open road, to inscribe a new sense of temporality and history (and, with both, a new beginning) on the planet. Toward the end of the film Schreber becomes Murdoch's ally and injects him with a lifetime of synthesized memories in which he teaches Murdoch how to develop his ability to tune (morph) the city so that he can defeat and kill the Strangers. Once in possession of this knowledge, Murdoch destroys the technology that allows the Strangers to morph the material world so that he can free the inhabitants of the city from the aliens' radical control over their experience of time, space, and identity. However, before doing so, Murdoch morphs the city one last time: he exposes the planet to a sun and surrounds it with beaches and

water to impose Earthly markers of time—tides, sunrises, and sunsets—on the planet, and with each a sense of a future and a past. The film ends as the sun rises for the first time over the (formerly) dark city, and Murdoch meets the woman who was his wife (her memories of that fabricated past having been erased by the Strangers) for the "first" time and begins an entirely new future with her.

The Matrix perhaps most self-consciously links its refusal of a "closed" conclusion with the humans' broader struggle for freedom from machine/digital control. At the end of the film Neo's digital avatar temporarily defeats Smith in a manner that echoes and exceeds Smith's use of the morph to occupy the digital bodies of humans "hardwired" into the matrix: he leaps directly into Smith's body and makes it stretch and contort until it finally explodes into bits of code, leaving Neo's digital self standing triumphantly in Smith's place. Neo's ability to master the morph within the matrix signals his appropriation of the digital power used by the machines to enslave humanity, an idea clearly expressed in the voice-over addressed to the machines that ends the film:

> I know you're out there. I can feel you now. I know that you're afraid. You're afraid of us. You're afraid of change. I don't know the future. I didn't come here to tell you how this is going to end. I came here to tell you how it's going to begin. I'll hang up this phone and then I'm going to show these people what you don't want them to see. I'm going to show them a world without you. A world without rules and controls, without borders and boundaries. A world where anything is possible. Where we go from there is a choice I leave to you.

While such endings are crucial to the open-ended structure of installments within franchises, they simultaneously link narrative (non)resolution of the violent conflict between forces of freedom and control to digital plasmaticness in general and the morph in particular. Hence in *X-Men* the play between plasmaticness and ossification that organizes the film's narrative continues through the film's conclusion, which details the fates of Magneto and Mystique. Just as Kelly's staunch opposition to mutant plasmaticness results in his own unstoppable metamorphosis into plasma, Magneto's attempt to create a new brotherhood of mutants results in his imprisonment in a hard, transparent, plastic cell. While his new prison makes it impossible for Magneto to subject metal to his will, it also represents the ossification of that which was formerly pliant and plasmatic.

And though Kelly's short prison sentence produced an evolutionary leap forward (once he is transformed, Magneto says to him, "Welcome to the future, brother"), the plastic prison temporarily transforms Magneto into an earlier life-form—a mere human unable to control magnetic fields. And despite the fact that—or precisely because—Senator Kelly has been returned to the primal state of liquidity, his place in the Senate can be taken up by the mutant who embodies the very "omnipotence of plasma" he sought to contain: the film ends with the revelation that Mystique now masquerades as the senator in order to oppose the Mutant Registration Act in favor of mutant rights. This image of Mystique-as-Kelly, and the desire for sovereignty it represents, seems to demand the counter-image of the imprisoned, ossified Magneto, bringing the film back to its beginning, in which the prison called forth the protean possibilities of mutation, linking the morph and its seemingly endless transformations to the thwarted but nevertheless unyielding desire for liberty.

Conclusion

I conclude with a brief discussion of John Carpenter's *The Thing*, which, though it uses analog special effects to stage its scenes of (horrifying and gooey) transformation, nevertheless anticipates the digital morph as it elaborates the concepts so strongly linked to cinematic metamorphosis throughout the history of popular live-action film. Set in an isolated research camp in Antarctica in the early winter of 1982, the film narrates the beginning of the global colonization of Earth by an invading alien organism that arrives at the camp in the guise of a sled dog. Seemingly without its own original default form, the alien organism overtakes, absorbs, and then perfectly imitates any creature with which it comes into contact, down to the cellular level. Its perfect simulation of the life-form it consumes enables the Thing to spread undetected among the small group of researchers and staff at the camp, unless it is discovered while absorbing and transforming into its latest prey. Much as in the other films under consideration here, *The Thing*'s transformation scenes function as effects emblems for the narrative struggle over confinement and freedom, ossification and radical plasmaticness.

Crash-landing in the Antarctic at least 100,000 years earlier, the Thing has awaited discovery and liberation while frozen deep in the ice. The two isolated research camps where the Thing begins its conquest provide precisely the setting it requires in order to become ubiquitous: early on

in the film, Dr. Blair (Wilford Brimley) writes that the Thing "could have imitated a million life-forms on a million planets, could change into any one of them at any time. Now it wants life-forms on Earth. . . . It needs to be alone and in close proximity with a life-form to be absorbed. The chameleon strikes in the dark." Hence the radically closed setting of the (confining, claustrophobic) camp and its extreme isolation in the Antarctic provide the perfect conditions of possibility for the Thing to spread via metamorphosis. The Thing is discovered after it is locked up in a kennel with the camp's dogs and it attacks them as they try to claw and chew their way out of the cage. Later, when Blair destroys the camp's transportation and communication technologies in order to prevent the Thing from spreading outside, the others lock him alone in a shed, thereby unwittingly ensuring his infection. Unable to leave the camp and confined in close proximity to one another, the protagonists are certain to be overtaken, allowing the Thing to return to civilization in the spring in the guise of the researchers (dead or alive).

Early on in the film the protagonists struggle to identify and classify the Thing after it begins its conquest of the small camp. In an important scene Blair sits in front of a computer as a program simulates the biological process used by the Thing to become and perfectly simulate the life-form it absorbs—in this case the camp's sled dogs. Primitive-looking computer graphics show a red, triangular "intruder" cell as it first moves toward a blue, oval "dog" cell, absorbs it, and turns into a blue oval. The process repeats itself as the intruder cell (now simulating the blue oval of the dog cell) approaches another blue oval dog cell and turns red momentarily as it assimilates the dog cell before finally replicating the latter's shape. In sharp contrast to the protracted and bloody scene in which the Thing attacks the camp's dogs, the computer graphics represent the assimilation process as quick and smooth. While analog special effects increase the horror of the Thing's metamorphoses (it appears to have human, dog, arachnid, and crustacean characteristics as well as tentacles, claws, and other unidentifiable but vaguely familiar zoological life-forms), digital transformation communicates the terrifying ease with which, at the cellular level, the Thing changes a unique, classifiable life-form into an organism that is no specific thing at all. As Stephen Prince argues, the Thing "represents a form of cosmic pollution, an entity existing outside the accepted categories that give shape to human life and knowledge. Its very existence challenges the ontology separating human

from non-human, solid from liquid, edible from inedible. It threatens to erase the distinctions, and, in doing so, to erase the bounded human world. This threat is both epistemological and material."[34] By attaching itself "to any and all forms of animal existence" (in Eisenstein's words), the Thing occupies the uncanny category of the pure composite.[35] The "quick change" (to borrow a phrase from Solomon)[36] of computer-graphic metamorphosis seems necessary to make the information that follows credible, as the program calculates the "probability that one or more team members may be infected by intruder organism" to be 75 percent and concludes that, should the intruder organism reach civilized areas, it would infect the "entire world population" within "27,000 hours from first contact." *The Thing* imagines an encounter with a formless organism whose goal is the imitation of *all* life-forms, and that is in possession of the most fearsome "omnipotence of plasma" that compels it to absorb and bring to extinction every species with which it comes into contact.

Like Alciati's emblems and the other effects emblems I discuss in this book, the morph often gives expression to anxieties and fantasies arising from the historical context in which they were produced and consumed. *The Thing*'s incipient digital morph and its special-effects dramatization of conquest through perfect simulation help foreground a range of possibilities and perils linked to technological change that are more self-consciously elaborated by *The Matrix*, *Terminator 2*, *Hulk*, and *Dark City*. *The Thing*'s fantasy of absorption and perfect cellular simulation resonates strongly with scholarly discourses on digital remediation and convergence analyzed in detail by Philip Rosen. Scholarship on digital media has focused on the digitization of analog forms of representation, such as painting, photography, and cinema, and the effects of such remediation: namely, the transformation of continuous, analog forms of representation into a discontinuous form based on binary code and the subsequent malleability of such forms at the level of the pixel. Analyzing scholarship on digital culture that is utopian in its arguments, Rosen notes, "In the digital utopia, images are being perpetually recoded into numbers. Historically precedent regimes of media and signification are thereby perpetually appropriated and subjected to a unique capacity of the digital, practically infinite manipulability. Thus the digital spreads, infiltrates, overwhelms, conquers all other media — but, like many modern conquerors, does so in the name of liberation, liberation from constraint."[37] The analog and digital morphing scenes in *The Thing* express not the utopian but the (para-

noid) fantasy of the digital remediation and perfect simulation of an (analog) original by a (digital) copy (at the cellular and global levels). Even the ontological status of the Thing resonates within a broader digital imaginary that expands far beyond Blair's computer-graphic representation: much as digitization transforms a continuous object into a discontinuous one composed of an array of discrete pixels, the Thing transforms an individual being into an organism in which each of its parts — down to the cellular level — is a discrete entity able to function independently of all other constituent parts, such that every cell can become, change, or morph on its own. In films such as *Terminator 2*, *The Matrix*, and even *The Thing*, in which copies or digital simulations kill the originals they replicate, we might read the morph as a metaphor for the digital remediation of other (analog) media, such that all culture converges in the computer to be liberated (from the laws of physics or the constraints of indexicality) and controlled by new technologies. The films under consideration here display the morph within narrative situations that pit constraint against the drive for freedom, and ossification against plasmaticness, and often stage a collision between digital and analog, precisely because the morph so readily plays out the fantasy of digital media's conquest of all other media. Hence Sobchack argues, "Exuberant and liberating in its democratic lack of hierarchical attachment to any privileged form of being while bent on some ultimate totalitarian mastery of all forms, exuding its own freedom while globally incorporating and homogenizing that of all in its path, the morph seems to double the dramatic actions of both our nation and our technoculture."[38] This play between liberation and constraint characterizes all spectacular visual effects, which are always the product of the dialectical relationship between historically possible innovations and historically specific limitations (technological, aesthetic, cultural, economic) that constitute the conditions of their possibility. This dialectic includes the conquest and transformation of analog visual effects by digital visual effects.

Like the other digital effects emblems I analyze in this book, the morph can resonate in a variety of ways depending on the historical contexts in which the films they appear in were manufactured and viewed. This capacity for signification demonstrates that the spectacular effect — digital, optical, or special — has never functioned as "empty" spectacle as so many film reviews and so much critical work on popular cinema suggests. Rather, digital effects such as computer-generated verticality,

digital multitudes, digital creatures, and morphs—as well as their analog precursors—function emblematically in the films in which they appear. As such, they are extraordinarily capacious in their ability to accommodate and give compelling and complex articulation to a range of concepts, themes, anxieties, fantasies, and conflicts arising both from the cinematic narratives in which they play such an important role and from the broader historical contexts in which they were produced and exhibited.

CONCLUSION

Throughout this book I have used the emblem as a tool for opening up spectacular digital and analog visual effects to detailed critical analysis. Effects emblems are stunning (and often computer-generated or digitally enhanced) visual effects that give spectacular expression to the major conceits, themes, anxieties, and desires both of the films in which they appear and of the historical moments in which they were produced and exhibited. The full significance of a cinematic effects emblem is rarely entirely accessible without the aid of dialogue and story, which work in a mode of mutual elaboration and elucidation with an effects shot or sequence to crystallize and disclose a particular effects emblem's central concept or conceit. Hence, like emblem books described by Emanuele Tesauro, effects emblems consist of "popular symbol[s] composed of figures and words signifying by means of a motif any theme belonging to human life."[1] The visual effects discussed in this book are emblematic images that allegorize the complex concepts central to the narratives of the films in which they appear, much as the images found in emblem books work with their accompanying written texts and epigrams to create allegorical assemblages that express certain ideas, themes, or morals. Importantly, then, the digital effects emblem is a particular *type* of spectacular visual effect that is to be distinguished from visual effects that are less spectacular and meant to go relatively unnoticed.

There are significant differences between emblem books and

cinematic visual effects that might at first make these historically and technologically distinct media seem an unlikely pairing. One features single images accompanied by a brief written text; is profoundly tied to graphic illustrations created by woodcuts, engravings, and illustrations; and emerged into popular culture as the result of a revolution in printing. The other is embedded in a lengthy narrative composed of hundreds of shots and a soundtrack; is inseparable from time-based, moving image culture; and is the result of a revolution in computer and digital technologies. Despite these differences, the emblem's typical tripartite structure, its tendency to draw from a broad range of cultural sources (mythology, fairy tales, religious texts, nature, etc.), and its linking of image to epigram and written text to produce allegorical meanings make the emblem particularly useful for thinking about and analyzing spectacular visual effects—their mode of address; their relationship to dialogue, narrative, and character; and the kinds of spectatorship they demand.

While many critical works have defined elaborate visual effects as either discontinuous or empty spectacle devoid of meaning (and, by implication, film audiences as passive consumers of low-brow fare),[2] "effects emblems" in fact function as spectacular sites of intense and often complex signification; as such, they demand a particular kind of spectator. Like the allegorical images in emblem books, the spectacular visual effects shot or sequence is part of a constellation of representations that, taken together, yield the broader concepts at stake in the plight of a particular protagonist as he or she jumps into the void from a mountainside, shape-shifts to mimic the appearance of another being, encounters a fantastic yet highly realistic creature, or joins a small, rag-tag group of protagonists in opposition to a fearsome multitude. Just as the full meaning of and the visual and narrative pleasures offered by the emblem required the reader to synthesize the emblem's various parts into an allegorical whole,[3] so too does the digital effects emblem offer spectators the greatest visual, narrative, and epistemological pleasure when they engage spectacular effects as one part of a dynamic textual assemblage. This dynamic assemblage endows the digitally enhanced long fall with the affect and allegorical significance linked to the protagonists' resistance against or acquiescence to powerful historical forces; it ties the appearance of the multitude to occulted pasts, the arrival of apocalypse, and the demand for collective action; it links the fearsome, figural vitality of digital creatures (and the feelings of dread, anxiety, and possibility they provoke) to

the technological mediation of life and death; and it makes metamorphic transformation inseparable from the expression of a Protean desire both for freedom from confinement and to know the past and exercise control over the future.

Rather than disrupt or arrest narrative, and rather than function in a mode of discontinuity, the spectacular visual effects discussed in this book rely heavily on dialogue, narrative, and characterization in order to function emblematically in the films in which they appear. The dialogue that brackets, precedes, or follows the display of a spectacular visual effect often foregrounds the meaning attached to an effect, to reveal or unveil its significance; in turn, the spectacular effect charges such dialogue with further significance, affect, and dramatic effect. Thus the speeches delivered in *The Two Towers* by Saruman and King Theoden, respectively, define the creation and impending arrival of the massive Uruk-hai army in spatio-temporal terms, so that its composition within the frame comes to represent the end of one historical era and the beginning of another. In *X-Men* Magneto's declaration from the top of the Statue of Liberty that "there is no land of tolerance, there is no peace — not here or anywhere else" asks us to understand the mutant plasmaticness and metamorphosis on display in the ensuing fight as expressions of a desire for, and struggle over, such freedom and, with it, protean possibility. While these examples feature heightened rhetoric and overblown language, in other instances dialogue is delivered in a more naturalistic mode. In *Crouching Tiger, Hidden Dragon*, for example, the conversations between Jen and Shu Lien that bookend their vertically oriented fight — in which Jen confesses she would rather live the liberated life of a warrior than become a wife in a noble family — frame her stunning upward mobility as a rebellion against filial piety and tradition. In other films such dialogue is organized in the question-and-answer format often found in emblem books (such as Alciati's Proteus emblem). The emblematic scene in *I, Robot* in which Dr. Calvin commands a large group of NS-5s to identify the "robot in this formation that does not belong" and is answered by the robots with the univocal reply "One of us" may be a more concise example, but it is nevertheless conceptually rich in its expression of the idea of a multiplicity that functions as one.

Like the attractions to which they have often been compared, and like emblem books, digital effects emblems directly (and sometimes aggressively) solicit the look of the spectator with an image that is fascinat-

ing, fantastical, terrifying, or astonishing. This solicitation takes place not only at the level of the film image but also in the promotional materials (trailers, teasers, etc.) that surround a particular film and the cutting-edge visual effects it promises to deliver. As Stephen Prince argues, digital effects often "beckon audiences in a beguiling fashion, promising to raise the curtain on domains of the imagination."[4] In the process of attempting to fulfill this promise, films that trade on their spectacular visual effects court artificiality: spectacular visual effects are the outcome of the on-going efforts to create groundbreaking, awe-inspiring images with the help of old and new practices and technologies. The pursuit of this goal is inseparable from the demand to make such effects seamless, so that the fantastical and fascinating does not lapse into the inadvertently arti-ficial and "fake"—into an obviously constructed image that foregrounds its own technological origins. This mandates the seamless compositing of the heterogeneous elements that make up an effects sequence, so that the ontological differences between digital and live-action elements and computer-generated and analog visual effects are imperceptible. Much as effects emblems court artificiality in their pursuit of awe-inspiring, innovative visual effects, they also do so in their pursuit of allegorical sig-nificance and meaning. In the process they risk pulling the spectator out of the fictional world of a film by revealing their discursive construction. The challenge taken up by the digital effects emblem goes beyond the successful synthesis of its heterogeneous elements (live action footage, analog effects, and CGI) and their credible integration within the die-gesis: as an allegorical image, the effects emblem must be integrated at a discursive or thematic level with story, narrative, character, and dialogue so that it resonates strongly with, and seems inseparable from, the con-ceits at stake in the development of each. The effects emblem's visually spectacular, affectively charged expression of a film's thematic obsessions, anxieties, and fantasies is the outcome of mutual construction and in-flection: while narrative, dialogue, and character reveal the (conceptual) stakes of a visual effects shot or sequence and charge it with meaning, effects emblems convert such imaginative ideas into highly charged and awe-inspiring spectacles.

Importantly, part of the affective response provoked by visual effects (which includes delight, dread, fascination, and fear) has much to do with the link between visual effects and the development of character psy-chology. Some of the effects I have analyzed in this book are the out-

ward expression of a character's internal psychological or emotional state. For example, Bruce Banner's digital metamorphosis into the Hulk and Dr. Jekyll's optical effects transformation into Hyde are both spectacular, outward expressions of internal psychological states — the first of long-repressed rage linked to violent family trauma, and the second of repressed sexual desire. Indeed, the eponymous titles of *Hulk* and *Dr. Jekyll and Mr. Hyde* ask us to read their transformation scenes as inseparable from the development and display of their title characters' psychological development. Similarly, the mastery of the laws of physics and the gravity-defying verticality of Neo in *The Matrix* and Jake Sully in *Avatar* are inseparable from the new ontological heights reached by their characters as they become "the One" and "Toruk Makto," respectively, while Rose's downward mobility in *Titanic* facilitates her transformation into a New Woman.

Although spectacular visual effects have been overly associated with blockbuster films — in particular, science fiction films, super hero adaptations, and action thrillers — recently they have been used to create fascinating effects emblems in independent films. These films use their effects emblems in a less schematic fashion than do blockbuster films and do not fit neatly into any of this book's individual chapters; nevertheless, some of these films focus on themes central to many of the films I discuss here (particularly apocalypse) and feature spectacular effects emblems that function allegorically to represent themes, anxieties, and concepts central to their narratives. For example, Terence Malick's *Tree of Life* (2011) uses digital and optical visual effects to depict a range of natural phenomena (dinosaurs, galaxies, etc.) that allegorize Birth, Death, Grace, and Nature on epic and cosmic levels. *Take Shelter* (Jeff Nichols, 2011) uses visual effects to create nightmare images of apocalyptic storms that at first seem to be the product of the protagonist's mental illness but are ultimately revealed to be signs of the coming apocalypse.

Lars von Trier's *Melancholia* (2011) provides the most salient example of effects emblems in independent films, and it opens up the study of effects emblems beyond those that appear in blockbuster films. The film begins with a series of sixteen haunting, single-shot, digitally composited images consisting (variously) of live-action elements, computer-generated images, and optical and digital visual effects. The live-action elements of five of these shots were filmed with a high-speed Phantom camera that dilates time and distills a brief moment of action into extreme

slow motion. The near stillness of these images (which, according to the film's cinematographer, Manuel Alberto Claro, were conceived of as "intricate paintings" marked by "a sense of artifice and unreality" as found in paintings of the Renaissance era[5]) brings them closer to the engravings and illustrations of emblem books. And though they appear, mosaic-like, as a series of seemingly discontinuous images, the prologue's shots reference and foreshadow upcoming scenes in the film and therefore function like the overture to Wagner's *Tristan and Isolde* that accompanies them on the soundtrack: they introduce the film's major themes and concepts, as well as its overall structure, which is organized around the approach, flyby, and return of the rogue planet Melancholia, and, finally, its collision with Earth. These images ask to be read not just as allegories of the coming apocalypse they represent but also as emblems of the protagonists' internal psychological states and their relationship to the fateful narrative end from which, the prologue makes clear, no one will be spared. As Steven Shaviro notes, *Melancholia* is Lars von Trier's "intimate notebook on depression and his metaphysical speculation on last things."[6]

The prologue opens with a look: the camera fades in to an arresting close-up of Justine (Kirsten Dunst); her eyes are closed and her skin has a gray, almost deathly pallor. She slowly opens her eyes and, with an expression of deadened despair, stares directly ahead, unblinking, as birds begin to drop from the sky in slow motion and tumble, head-over-tail, through the frame (fig. Conc.1). Like the act of pulling back a curtain, this look suddenly reveals (in advance of the narrative proper) that which Justine "sees" — apocalypse — and in the process identifies the origins of her own melancholia. The vertical movement of the birds as they succumb to gravity references the inexorable laws of (astro)physics that will set two celestial bodies — Melancholia and Earth — on a collision course with one another. This emblematic shot introduces the protagonist's dilemma: she cannot live or move into the future because of the end that she sees and knows is on the way; this end does not herald the beginning of a new era or some unknown future or afterlife, but instead announces the horrifying advent of "Nothing." By the end of the prologue the audience occupies a similar position of having foreseen and therefore knowing the end, and suspects that the film will not end with a resolution of narrative conflicts, but with an abrupt, violent interruption of all life by inescapable death.

This opening emblematic image invokes, from the start, a favorite

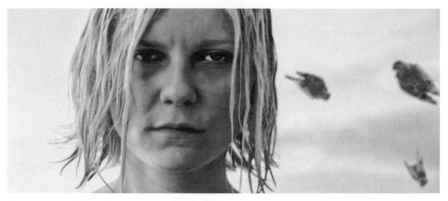

Figure Conc.1 Falling birds are an emblem of the apocalypse in *Melancholia* (Zentropa Entertainment, 2011).

topic of many early emblem books, which were profoundly concerned with temporality, the ephemerality of life on earth, and the fact that, as one emblem book explained by way of conclusion, "Time brings all things to an end."[7] *Melancholia* confirms its own concern with the end of all things in the prologue's second effects emblem—a strangely lit daytime shot of the landscape in front of the resort that serves as the film's only setting. The bushes that line the perfectly manicured lawn and the sundial that occupies the foreground of the frame cast shadows in two different directions—one to the right, the other to the left, so that the sundial reads two different times simultaneously—as pools of light coming from two separate, unseen sources reflect off the surface of the sea in the background. Midfield, the tiny image of a woman playfully spinning and swinging a child around by the arms creates two sets of shadows that rhyme with the sundial's and spin (clockwise) like hands of a timepiece (fig. Conc.2). Even before it is visible in the frame, Melancholia imposes itself on the depicted landscape to suggest the end of time: the end of the cyclical temporality of nature, the end of night and day, and the end of the rationalized time of scientific thought and modern industry. These opening shots are effects emblems—allegorical images that introduce the film's profound concern with the collapse of human, Earth-bound time into the empty timelessness of the void. The sundial, the surplus shadows and light sources, and the spinning figures all announce the beginning of *Melancholia*'s narrative countdown to this inexorable end. If we fail to comprehend this shot as an emblem of apocalypse, the allegorical significance of a later shot in the prologue, which displays the image of a

Figure Conc.2 Double sets of shadows indicate the planet Melancholia's presence, and its undoing of time on Earth, before it is seen in the prologue of *Melancholia* (Zentropa Entertainment, 2011).

burning bush through the frame of a window in Claire's (Charlotte Gainsbourg) study, suggests that the unraveling we are about to witness takes place on a cosmic, biblical scale. Another shot of Justine floating down a river in her wedding dress evokes *Hamlet*'s Ophelia (and, as Shaviro notes, also references John Everett Millais's painting, *Ophelia* [1851–52][8]) to foreshadow Justine's declining mental health and to frame her wedding, in advance, as a tragic failure and as a love story that will end with the deaths of everyone involved.

Throughout the prologue, images of the film's protagonists (Justine, Claire, and Leo [Cameron Spurr]) are intercut with images of Melancholia as it moves through space—past, toward, and, finally, into Earth. Though the images that evoke later scenes and bits of dialogue from the body of the film are not arranged so they correspond to the unfolding of the plot (and in this respect can be compared to the mosaic structure of emblem books), the computer-generated shots of Melancholia's "Dance of Death" with Earth unfold chronologically. First, we see Melancholia as a small, red celestial body that moves swiftly toward and then disappears behind Earth. The next shot of the planet shows Melancholia as it passes by Earth, referencing the flyby that creates the incredible spectacle of the massive planet rising over the horizon in the second half of the film. The next time the planet appears on-screen, we see it approach and move partially behind Earth (a shot that Manohla Dargis describes as an image of the planets "kissing"[9]). Finally, the prologue's concluding effects emblem displays the stunning computer-generated image of Melancholia colliding with, shat-

tering, and swallowing up Earth. The planet is presented through a series of images that charts its changing relationship with Earth: first, an introduction, then a dance, then a kiss, and, finally, an apocalyptic consummation (to extend Dargis's metaphor). Put differently, this series of emblematic images allegorizes the cosmic (catastrophic) wedding of two worlds that is the film's true subject. Importantly, these prologue shots also follow the planet's shifting status as different *types* of spectacle for the protagonists as the narrative unfolds. Melancholia first appears as a small, red light in the sky, a harmless curiosity that John (Kiefer Sutherland) mistakenly identifies as the star Antares. During its flyby phase, it progresses from a curiosity to an astonishing, sublime spectacle as it rises over the nighttime horizon and then moves away, only to return, once again, as a sign of inevitable death. In the final two shots of the film, as in the final shot of the prologue, Melancholia enacts apocalypse and, with it, the end of representation: once it hits Earth, the screen cuts to black. These images, and their chronological organization in the prologue, not only reveal the narrative structure of the film but also frame the ensuing action and dialogue as the inception of the end of everything, rather than the beginning of a marriage and the initiation of the romantic couple's narrative future. *Melancholia's* prologue confirms Benjamin's argument that "Allegory establishe[s] itself most permanently where transitoriness and eternity [confront] each other most closely."[10] Indeed, the prologue offers emblematic representations of later moments in the film that are linked to the protagonists' confrontation of the fact that not only is life on Earth ephemeral but all life is about to disappear into eternal and infinite Nothing.

Though presented in a photorealistic (or "Hubble-esque") style, these effects shots of the rogue planet, along with the prologue's more artificial, stylized images, participate in the film's (expressionistic) dissolution of the line that separates the internal self and the external world, psyche and cosmos, as they confirm from the outset that Justine's crippling despair is inseparable from her knowledge of the future that hurtles, unstoppable, toward the present (she insists to Claire that she "know[s] things"—including the fact that "life is only on Earth, and not for very long"). Like many of the other effects emblems discussed in this book, several of the shots in the prologue externalize the internal emotional and psychological states described or experienced by the protagonists in later scenes and are, therefore, inseparable from the development of character. A shot of Claire trudging across the golf course with Leo in her

Figure Conc.3 Claire carries Leo across the golf course in extreme slow motion in the prologue of *Melancholia* (Zentropa Entertainment, 2011). Her sinking legs externalize and emblematize her exhaustion and desperation as Melancholia draws near.

Figure Conc.4 Justine walks across the lawn in her wedding dress, burdened by the heavy yarn around her legs (a sensation she describes later in the film) in the prologue of *Melancholia* (Zentropa Entertainment, 2011).

arms as her legs sink through the ground up to her knees represents her exhausting, breathless, and futile struggle against Melancholia as it depletes the oxygen in Earth's atmosphere and undermines her attempts to save her son (fig. Conc.3). A shot of Justine walking across the resort's lawn in extreme slow motion as thick tendrils of tangled gray rope hang from the trees in the background, wrap around her ankles and torso, and drag behind her like a grim train for her wedding dress (fig. Conc.4) emblematizes the burdensome feeling of despair she describes to Claire as her wedding begins to fall apart: lying exhausted on Leo's bed, Justine mutters, "I'm trudging through this gray, wooly yarn. It's pulling into my legs. It's really heavy to drag along." Though the first part of the film sets

Figure Conc.5 Electricity streams upward from Justine's fingers as Melancholia approaches Earth in the prologue of *Melancholia* (Zentropa Entertainment, 2011).

up Justine's future (via her marriage, her promotion, and the plot of land purchased for her by her husband), fear of the apocalyptic Nothing she sees and knows is on the way impedes her progress into this life. The shot of the rope-bound Justine in her wedding dress contrasts with the one that immediately precedes it, which shows her raising her hands above her shoulders as she gazes with wonder at the blue electrical charges that stream upward from her fingertips as Melancholia's approach alters Earth's atmosphere and draws all of Earth's energy and oxygen up to itself (fig. Conc.5). (We never see this actual shot at the end of the film, but we do see a shot of the electrical charges spiking up from telephone poles that appear behind her.) The look of fascination with which Justine regards this sign of apocalypse corresponds to the disappearance of her crippling despair as the planet draws closer toward the end of the film. In fact, the trajectory of her depression follows the planet's movements. When Melancholia is just a worrisome red light in the sky, Justine is anxious and afraid; later, when Melancholia disappears and "hides" behind the sun, she is crippled by a depression so overwhelming that she cannot eat, bathe, or get out of bed; once Melancholia reappears and signs of the end it portends begin to materialize (snow flurries in summer; birds singing at night; swarms of beetles, moths, and worms seeping up from the ground), Justine is able to live again as certainty of what will be converts anxiety and dread to cold, bitter acceptance.

These spectacular images are effects emblems (the product of new as well as very old effects techniques and technologies)—fascinating images that are iconic enough to suggest allegorical meanings even be-

fore such meanings are borne out and elaborated in dialogue or action later on in the narrative. However discontinuous they appear within the prologue, they are ultimately integrated into the narrative as it unfolds, as the images are invoked by later shots that repeat, in a less stylized and overtly allegorical form, the action seen in the prologue or as a bit of dialogue describes one of the striking (even unforgettable) images that open the film. By echoing the enigmatic images seen in the prologue, such moments bring us back to it and encourage us to read the film in its entirety as part of a dynamic emblematic assemblage.

Melancholia's focus on and allegorical representation of the absolute finality of "the End" bears resemblance to the emblem book's tendency to focus on the inevitability of death and to orchestrate its cautionary tales around reminders of the ephemerality of life and the transitory nature of the material world. As John Manning explains, "The form and structure of many emblem books are dictated by a chiliastic horror, and their attitudes are shaped by an acute *post mortem* consciousness."[11] Some emblem books used the planets and zodiacal signs to chart human life from the moment of conception to death, while others used celestial bodies to illustrate the history of the world from beginning to end.[12] Whether they focus on the individual or humanity in its entirety, the emphasis, Manning explains, "falls inevitably on the concluding emblems, where the whole plot reaches its spectacular conclusion, where old things are swept away to be replaced with a new heaven and a new earth."[13]

Just as emblem books focused on the variety of ends met by individuals of different ages and moral stature, *Melancholia* focuses on its characters' anticipation of and preparation for the End. In contrast to Justine, Claire clings to the rituals that structure and give meaning to life (and death), and when it becomes clear that Melancholia will hit Earth, she tries to flee with Leo to town, as if embedding herself in a larger social formation will somehow shield them both from Melancholia's destruction.[14] When her plan fails, she declares, "I want to do this the right way" and begs Justine to join her and Leo on the terrace so that they can have a glass of wine as the world ends. Justine cruelly rejects this suggestion and turns her attention to building a magic cave for Leo—the necessary, innocent fiction (or disavowal) he requires to endure this End. The penultimate shot of the film's emblematic prologue refers to this fiction, showing Leo whittling a tree branch for the magic cave he and Justine build at the end of the film, as Justine emerges from the woods behind him. Leo looks

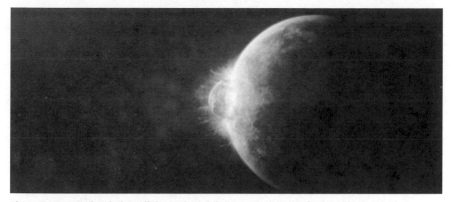

Figure Conc.6 Melancholia collides with and destroys Earth in the final emblematic image of the prologue of *Melancholia* (Zentropa Entertainment, 2011).

up at the sky, and an edit creates the illusion of a cosmic eye-line match as the shot cuts to outer space to show Melancholia's violent collision with, and annihilation of, Earth (fig. Conc.6). The prologue's concluding shot makes clear the difference between the representation of death and apocalypse in these emblematic shots and those found in emblem books: while the latter tended to insist that death and Armageddon ultimately give way to an eternal afterlife (in heaven or hell), the former insist that there is no "after" once life ends. *Melancholia* therefore encourages spectators to read the characters and actions represented in the film allegorically, as examples of the various ways one lives, or fails to live, with the knowledge of the inevitable arrival of the end and, with it, dissolution into Nothing. The advertising tagline Justine finally offers her boss (who has been requesting one from her throughout her wedding), "Nothing" serves as the perfect epigram for the film's final, emblematic shot of darkness. Each of the prologue's effects emblems is "loaded with narrative resonance" (to borrow a phrase from Geoff King), the underlying meaning of which becomes clearer as the film progresses.[15]

The shots discussed here, as well as many of the effects emblems I have analyzed throughout this book, are composed of a combination of optical effects that filmmakers have used for more than a hundred years and digital effects that are, by comparison, relatively new. In this respect spectacular visual effects (in blockbuster as well as independent films) provide us with examples of how, in Stephen Prince's words, "the digital toolbox furnishes new capabilities and new aesthetics while maintaining continuity with the past,"[16] not only in terms of the technologies and practices

that allow spectacular effects to be realized on-screen but also in terms of their modes of signification, their narrative integration, and their address to audiences. In *Spectacular Digital Effects* I appropriate the highly fungible and centuries-old form of the emblem in order to propose a method for the critical analysis of a particular type of spectacular visual effect in narrative cinema. Throughout, I demonstrate how effects emblems join astonishing, attention-seeking images to dialogue and story, often working with mise-en-scène, setting, and montage, in order to give spectacular, allegorical expression to the themes, concepts, conflicts, and conceits that are stake in a film and drive its narrative forward. The spectacular images of effects emblems are often fantastic enough, and the concepts they elaborate are often broad enough (e.g., freedom vs. confinement, resistance against tradition), to allow them (and the films in which they appear) to address and accommodate the diverse and at times conflicting anxieties, desires, and interpretations of global audiences. The digital technologies that have made possible the seamless compositing of analog and digital visual effects—and both of these with the body of a film— have expanded the domain of spectacular effects sequences in narrative cinema, enabling them to appear on-screen with increasing frequency and duration. As a result, these technologies make newly visible the allegorical work accomplished by spectacular visual effects throughout narrative film history in films such as *The Birds*, *Dr. Jekyll and Mr. Hyde*, and *The Thing*. Spectacular digital effects emblems and the various (analog and digital) technologies used to create them are less harbingers of the death of cinema than they are the artifacts of the cinema's ongoing engagement with new technologies and other media as it moves through its most recent—and perhaps most fascinating—transitional era.

NOTES

INTRODUCTION

1. John Belton disputes the comparison between this most recent era of technological change and the shift to recorded synchronous sound in "Digital Cinema: A False Revolution," *The Film Theory Reader: Debates and Arguments*, ed. Marc Furstenau, 282–93 (London: Routledge, 2010).

2. On convergences between old and new media as well as different forms of popular entertainment, see Henry Jenkins, *Convergence Culture: Where Old and New Media Collide* (New York: New York University Press, 2008); Angela Ndalianis, *Neobaroque Aesthetics and Contemporary Entertainment* (Cambridge, MA: MIT Press, 2005); and Chuck Tryon, *Reinventing Cinema: Movies in the Age of Media Convergence* (New Brunswick, NJ: Rutgers University Press, 2009).

3. David Thorburn and Henry Jenkins, "Introduction: Towards an Aesthetics of Transition," *Rethinking Media Change: The Aesthetics of Transition*, ed. David Thorburn and Henry Jenkins, 1–16 (Cambridge, MA: MIT Press, 2004).

4. Rehearsing this debate is beyond the scope of this project; however, Philip Rosen, Tom Gunning, and Stephen Prince have each convincingly and elegantly shown how arguments linking indexicality to an essential identity for cinema are flawed. See Philip Rosen, *Change Mummified: Cinema, Historicity, Theory* (Minneapolis: University of Minnesota Press, 2001); Tom Gunning, "What's the Point of an Index? Or, Faking Photographs," *Still/Moving: Between Cinema and Photography*, ed. Karen Beckmann and Jean Ma, 23–40 (Durham, NC: Duke University Press, 2008), and "Moving Away from the Index: Cinema and the Impression of Reality," *differences* 18.1 (2007): 29–52; and Stephen Prince, *Digital Visual Effects in Cinema: The Seduction of Reality* (New Brunswick, NJ: Rutgers University Press, 2012).

5. Lev Manovich, *The Language of New Media* (Cambridge, MA: MIT Press, 2002), 295.

6. Prince, *Digital Visual Effects*, 4–5.

7. See especially D. N. Rodowick, *The Virtual Life of Film* (Cambridge, MA: Harvard University Press, 2007).

8. On motion capture processes, see especially Tom Gunning, "Gollum and Golem:

Special Effects and the Technology of Artificial Bodies," *From Hobbits to Hollywood: Essays on Peter Jackson's "Lord of the Rings,"* ed. Ernest Mathijs and Murray Pomerance, 319–49 (Amsterdam: Rodopi, 2006); Dan North, *Performing Illusions: Cinema, Special Effects, and the Virtual Actor* (London: Wallflower, 2008); Lisa Bode, "No Longer Themselves? Framing Digitally Enabled Posthumous 'Performance,'" *Cinema Journal* 49.4 (summer 2010): 46–70; and Scott Balcerzak, "Andy Serkis as Actor, Body and Gorilla: Motion Capture and the Presence of Performance," *Cinephilia in the Age of Digital Reproduction: Film, Pleasure and Digital Culture*, ed. Scott Balcerzak and Jason Sperb, 195–213 (London: Wallflower, 2009).

9. See Stephen Prince, "The Emergence of Filmic Artifacts: Cinema and Cinematography in the Digital Era," *Film Quarterly* 57.3 (2004): 24–33. In the parallax effect, as the digital camera "moves" through space, objects in the foreground must appear to move more quickly than objects in the background of a shot.

10. On big-budget spectacle in Hollywood cinema, see Sheldon Hall and Steve Neale, *Epics, Spectacles and Blockbusters: A Hollywood History* (Detroit: Wayne State University Press, 2010); and Geoff King, *New Hollywood Cinema: An Introduction* (New York: Columbia University Press, 2002).

11. Exceptions include Christian Metz, "*Trucage* and the Film," *Critical Inquiry* 3.4 (summer 1977): 657–75; and Albert J. La Valley, "Traditions of Trickery: Special Effects in Science Fiction Film," *Shadows of the Magic Lamp*, ed. George Slusser and Eric S. Rabkin, 141–58 (Carbondale: Southern Illinois University Press, 1985).

12. Scott Bukatman, *Matters of Gravity: Special Effects and Supermen in the 20th Century* (Durham, NC: Duke University Press, 2003), 111–30; and Ndalianis, *Neo-baroque Aesthetics*.

13. Michele Pierson, *Special Effects: Still in Search of Wonder* (New York: Columbia University Press, 2002).

14. Vivian Sobchack, "'At the Still Point of the Turning World': Meta-morphing and Meta-stasis," *Meta-morphing: Visual Transformation and the Culture of Quick Change*, ed. Vivian Sobchack, 130–58 (Minneapolis: University of Minnesota Press, 2000); Bob Rehak, "The Migration of Forms: Bullet Time as Microgenre," *Film Criticism* 32.1 (fall 2007): 26–48; North, *Performing Illusions*.

15. Prince, *Digital Visual Effects*, 9.

16. Kevin S. Sandler and Gaylyn Studlar, *Titanic: Anatomy of a Blockbuster* (New Brunswick, NJ: Rutgers University Press, 1999); Ernest Mathijs and Murray Pomerance, eds., *From Hobbits to Hollywood: Essays on Peter Jackson's "Lord of the Rings"* (Amsterdam: Rodopi, 2006).

17. On the affective intensities provoked by science fiction special effects, see Vivian Sobchack, *Screening Space: The American Science Fiction Film* (New Brunswick, NJ: Rutgers University Press, 1997). On fans' responses to special and digital visual effects and the feelings of wonder and astonishment they provoke, see Pierson, *Special Effects*. On the sublime and special effects, see Scott Bukatman's excellent *Matters of Gravity*.

18. Sobchack, *Screening Space*; Bukatman, *Matters of Gravity*; Pierson, *Special Effects*, respectively.

19. For an extended discussion of the relationship between spectacle and narrative in

post-classical cinema, see Geoff King, *Spectacular Narratives: Hollywood in the Age of the Blockbuster* (New York: I. B. Tauris, 2000); and Prince, *Digital Visual Effects*.

20. Tom Gunning, "The Cinema of Attractions: Early Film, Its Spectator, and the Avant-Garde, *Wide Angle* 8.3–4 (fall 1986): 63–70, and "Now You See It, Now You Don't: The Temporality of the Cinema of Attractions," *The Silent Cinema Reader*, ed. Lee Grieveson and Peter Kramer, 41–50 (London: Routledge, 2004).

21. Wanda Strauven, "Introduction to an Attractive Concept," *The Cinema of Attractions Reloaded*, ed. Wanda Strauven (Amsterdam: Amsterdam University Press, 2006), 11. Strauven quotes Gunning's entry on the "Cinema of Attractions" from the *Encyclopedia of Early Cinema* (London: Routledge, 2005), 124.

22. Thomas Elsaesser, "The New Film History as Media Archaeology," *Cinémas: Journal of Film Studies* 14.2–3 (2004): 100.

23. *Oxford English Dictionary* online, http://www.oed.com/ (accessed May 30, 2012).

24. John Manning, *The Emblem* (London: Reaktion Books, 2003), 47.

25. Quote from *Oxford English Dictionary* online.

26. Manning, *The Emblem*, 26, 55.

27. Manning, *The Emblem*, 26.

28. Manning, *The Emblem*, 115, 150–52, 275–85.

29. Manning, *The Emblem*, 85–86.

30. Sir Francis Bacon, *The Works of Francis Bacon, Lord Chancellor of England: A New Edition*, vol. 2, ed. Basil Montagu (London: William Pickering, 1825), 196.

31. Manning, *The Emblem*, 220–38.

32. John F. Moffitt, introduction to Andrea Alciati, *A Book of Emblems: The "Emblematum Liber" in Latin and English*, trans. and ed. John F. Moffitt (Jefferson: McFarland, 2002), 10. Moffitt notes that the woodcuts are by the artist Jörg Breu (13).

33. For a twentieth-century example of an emblem book, see Ian Hamilton Finlay and Ron Costley, *Heroic Emblems* (Calais and Vermont: Z Press, 1977). For discussions of emblems in cinema, see Karen Pinkus, "Emblematic Time," *New Directions in Emblem Studies*, ed. Amy Wygant, 93–108 (Glasgow: Glasgow Emblem Studies, 1999); M. E. Warlick, "Art, Allegory and Alchemy in Peter Greenaway's *Prospero's Books*," *New Directions in Emblem Studies*, ed. Amy Wygant, 109–36 (Glasgow: Glasgow Emblem Studies, 1999); Tom Gunning, *The Films of Fritz Lang: Allegories of Vision and Modernity* (London: BFI, 2008); and Miriam Hansen, *Babel and Babylon: Spectatorship in American Silent Film* (Cambridge, MA: Harvard University Press, 1994).

34. Andrea Alciati, *Emblematum Liber* (Leyden: Ex Officina Plantiniana Raphelengii, 1608), 109.

35. Andrea Alciati, *A Book of Emblems: The "Emblematum Liber" in Latin and English*, trans. and ed. John F. Moffitt (Jefferson: McFarland, 2002), 124. All quotations from the text of the *Emblematum Liber* are Moffitt's translations.

36. Jacob Cats and Robert Farlie, *Moral Emblems: With Aphorisms, Adages, and Proverbs of All Ages and Nations*, illustrated by John Leighton, ed. and trans. Richard Pigot (London: Longman, Green, Longman and Roberts, 1860), 189.

37. Cats and Farlie, *Moral Emblems*, 189–90.

38. Cats and Farlie, *Moral Emblems*, 189–90.

39. Walter Benjamin, *The Origin of German Tragic Drama*, trans. John Osborne (London: Verso, 2009), 185.

40. Gunning, *The Films of Fritz Lang*, 26–27.

41. Manning argues of the emblem, "This was attention-seeking poetry addressed *to* someone, and demanded or challenged interpretation." Manning, *The Emblem*, 26.

42. Rehak, "The Migration of Forms."

43. Manning, *The Emblem*, 228–32, 239.

44. Sean Cubbitt discusses the blue screen technologies used to create this parallax effect in "Digital Filming and Special Effects," *The New Media Book*, ed. Dan Harries, 17–29 (London: Palgrave Macmillan, 2002).

45. Jean-Pierre Geuens, "The Digital World Picture," *Film Quarterly* 55.4 (summer 2002): 20.

46. I borrow this term, of course, from Jay Bolter and Richard Grusin, who define remediation as the various ways that new forms of media often make use of the representational or presentational modes of older media, as well as the processes by which "older media refashion themselves to answer the challenges of new media." Jay Bolter and Richard Grusin, *Remediation* (Cambridge, MA: MIT Press, 2000), 15.

47. Bukatman, *Matters of Gravity*, 81–110.

48. Sergei Eisenstein, *Eisenstein on Disney*, trans. Alan Y. Upchurch (London: Methuen, 1988), 64, 21.

49. Sobchack, "At the Still Point of the Turning World."

50. Eisenstein, *Eisenstein on Disney*, 64.

51. Hansen, "The Mass Production of the Senses: Classical Cinema as Vernacular Modernism," *Reinventing Film Studies*, ed. Christine Gledhill and Linda Williams (London: Arnold, 2000), 341, 343.

52. Michael Hardt and Antonio Negri, *Multitude: War and Democracy in the Age of Empire* (New York: Penguin, 2005), 12.

53. Hansen, "Mass Production of the Senses," 342.

54. Benjamin, *The Origin of German Tragic Drama*, 178.

55. Andreas Huyssen, "The Urban Miniature and the Feuilleton in Kracauer and Benjamin," *Culture in the Anteroom: The Legacies of Siegfried Kracauer*, ed. Gerd Gemunden and Johannes von Moltke (Ann Arbor: University of Michigan Press, 2012), 219.

56. Huyssen, "The Urban Miniature," 219.

57. Richard Rickett, *Special Effects: History and Technique* (New York: Billboard Books, 2007).

58. The one exception is James Cameron's *Terminator 2: Judgment Day*. The original theatrical release is now available only on VHS and somewhat difficult to access (particularly for students). All of the effects I discuss in relation to *T2* appear in the original version; only dialogue and dream sequences have been added to the "Extreme Edition" that circulates on DVD.

1. THE NEW VERTICALITY

1. Andrea Alciati, *Emblematum Liber* (Leyden: Ex Officina Plantiniana Raphelengii, 1608), 62. Translation of the Latin text taken from Andrea Alciati, *A Book of Em-*

blems: The "Emblematum Liber" in Latin and English, trans. and ed. John F. Moffitt (Jefferson: McFarland, 2002), 75.

2. David Cook, *A History of Narrative Film*, 4th ed. (London: W. W. Norton, 2004), 890–91.

3. For phenomenological analyses of verticality and horizontality, see Gaston Bachelard, *Air and Dreams: An Essay on the Imagination of Movement* (Dallas: Dallas Institute Publications, 2002); and Bernd Jaeger, "Horizontality and Verticality: A Phenomenological Exploration into Lived Space," *Duquesne Studies in Phenomenological Psychology*, vol. 1, 212–35 (Pittsburgh: Duquesne University Press, 1971).

4. On the use of the staircase in melodramas, see Thomas Elsaesser, "Tales of Sound and Fury: Observations on the Family Melodrama," *Home Is Where the Heart Is: Studies in Melodrama and the Woman's Film*, ed. Christine Gledhill, 43–69 (London: BFI, 1987).

5. Constance Balides, "Jurassic Post-Fordism: Tall Tales of Economics in the Theme Park," *Screen* 41.2 (summer 2000): 135.

6. Raymond Williams, *Marxism and Literature* (Oxford: Oxford University Press, 1978).

7. I have in mind here a number of mass-mediated conflicts taking place in the past decade or so — including the Balkan wars of the 1990s; the suppression of student protests and the Tianamen Square uprising in Beijing in 1989; the ongoing conflict between China and Taiwan; the rise of religious fundamentalism throughout the world; the recent unilateralism in U.S. foreign policy and George W. Bush's now notorious declaration in an address to a joint session of Congress, "Either you are with us or you are with the terrorists" (September 20, 2011); the polarization of electoral politics in the United States (red states vs. blue, the Tea Party vs. everyone else, the 99% vs. the 1%); the hyperviolent discourse on terror; and the increasing disparity between wealthy and poor nations and populations, thanks in part to the increasing power of multinational corporations.

8. Film scholars argue that this is a general tendency of the blockbuster. See especially Geoff King, *Spectacular Narratives: Hollywood in the Age of the Blockbuster* (New York: I. B. Tauris, 2000); and Charles Acland, *Screen Traffic: Movies, Multiplexes, and Global Culture* (Durham, NC: Duke University Press, 2003).

9. Two notable works link verticality to historical change and conflict in previous eras: In "Bodies in the Air: The Magic of Science and the Fate of Early 'Martial Arts' Film in China" (*Post Script* 20.2–3 [2000]: 43–60), Zhang Zhen argues that martial arts films of the 1930s used "flying bodies" to express anxiety toward social and cultural changes precipitated by the emergence of technological modernity in China. In *Film Noir and the Spaces of Modernity* (Cambridge, MA: Harvard University Press, 2004), Ed Dimendberg argues that film noir represents the alienating effects of the American city's postwar verticality to express "longing for older horizontal forms and a reminder of the discomforts of the elevated city of capitalist commerce" (96).

10. Cook, *A History of Narrative Film*, 398.

11. *Titanic* made more than $600 million and was the top grossing film of all time until it was surpassed by *Avatar*. *Hero* broke box office records in China and grossed more

than $53 million in the United States. See http://www.boxoffice.com/statistics /alltime_numbers/domestic/data (accessed July 5, 2013); and Nelson H. Wu, "B.O. Goes from Zero to 'Hero,'" *Variety*, January 26, 2003, http://variety.com/2003 /film/news/b-o-goes-from-zero-to-hero-1117879454/ (accessed June 28, 2013).

12. See especially Adrienne Munich and Maura Spiegel, "Heart of the Ocean: Diamonds and Desire in *Titanic*," and Laurie Ouellette, "Ship of Dreams: Cross-Class Romance and the Cultural Fantasy of *Titanic*," both in *Titanic: Anatomy of a Blockbuster*, ed. Kevin S. Sandler and Gaylyn Studlar, 155–68 and 169–88 (New Brunswick, NJ: Rutgers University Press, 1999).

13. Jaeger, "Horizontality and Verticality," 225.

14. See especially Ouellette, "Ship of Dreams."

15. The aesthetic beauty of this film's images of self-sacrifice led most reviewers to describe the film as an homage to pacifism. However, J. Hoberman argues, "*Hero*'s vast imperial sets and symmetrical tumult, its decorative dialectical montage and sanctimonious traditionalism, its glorification of ruthless leadership and self-sacrifice on the altar of national greatness, not to mention the sense that this might somehow stoke the engine of political regeneration, are all redolent of fascinatin' fascism." J. Hoberman, "Man with No Name Tells Story of Heroics, Color Coordination," *Village Voice*, August 23, 2004, http://www.villagevoice.com/2004-08 -17/film/man-with-no-name-tells-a-story-of-heroics-color-coordination/full/ (accessed June 20, 2013).

16. For a discussion of these Confucian principles and their application to Chinese film, see Jenny Kowk Wah Lau, "*Ju Dou*: A Hermeneutical Reading of Cross-Cultural Cinema," *Film Quarterly* 25.2 (winter 1991–92): 2–10.

17. Christina Klein, "*Crouching Tiger, Hidden Dragon*: A Diasporic Reading," *Cinema Journal* 43.4 (summer 2004): 34.

18. Klein, "*Crouching Tiger, Hidden Dragon*," 34.

19. Walter Benjamin, *The Origin of German Tragic Drama*, trans. John Osborne (London: Verso, 2009), 185.

20. Klein, "*Crouching Tiger, Hidden Dragon*," 34.

21. For a discussion of unmarried daughters, female warriors, and their relation to tradition and modernity in Chinese cinema, see especially Chris Berry and Mary Farquhar, *China on Screen: Cinema and Nation* (Cambridge: Cambridge University Press, 2006).

22. Steve Neale, "Melodrama and Tears," *Screen* 27.6 (December 1986): 12.

23. Mikhail Bakhtin, *The Dialogic Imagination: Four Essays*, ed. Michael Holquist, trans. Caryl Emerson and Michael Holquist (Austin: University of Texas Press, 1981), 84.

24. Benjamin, *The Origin of the German Tragic Drama*, 177.

25. See especially Lev Manovich, *The Language of New Media* (Cambridge, MA: MIT Press, 2002); Michele Pierson, *Special Effects: Still in Search of Wonder* (New York: Columbia University Press, 2002); and Philip Rosen, *Change Mummified: Cinema, Historicity, Theory* (Minneapolis: University of Minnesota Press, 2001), 301–50.

26. Michael Allen argues that the impact of digital technologies on celluloid film form

has been "a combination of change and continuity over time." Michael Allen, "The Impact of Digital Technologies on Film Aesthetics," *The New Media Book*, ed. Dan Harries (London: Palgrave Macmillan, 2002), 109.

27. The "Falling Man" photo, which shows a man falling headlong from the North Tower of the World Trade Center, was shot by the Associated Press photographer Richard Drew on September 11, 2001.

2. THE DIGITAL MULTITUDE AS EFFECTS EMBLEM

1. The most helpful of these works include Eric S. Faden, "Crowd Control: Early Cinema, Sound, and Digital Images," *Journal of Film and Video* 53.2–3 (2001): 93–106; Richard Rickitt, *Special Effects: History and Technique* (New York: Billboard Books, 2007); Paul Sammon, "Bug Bytes," *Cinefex*, no. 73 (March 1998): 66–90; and Barbara Robertson, "The Big and the Sméagol," *Computer Graphics World* 27.1 (January 2004): 16–22.

2. Kirsten Moana Thompson moves beyond a consideration of software programs and compositing strategies used to create multitudes in her discussion of how the massive armies in *The Lord of the Rings* correspond to the trilogy's epic grandeur, vertiginous camerawork, and fantastic mise-en-scène. Kirsten Moana Thompson, "Scale, Spectacle, and Movement: MASSIVE Software and Digital Special Effects in *The Lord of the Rings*," *From Hobbits to Hollywood: Essays on Peter Jackson's "Lord of the Rings*," ed. Ernest Mathijs and Murray Pomerance, 283–99 (Amsterdam: Rodopi, 2006).

3. Siegfried Kracauer, *The Mass Ornament: Weimar Essays*, trans. Thomas Y. Levin (Cambridge, MA: Harvard University Press, 1995), 79–98. On crowds and multitudes in political theory, see Michael Hardt and Antonio Negri, *Multitude: War and Democracy in the Age of Empire* (New York: Penguin, 2005). On sociological theories of the crowd, see Gustave Le Bon, *The Crowd: A Study of the Popular Mind* (Mineola, NY: Dover, 2002; repr. ed.).

4. Frank Tomasulo, "The Mass Psychology of Fascist Cinema: Leni Riefenstahl's *Triumph of the Will*," *Documenting the Documentary: Close Readings of Documentary Film and Video*, ed. Barry Keith Grant and Jeannette Sloniowski (Detroit: Wayne State University Press, 1998), 102.

5. On the new horizontal composition of groups and crowds in widescreen films, see John Belton, *Widescreen Cinema* (Cambridge, MA: Harvard University Press, 1992), 183–210.

6. The sodium vapor process allows filmmakers to combine actors and background footage. It is a photochemical process in which actors are filmed against a white screen lit by sodium vapor lights. This footage is combined with background footage in an optical printer using mattes and counter-mattes.

7. Sir Francis Bacon, *The Works of Francis Bacon, Lord Chancellor of England: A New Edition*, vol. 2, ed. Basil Montagu (London: William Pickering, 1825), 196. John Manning discusses the use of binary opposites in emblem books in *The Emblem* (London: Reaktion Books, 2003), 228–32, 239, 301–2.

8. Jacob Cats and Robert Farlie, *Moral Emblems: With Aphorisms, Adages, and Proverbs*

of All Ages and Nations, illustrated by John Leighton, ed. and trans. Richard Pigot (London: Longman, Green, Longman and Roberts, 1860), 189.

9. *Oxford English Dictionary* online, http://www.oed.com/ (accessed May 20, 2009).

10. *Oxford English Dictionary* online.

11. Elias Canetti, *Crowds and Power* (Farrar, Straus and Giroux, 1984), 16.

12. Canetti, *Crowds and Power*, 16–17.

13. Canetti, *Crowds and Power*, 46.

14. Jeffrey T. Schnapp, "Mob Porn," *Crowds*, ed. Jeffrey T. Schnapp and Matthew Tiews (Stanford: Stanford University Press, 2006), 5.

15. *Oxford English Dictionary* online.

16. Walter Benjamin, *The Origin of German Tragic Drama*, trans. John Osborne (London: Verso, 2009), 185.

17. Eugene Thacker, "Networks, Swarms, Multitudes: Part Two," *CTheory*, a142b, May 18, 2004, http://www.ctheory.net/articles.aspx?id=423 (accessed May 29, 2009).

18. Canetti, *Crowds and Power*, 18.

19. Canetti, *Crowds and Power*, 20.

20. Hardt and Negri, *Multitude*, 138.

21. Hardt and Negri, *Multitude*, 138–39.

22. Kracauer, *The Mass Ornament*, 76, emphasis in original.

23. Quoted in Rickitt, *Special Effects*, 216.

24. Canetti, *Crowds and Power*, 18.

25. Aside from the ontological difference between computer-generated images and historical subjects, its antipathy to individuation and difference, as well as its subordination to a ruling figure, distinguishes the digital multitude from the "biopolitical multitude" discussed by Hardt and Negri, which, they argue, preserves all differences, and "cannot be reduced to a unity and does not submit to the rule of one." Hardt and Negri, *Multitude*, 330.

26. For an analysis of the racial and gender politics of these oppositions, see Michael Rogin, *Independence Day, or How I Learned to Stop Worrying and Love the Enola Gay* (London: BFI, 1998).

27. This shot is made up of thirty-two different exposures and a matte painting by Albert Whitlock. Frederick S. Clarke describes the different components of the shot as follows: "Approximately a third of the birds in the shot were dummies, mostly used in the background and on the barn roof for atmospheric purposes. A few were chickens and ducks which had been purchased from a local slaughterhouse, and dyed to mask their natural color. The foreground was shot in three panel sections; the few live sea gulls available were shot and re-shot for each piece. Just above the heads of the crows was a long, slender middle section with more of the same gulls spread apart. The car going down the driveway, with the birds on each side of it, was another piece of film, as was the barn, and so on." Frederick S. Clarke, "The Making of *The Birds*," *Cinefantastique* 10.2 (1980): 14–35.

28. Angela Ndalianis, *Neo-baroque Aesthetics and Contemporary Entertainment* (Cambridge, MA: MIT Press, 2005), 152.

29. Bainard Cowan, "Walter Benjamin's Theory of Allegory," *New German Critique* 22 (winter 1981): 110.

30. See, for example, Howard Rheingold, *Smart Mobs: The Next Social Revolution* (New York: Basic Books, 2002); and Hardt and Negri, *Multitude*.

31. Bukatman, "The Artificial Infinite: On Special Effects and the Sublime," *Visual Display: Culture beyond Appearances*, ed. Lynne Cooke and Peter Wollen (Seattle: Bay Press, 1995), 255.

32. See, for example, Andrew Pollack, "Computer Images Stake Out New Territory," *New York Times*, July 23, 1991 (Arts section); Peter Hartlaub, "Film Review: *The Day the Earth Stood Still*," *San Francisco Chronicle*, December 12, 2008 (Entertainment section); Stephen Prince, "The Emergence of Filmic Artifacts: Cinema and Cinematography in the Digital Era," *Film Quarterly* 57.3 (2004): 24–33; Wheeler Winston Dixon, "Twenty-Five Reasons Why It's All Over," *The End of Cinema As We Know It: American Film in the Nineties*, ed. Jon Lewis, 356–66 (New York: New York University Press, 2001). For an analysis of such arguments as they relate to spectacle and narrative, see Scott McQuire, "Impact Aesthetics: Back to the Future in Digital Cinema? Millennial Fantasies," *Convergence* 6.2 (2000): 41–61. For an analysis of the status of film and film studies in an era of digital platforms and new media, see D. N. Rodowick, *The Virtual Life of Film* (Cambridge, MA: Harvard University Press, 2007).

33. David Edgerton, *The Shock of the Old: Technology and Global History since 1900* (London: Oxford University Press, 2007).

34. Anton Kaes, "Movies and Masses," *Crowds*, ed. Jeffrey T. Schnapp and Matthew Tiews (Stanford: Stanford University Press, 2006), 156–57.

3. VITAL FIGURES

1. Given animation's historical imperative to produce *lifelike* creatures, I set aside terms such as "real" and "realistic" used so often in scholarly discussions of digital creatures, in which there is often slippage between generic and aesthetic modes of realism and more quotidian notions of "reality" and "realness."

2. *Oxford English Dictionary* online, http://www.oed.com/ (accessed January 2010).

3. *Oxford English Dictionary* online.

4. Tom Gunning discusses Vaucanson's duck and other artificial creatures in "Gollum and Golem: Special Effects and the Technology of Artificial Bodies," *From Hobbits to Hollywood: Essays on Peter Jackson's "Lord of the Rings,"* ed. Ernest Mathijs and Murray Pomerance, 319–49 (Amsterdam: Rodopi, 2006).

5. Jessica Riskin, "The Defecating Duck, or, The Ambiguous Origins of Artificial Life," *Critical Inquiry* 29.4 (summer 2003): 613.

6. Riskin, "The Defecating Duck," 613.

7. Riskin, "The Defecating Duck," 633.

8. Riskin, "The Defecating Duck," 631.

9. Eugene Thacker, *Biomedia* (Minneapolis: University of Minnesota Press, 2004), 5.

10. Thacker, *Biomedia*, 6.

11. Thacker, *Biomedia*, 6.

12. Gunning, "Gollum and Golem," 344.

13. On the dinosaurs' design, see Jody Duncan, "The Beauty in the Beasts," *Cinefex*, no. 55 (August 1993): 63.

14. Stephen Prince, "True Lies: Perceptual Realism, Digital Images, and Film Theory," *Film Quarterly* 49.3 (spring 1996): 29.

15. Sergei Eisenstein, *Eisenstein on Disney*, trans. Alan Y. Upchurch (London: Methuen, 1988).

16. *Oxford English Dictionary* online, http://www.oed.com/ s.v. "vital" (accessed January 2010).

17. See Mary Ann Doane, *Femmes Fatales: Feminism, Film Theory, Psychoanalysis* (London: Routledge, 1991), 214.

18. Barbara Creed, "The Cyberstar: Digital Pleasures and the End of the Unconscious," *Screen* 41.1 (2000): 85.

19. See, for example, Scott Balcerzak, "Andy Serkis as Actor, Body and Gorilla: Motion Capture and the Presence of Performance," *Cinephilia in the Age of Digital Reproduction: Film, Pleasure and Digital Culture*, ed. Scott Balcerzak and Jason Sperb, 195–213 (London: Wallflower, 2009).

20. Joe Fordham, "Middle-earth Strikes Back," *Cinefex*, no. 92: 75.

21. Animation supervisor Randall William Cook quoted in Fordham, "Middle-earth Strikes Back," 76.

22. Joe Fordham, "Return of the King," *Cinefex*, no. 104 (January 2006): 57.

23. Quoted in Fordham, "Return of the King," 57.

24. Jody Duncan, "The Seduction of Reality," *Cinefex*, no. 120 (January 2010): 138; Cameron interview in *Capturing Avatar* (documentary), *Avatar* Blu-ray Extended Collector's Edition, disc 2 (Twentieth Century Fox Home Entertainment, 2010).

25. Prince, "True Lies," 33.

26. Andrea Alciati, *Emblematum Liber* (Leyden: Ex Officina Plantiniana Raphelengii, 1608), 77; translation of the Latin text taken from Andrea Alciati, *A Book of Emblems: The "Emblematum Liber" in Latin and English*, trans. and ed. John F. Moffitt (Jefferson: McFarland, 2002), 91.

27. Alciati, *A Book of Emblems*, trans. and ed. Moffitt, 117.

28. Alciati, *Emblematum Liber*, 122; translation of the Latin text taken from Alciati, *A Book of Emblems*, trans. and ed. Moffitt, 137.

29. See John Manning, *The Emblem* (London: Reaktion Books, 2003), 166–67.

30. Alciati, *A Book of Emblems*, trans. and ed. Moffitt, 109.

31. Gunning, "Gollum and Golem," 344.

32. Angela Ndalianis, *Neo-baroque Aesthetics and Contemporary Entertainment* (Cambridge, MA: MIT Press, 2005), 166.

33. See W. J. T. Mitchell, *The Reconfigured Eye: Visual Truth in the Post-photographic Era* (Cambridge, MA: MIT Press, 1992); Philip Rosen, *Change Mummified: Cinema, Historicity, Theory* (Minneapolis: University of Minnesota Press, 2001); D. N. Rodowick, *The Virtual Life of Film* (Cambridge, MA: Harvard University Press, 2007).

34. Scott Bukatman, *Poetics of Slumberland: Animated Spirits and the Animating Spirit* (Berkeley: University of California Press, 2012), 108, emphasis in original.

35. Fordham, "Return of the King," 68–69.

36. For a detailed discussion of the systematic symmetry that structures the plot of *King Kong* (1933), see Cynthia Erb, *Tracking King Kong: A Hollywood Icon in World Culture*, 2nd ed. (Detroit: Wayne State University Press, 2009), 102–3.

37. This plot point refers to the so-called McFarland incident, an event that took place in South Korea in 2000 during which a U.S. military officer ordered formaldehyde to be dumped into the sewer system.

38. Kyung Hyun Kim, *Virtual Hallyu: Korean Cinema of the Global Era* (Durham, NC: Duke University Press, 2011), 43.

39. Ji Sung Kim, "The Intimacy of Distance: South Korean Cinema and the Conditions of Capitalist Individuation" (PhD diss., University of California, Berkeley, 2013), 54. For an analysis of *The Host*'s role in the globalization of South Korea's film industry, see Nikki J. Y. Lee, "Localized Globalization and a Monster National: *The Host* and the South Korean Film Industry," *Cinema Journal* 50.3 (spring 2011): 45–61.

40. Kim, *Virtual Hallyu*, 44.

41. Kim, "The Intimacy of Distance," 48.

42. Christina Klein, "Why American Studies Needs to Think about Korean Cinema, or, Transnational Genres in the Films of Bong Joon-ho," *American Quarterly* 60.4 (December 2008): 873.

43. Thacker, *Biomedia*, 6, 26, 5.

44. Peter Greenaway, "New Possibilities," Avenali Lecture, Townsend Center for the Humanities, University of California, Berkeley, September 13, 2010.

45. Comments on my paper presented at "The Material and the Code" symposium, University of Chicago, February 2010.

4. THE MORPH

1. For a history of the morph, see Mark J. P. Wolf, "A Brief History of Morphing," *Meta-morphing: Visual Transformation and the Culture of Quick Change,* ed. Vivian Sobchack, 83–101 (Minneapolis: University of Minnesota Press, 2000).

2. On magic lantern shows, see Erik Barnouw, *The Magician and the Cinema* (Oxford: Oxford University Press, 1981).

3. Scott Bukatman, *Matters of Gravity: Special Effects and Supermen in the 20th Century* (Durham, NC: Duke University Press, 2003), 134–36.

4. Lev Manovich, *The Language of New Media* (Cambridge, MA: MIT Press, 2002), 295.

5. Vivian Sobchack, "Introduction," *Meta-morphing: Visual Transformation and the Culture of Quick Change*, ed. Vivian Sobchack (Minneapolis: University of Minnesota Press, 2000), xvi.

6. Sergei Eisenstein, *Eisenstein on Disney*, trans. Alan Y. Upchurch (London: Methuen, 1988), 3.

7. Eisenstein, *Eisenstein on Disney*, 64, 21.

8. Eisenstein, *Eisenstein on Disney*, 10.

9. Eisenstein, *Eisenstein on Disney*, 21.

10. Bukatman, *Matters of Gravity*, 134.

11. Eisenstein, *Eisenstein on Disney*, 43, 4.

12. Eisenstein, *Eisenstein on Disney*, 21.

13. Eisenstein, *Eisenstein on Disney*, 22.

14. *The Works of Francis Bacon*, 6:725–26. Quoted in Peter Pesic, "Shapes of Proteus in Renaissance Art," *Huntington Library Quarterly* 73.1 (March 2010): 59.

15. Homer, *The Odyssey*, trans. Allen Mandelbaum (New York: Bantam, 1990), 75–81; http://en.wikipedia.org/wiki/Proteus; Pesic, "Shapes of Proteus."

16. Virgil, *The Georgics*, Book 4, ed. Betty Radice, trans. L. P. Wilkinson (London: Penguin Books, 1982).

17. Pesic, "Shapes of Proteus," 64.

18. Andrea Alciati, *Emblematum Liber* (Leyden: Ex Officina Plantiniana Raphelengii, 1608), 189.

19. Andrea Alciati, *A Book of Emblems: The "Emblematum Liber" in Latin and English*, trans. and ed. John F. Moffitt (Jefferson: McFarland, 2002), 211.

20. Pesic, "Shapes of Proteus," 64.

21. Eisenstein, *Eisenstein on Disney*, 64.

22. Eisenstein, *Eisenstein on Disney*, 21–22.

23. See especially Matthew Solomon, "Quick Change in the 1890s: 'Twenty-Five Heads under One Hat,'" *Meta-morphing: Visual Transformation and the Culture of Quick Change*, ed. Vivian Sobchack (Minneapolis: University of Minnesota Press, 2000).

24. Pesic, "Shapes of Proteus," 63.

25. Sir Francis Bacon, *The Works of Francis Bacon, Lord Chancellor of England: A New Edition*, vol. 2, ed. Basil Montagu (London: William Pickering, 1825), 196.

26. Solomon, "Quick Change in the 1890s," 13.

27. Eisenstein, *Eisenstein on Disney*, 22.

28. Elias Canetti, *Crowds and Power* (New York: Farrar, Straus and Giroux, 1984), 345.

29. Sobchack argues that one of the defining features of the morph is its figural ability to collapse all distinction and assert "the sameness of difference." Vivian Sobchack, "'At the Still Point of the Turning World': Meta-morphing and Meta-stasis," *Meta-morphing: Visual Transformation and the Culture of Quick Change*, ed. Vivian Sobchack (Minneapolis: University of Minnesota Press, 2000), 139.

30. Scott Bukatman, "Taking Shape: Morphing and the Performance of Self," *Meta-morphing: Visual Transformation and the Culture of Quick Change*, ed. Vivian Sobchack (Minneapolis: University of Minnesota Press, 2000), 240.

31. Patrick Crogan, "Things Analog and Digital," *Senses of Cinema*, no. 5 (April 2000), http://www.sensesofcinema.com/2000/5/digital/ (accessed July 2012), 5.

32. Crogan, "Things Analog and Digital," 5.

33. Sobchack, "At the Still Point of the Turning World," 137.

34. Stephen Prince, "Dread, Taboo and *The Thing*: Toward a Social Theory of the Horror Film," *Wide Angle* 10.3 (1988): 26.

35. Eisenstein, *Eisenstein on Disney*, 21.

36. Solomon, "Quick Change in the 1890s," 3.

37. Philip Rosen, *Change Mummified: Cinema, Historicity, Theory* (Minneapolis: University of Minnesota Press, 2001), 324.

38. Sobchack, "Introduction," xii.

CONCLUSION

1. Emanuele Tesauro, *Idea delle Perfette Imprese*, 488. Quoted in Robin Raybould, *An Introduction to the Symbolic Literature of the Renaissance* (Oxford: Trafford, 2005), 253.

2. See, for example, Annette Kuhn, "Introduction," *Alien Zone II*, ed. Annette Kuhn, 1–9 (London: Verso, 1999); and Wanda Strauven, "Introduction to an Attractive Concept," and Viva Paci, "The Attraction of the Intelligent Eye: Obsessions with the Vision Machine in Early Film Theories," both in *The Cinema of Attractions Reloaded*, ed. Wanda Strauven, 11–27 and 121–37 (Amsterdam: Amsterdam University Press, 2006).

3. Manning, *The Emblem*, 85.

4. Stephen Prince, *Digital Visual Effects in Cinema: The Seduction of Reality* (New Brunswick, NJ: Rutgers University Press, 2012), 226.

5. Rob White, "Interview with Manuel Alberto Claro," *Film Quarterly* 65.4 (summer 2012): 20.

6. Steven Shaviro, "Melancholia: Or, The Romantic Anti-sublime," ed. Catherine Grant and Russell Pearce, *Sequence* 1.1 (2012): 7, http://reframe.sussex.ac.uk/sequence1/1-1-melancholia-or-the-romantic-anti-sublime/ (accessed July 3, 2013).

7. Geffrey Whitney, *A Choice of Emblemes* (Leiden, 1586), 130. Quoted in John Manning, *The Emblem* (London: Reaktion Books, 2003), 276.

8. Shaviro, "*Melancholia*: Or, The Romantic Anti-sublime," 10, 27.

9. Manohla Dargis, "This Is How the End Begins," *New York Times*, December 30, 2011 (Arts section).

10. Walter Benjamin, *The Origin of German Tragic Drama*, trans. John Osborne (London: Verso, 2009), 224.

11. Manning, *The Emblem*, 275.

12. Manning, *The Emblem*, 285.

13. Manning, *The Emblem*, 284.

14. Steven Shaviro notes that "it is precisely because of her everyday competence, and her attachment to normative bourgeois family life, that Claire is unable to cope with the threat of universal destruction." Shaviro, "*Melancholia*: Or the Romantic Anti-sublime," 23.

15. Geoff King, *Spectacular Narratives: Hollywood in the Age of the Blockbuster* (New York: I. B. Tauris, 2000), 48.

16. Prince, *Digital Visual Effects*, 225.

BIBLIOGRAPHY

Acland, Charles. *Screen Traffic: Movies, Multiplexes, and Global Culture*. Durham, NC: Duke University Press, 2003.

Alciati, Andrea. *A Book of Emblems: The "Emblematum Liber" in Latin and English*. Translated and edited by John F. Moffitt. Jefferson: McFarland, 2002.

————. *Emblematum Liber*. Leyden: Ex Officina Plantiniana Raphelengii, 1608.

Allen, Michael. "The Impact of Digital Technologies on Film Aesthetics." *The New Media Book*, edited by Dan Harries, 109–18. London: Palgrave Macmillan, 2002.

Bachelard, Gaston. *Air and Dreams: An Essay on the Imagination of Movement*. Dallas: Dallas Institute Publications, 2002.

Bacon, Sir Francis. *The Works of Francis Bacon, Lord Chancellor of England: A New Edition*. 16 vols. Edited by Basil Montagu. London: William Pickering, 1825–34.

Bakhtin, M. M. *The Dialogic Imagination: Four Essays*. Edited by Michael Holquist. Translated by Caryl Emerson and Michael Holquist. Austin: University of Texas Press, 1981.

Balcerzak, Scott. "Andy Serkis as Actor, Body and Gorilla: Motion Capture and the Presence of Performance." *Cinephilia in the Age of Digital Reproduction: Film, Pleasure and Digital Culture*, edited by Scott Balcerzak and Jason Sperb, 195–213. London: Wallflower, 2009.

Balides, Constance. "Jurassic Post-Fordism: Tall Tales of Economics in the Theme Park." *Screen* 41.2 (summer 2000): 139–60.

Barnouw, Erik. *The Magician and the Cinema*. Oxford: Oxford University Press, 1981.

Belton, John. "Digital Cinema: A False Revolution." *The Film Theory Reader: Debates and Arguments*, edited by Marc Furstenau, 282–93. London: Routledge, 2010.

————. *Widescreen Cinema*. Cambridge, MA: Harvard University Press, 1992.

Benjamin, Walter. *The Origin of German Tragic Drama*. Translated by John Osborne. London: Verso, 2009.

Berry, Chris, and Mary Farquhar. *China on Screen: Cinema and Nation*. Cambridge: Cambridge University Press, 2006.

Bode, Lisa. "No Longer Themselves? Framing Digitally Enabled Posthumous 'Performance.'" *Cinema Journal* 49.4 (summer 2010): 46–70.

Bolter, Jay, and Richard Grusin. *Remediation*. Cambridge, MA: MIT Press, 2000.

Bukatman, Scott. "The Artificial Infinite: On Special Effects and the Sublime." *Visual Display: Culture beyond Appearances*, edited by Lynne Cooke and Peter Wollen, 255–89. Seattle: Bay Press, 1995.

———. *Matters of Gravity: Special Effects and Supermen in the 20th Century*. Durham, NC: Duke University Press, 2003.

———. *The Poetics of Slumberland: Animated Spirits and the Animating Spirit*. Berkeley: University of California Press, 2012.

———. "Taking Shape: Morphing and the Performance of Self." *Meta-morphing: Visual Transformation and the Culture of Quick Change*, edited by Vivian Sobchack, 225–49. Minneapolis: University of Minnesota Press, 2000.

Canetti, Elias. *Crowds and Power*. New York: Farrar, Straus and Giroux, 1984.

Cats, Jacob, and Robert Farlie. *Moral Emblems: With Aphorisms, Adages, and Proverbs of All Ages and Nations*. Illustrated by John Leighton. Edited and translated by Richard Pigot. London: Longman, Green, Longman and Roberts, 1860.

Clarke, Frederick. "The Making of *The Birds*." *Cinefantastique* 10.2 (1980): 14–35.

Cook, David. *A History of Narrative Film*, 4th ed. London: W. W. Norton, 2004.

Cowan, Bainard. "Walter Benjamin's Theory of Allegory." *New German Critique* 22 (winter 1981): 109–22.

Creed, Barbara. "The Cyberstar: Digital Pleasures and the End of the Unconscious." *Screen* 41.1 (2000): 79–85.

Crogan, Patrick. "Things Analog and Digital." *Senses of Cinema*, no. 5 (April 2000). Accessed July 2012. http://www.sensesofcinema.com/2000/5/digital/.

Cubbitt, Sean. "Digital Filming and Special Effects." *The New Media Book*, edited by Dan Harries, 17–29. London: Palgrave Macmillan, 2002.

Dargis, Manohla. "This Is How the End Begins." *New York Times*, December 30, 2011 (Arts section).

Dimendberg, Ed. *Film Noir and the Spaces of Modernity*. Cambridge, MA: Harvard University Press, 2004.

Dixon, Wheeler Winston. "Twenty-Five Reasons Why It's All Over." *The End of Cinema As We Know It: American Film in the Nineties*, edited by Jon Lewis, 356–66. New York: New York University Press, 2001.

Doane, Mary Ann. *Femmes Fatales: Feminism, Film Theory, Psychoanalysis*. London: Routledge, 1991.

Duncan, Jody. "The Seduction of Reality." *Cinefex*, no. 120 (January 2010): 68–146.

———. "The Beauty in the Beasts." *Cinefex*, no. 55 (August 1993): 42–95.

Edgerton, David. *The Shock of the Old: Technology and Global History since 1900*. London: Oxford University Press, 2007.

Eisenstein, Sergei. "The Dynamic Square." *S. M. Eisenstein: Selected Writings 1922–1934*, edited by Richard Taylor, 206–18. Bloomington: Indiana University Press, 1988.

———. *Eisenstein on Disney*. Translated by Alan Y. Upchurch. London: Methuen, 1988.

Elsaesser, Thomas. "The New Film History as Media Archaeology." *Cinémas: Journal of Film Studies* 14.2–3 (2004): 75–117.

———. "Tales of Sound and Fury: Observations on the Family Melodrama." *Home Is Where the Heart Is: Studies in Melodrama and the Woman's Film*, edited by Christine Gledhill, 43–69. London: BFI, 1987.

Erb, Cynthia. *Tracking King Kong: A Hollywood Icon in World Culture*, 2nd ed. Detroit: Wayne State University Press, 2009.

Faden, Eric S. "Crowd Control: Early Cinema, Sound, and Digital Images." *Journal of Film and Video* 53.2–3 (2001): 93–106.

Finlay, Ian Hamilton, and Ron Costley. *Heroic Emblems*. Calais and Vermont: Z Press, 1977.

Fordham, Joe. "Return of the King." *Cinefex*, no. 104 (January 2006): 42–81, 123.

———. "Middle-earth Strikes Back." *Cinefex*, no. 92: 70–142.

Geuens, Jean-Pierre. "The Digital World Picture." *Film Quarterly* 55.4 (summer 2002): 16–27.

Greenaway, Peter. "New Possibilities." Avenali Lecture, Townsend Center for the Humanities, University of California, Berkeley, September 13, 2010.

Gunning, Tom. "The Cinema of Attractions: Early Film, Its Spectator, and the Avant-Garde. *Wide Angle* 8.3–4 (fall 1986): 63–70.

———. *The Films of Fritz Lang: Allegories of Vision and Modernity*. London: BFI, 2008.

———. "Gollum and Golem: Special Effects and the Technology of Artificial Bodies." *From Hobbits to Hollywood: Essays on Peter Jackson's "Lord of the Rings,"* edited by Ernest Mathijs and Murray Pomerance, 319–49. Amsterdam: Rodopi, 2006.

———. "Moving Away from the Index: Cinema and the Impression of Reality." *differences* 18.1 (2007): 29–52.

———. "Now You See It, Now You Don't: The Temporality of the Cinema of Attractions." *The Silent Cinema Reader*, edited by Lee Grieveson and Peter Kramer, 41–50. London: Routledge, 2004.

———. "What's the Point of an Index? Or, Faking Photographs." *Still/Moving: Between Cinema and Photography*, edited by Karen Beckmann and Jean Ma, 23–40. Durham, NC: Duke University Press, 2008.

Hall, Sheldon, and Steve Neale. *Epics, Spectacles and Blockbusters: A Hollywood History*. Detroit: Wayne State University Press, 2010.

Hansen, Miriam. *Babel and Babylon: Spectatorship in American Silent Film*. Cambridge, MA: Harvard University Press, 1994.

———. "The Mass Production of the Senses: Classical Cinema as Vernacular Modernism." *Reinventing Film Studies*, edited by Christine Gledhill and Linda Williams, 332–50. London: Arnold, 2000.

Hardt, Michael, and Antonio Negri. *Multitude: War and Democracy in the Age of Empire*. New York: Penguin, 2005.

Hartlaub, Peter. "Film Review: The Day the Earth Stood Still." *San Francisco Chronicle*, December 12, 2008 (Entertainment section).

Hoberman, J. "Man with No Name Tells Story of Heroics, Color Coordination." *Village Voice*, August 23, 2004. Accessed July 1, 2013. http://www.villagevoice.com /film/0434,hoberman2,56140,20.html.

Homer. *The Odyssey*. Translated by Allen Mandelbaum. New York: Bantam, 1990.

Huyssen, Andreas. "The Urban Miniature and the Feuilleton in Kracauer and

Benjamin." *Culture in the Anteroom: The Legacies of Siegfried Kracauer*, edited by Gerd Gemunden and Johannes von Moltke, 213–25. Ann Arbor: University of Michigan Press, 2012.

Jaeger, Bernd. "Horizontality and Verticality: A Phenomenological Exploration into Lived Space." *Duquesne Studies in Phenomenological Psychology*, vol. 1, 212–35. Pittsburgh: Duquesne University Press, 1971.

Jenkins, Henry. *Convergence Culture: Where Old and New Media Collide*. New York: New York University Press, 2008.

Kaes, Anton. "Movies and Masses." *Crowds*, edited by Jeffrey T. Schnapp and Matthew Tiews, 149–57. Stanford: Stanford University Press, 2006.

Kim, Ji Sung. "The Intimacy of Distance: South Korean Cinema and the Conditions of Capitalist Individuation." PhD dissertation, University of California, Berkeley, 2013.

Kim, Kyun Hyun. *Virtual Hallyu: Korean Cinema of the Global Era*. Durham, NC: Duke University Press, 2011.

King, Geoff. *New Hollywood Cinema: An Introduction*. New York: Columbia University Press, 2002.

————. *Spectacular Narratives: Hollywood in the Age of the Blockbuster*. New York: I. B. Tauris, 2000.

Klein, Christina. "*Crouching Tiger, Hidden Dragon*: A Diasporic Reading." *Cinema Journal* 43.4 (summer 2004): 18–42.

————. "Why American Studies Needs to Think about Korean Cinema, or, Transnational Genres in the Films of Bong Joon-ho. *American Quarterly* 60.4 (December 2008): 871–98.

Kracauer, Siegfried. *The Mass Ornament: Weimar Essays*. Translated by Thomas Y. Levin. Cambridge, MA: Harvard University Press, 1995.

Kuhn, Annette. "Introduction." *Alien Zone II*, edited by Annette Kuhn, 1–9. London: Verso, 1999.

Lau, Jenny Kowk Wah. "*Ju Dou*: A Hermeneutical Reading of Cross-Cultural Cinema." *Film Quarterly* 25.2 (winter 1991–92): 2–10.

La Valley, Albert J. "Traditions of Trickery: The Role of Special Effects in the Science Fiction Film." *Shadows of the Magic Lamp*, edited by George Slusser and Eric S. Rabkin, 141–58. Carbondale: Southern Illinois University Press, 1985.

Le Bon, Gustave. *The Crowd: A Study of the Popular Mind*. Mineola, NY: Dover, 2002. Reprint ed.

Lee, Nikki J. Y. "Localized Globalization and a Monster National: *The Host* and the South Korean Film Industry." *Cinema Journal* 50.3 (spring 2011): 45–61.

Manning, John. *The Emblem*. Reprint. London: Reaktion Books, 2003.

Manovich, Lev. *The Language of New Media*. Cambridge, MA: MIT Press, 2002.

Mathijs, Ernest, and Murray Pomerance, eds. *From Hobbits to Hollywood: Essays on Peter Jackson's "Lord of the Rings."* Amsterdam: Rodopi, 2006.

McQuire, Scott. "Impact Aesthetics: Back to the Future in Digital Cinema? Millennial Fantasies." *Convergence* 6.2 (2000): 41–61.

Metz, Christian. "*Trucage* and the Film." *Critical Inquiry* 3.4 (summer 1977): 657–75.

Mitchell, W. J. T. *The Reconfigured Eye: Visual Truth in the Post-photographic Era*. Cambridge, MA: MIT Press, 1992.

Munich, Adrienne, and Maura Spiegel. "Heart of the Ocean: Diamonds and Desire in *Titanic*." *Titanic: Anatomy of a Blockbuster*, edited by Kevin S. Sandler and Gaylyn Studlar, 155–68. New Brunswick, NJ: Rutgers University Press, 1999.

Ndalianis, Angela. *Neo-baroque Aesthetics and Contemporary Entertainment*. Cambridge, MA: MIT Press, 2005.

Neale, Steve. "Melodrama and Tears." *Screen* 27.6 (December 1986): 6–23.

North, Dan. *Performing Illusions: Cinema, Special Effects, and the Virtual Actor*. London: Wallflower, 2008.

Ouellette, Laurie. "Ship of Dreams: Cross-Class Romance and the Cultural Fantasy of *Titanic*." *Titanic: Anatomy of a Blockbuster*, edited by Kevin S. Sandler and Gaylyn Studlar, 169–88. New Brunswick, NJ: Rutgers University Press, 1999.

Paci, Viva. "The Attraction of the Intelligent Eye: Obsessions with the Vision Machine in Early Film Theories." *The Cinema of Attractions Reloaded*, edited by Wanda Strauven, 121–37. Amsterdam: Amsterdam University Press, 2006.

Pesic, Peter. "Shapes of Proteus in Renaissance Art." *Huntington Library Quarterly* 73.1 (March 2010): 57–82.

Pierson, Michele. *Special Effects: Still in Search of Wonder*. New York: Columbia University Press, 2002.

Pinkus, Karen. "Emblematic Time." *New Directions in Emblem Studies*, edited by Amy Wygant, 93–108. Glasgow: Glasgow Emblem Studies, 1999.

Pollack, Andrew. "Computer Images Stake Out New Territory." *New York Times*, July 23, 1991 (Arts section).

Prince, Stephen. *Digital Visual Effects in Cinema: The Seduction of Reality*. New Brunswick, NJ: Rutgers University Press, 2012.

———. "Dread, Taboo and *The Thing*: Toward a Social Theory of the Horror Film." *Wide Angle* 10.3 (1988): 19–29.

———. "The Emergence of Filmic Artifacts: Cinema and Cinematography in the Digital Era." *Film Quarterly* 57.3 (2004): 24–33.

———. "True Lies: Perceptual Realism, Digital Images, and Film Theory." *Film Quarterly* 49.3 (spring 1996): 27–37.

Raybould, Robin. *An Introduction to the Symbolic Literature of the Renaissance*. Oxford: Trafford, 2005.

Rehak, Bob. "The Migration of Forms: Bullet Time as Microgenre." *Film Criticism* 32.1 (fall 2007): 26–48.

Rheingold, Howard. *Smart Mobs: The Next Social Revolution*. New York: Basic Books, 2002.

Rickett, Richard. *Special Effects: History and Technique*. New York: Billboard Books, 2007.

Riskin, Jessica. "The Defecating Duck, or, The Ambiguous Origins of Artificial Life." *Critical Inquiry* 29.4 (summer 2003): 599–633.

Robertson, Barbara. "The Big and the Sméagol." *Computer Graphics World* 27.1 (January 2004): 16–22.

Rodowick, D. N. *The Virtual Life of Film*. Cambridge, MA: Harvard University Press, 2007.

Rogin, Michael. *Independence Day, or How I Learned to Stop Worrying and Love the Enola Gay*. London: BFI, 1998.

Rosen, Philip. *Change Mummified: Cinema, Historicity, Theory*. Minneapolis: University of Minnesota Press, 2001.

Sammon, Paul. "Bug Bytes." *Cinefex*, no. 73 (March 1998): 66–90.

Sandler, Kevin S., and Gaylyn Studlar. *Titanic: Anatomy of a Blockbuster*. New Brunswick, NJ: Rutgers University Press, 1999.

Schnapp, Jeffrey T. "Mob Porn." *Crowds*, edited by Jeffrey T. Schnapp and Matthew Tiews, 1–45. Stanford: Stanford University Press, 2006.

Shaviro, Steven. "Melancholia: Or, The Romantic Anti-sublime." Edited by Catherine Grant and Russell Pearce. *Sequence* 1.1 (2012): 1–55. Accessed July 3, 2013. http://reframe.sussex.ac.uk/sequence1/1-1-melancholia-or-the-romantic-anti- sublime/.

Sobchack, Vivian. "'At the Still Point of the Turning World': Meta-morphing and Meta-stasis." *Meta-morphing: Visual Transformation and the Culture of Quick Change*, edited by Vivian Sobchack, 130–58. Minneapolis: University of Minnesota Press, 2000.

———. "Introduction." *Meta-morphing: Visual Transformation and the Culture of Quick Change*, edited by Vivian Sobchack, xi–xxiii. Minneapolis: University of Minnesota Press, 2000.

———. *Screening Space: The American Science Fiction Film*. New Brunswick, NJ: Rutgers University Press, 1997.

Solomon, Matthew. "Quick Change in the 1890s: 'Twenty-Five Heads under One Hat.'" *Meta-morphing: Visual Transformation and the Culture of Quick Change*, edited by Vivian Sobchack, 3–20. Minneapolis: University of Minnesota Press, 2000.

Strauven, Wanda. "Introduction to an Attractive Concept." *The Cinema of Attractions Reloaded*, edited by Wanda Strauven, 11–27. Amsterdam: Amsterdam University Press, 2006.

Thacker, Eugene. *Biomedia*. Minneapolis: University of Minnesota Press, 2004.

———. "Networks, Swarms, Multitudes: Part Two." *CTheory*, a142b, May 18, 2004. Accessed May 29, 2009. http://www.ctheory.net/articles.aspx?id=423.

Thompson, Kirsten Moana. "Scale, Spectacle, and Movement: MASSIVE Software and Digital Special Effects in *The Lord of the Rings*." *From Hobbits to Hollywood: Essays on Peter Jackson's "Lord of the Rings,"* edited by Ernest Mathijs and Murray Pomerance, 283–99. Amsterdam: Rodopi, 2006.

Thorburn, David, and Henry Jenkins. "Introduction: Towards an Aesthetics of Transition." *Rethinking Media Change: The Aesthetics of Transition*, edited by David Thorburn and Henry Jenkins, 1–16. Cambridge, MA: MIT Press, 2004.

Tomasulo, Frank. "The Mass Psychology of Fascist Cinema: Leni Riefenstahl's *Triumph of the Will*." *Documenting the Documentary: Close Readings of Documentary Film and Video*, edited by Barry Keith Grant and Jeannette Sloniowski, 99–118. Detroit: Wayne State University Press, 1998.

Tryon, Chuck. *Reinventing Cinema: Movies in the Age of Media Convergence*. New Brunswick, NJ: Rutgers University Press, 2009.

Virgil. *The Georgics*. Edited by Betty Radice. Translated by L. P. Wilkinson. London: Penguin Books, 1982.

Warlick, M. E. "Art, Allegory and Alchemy in Peter Greenaway's *Prospero's Books*." *New Directions in Emblem Studies*, edited by Amy Wygant, 109–36. Glasgow: Glasgow Emblem Studies, 1999.

White, Rob. "Interview with Manuel Alberto Claro." *Film Quarterly* 65.4 (summer 2012): 17–20.

Whitney, Geffrey. *A Choice of Emblems*. Leiden, 1586.

Williams, Raymond. *Marxism and Literature*. Oxford: Oxford University Press, 1978.

Wolf, Mark J. P. "A Brief History of Morphing." *Meta-morphing: Visual Transformation and the Culture of Quick Change*, edited by Vivian Sobchack, 83–101. Minneapolis: University of Minnesota Press, 2000.

Zhang, Zhen. "Bodies in the Air: The Magic of Science and the Fate of Early 'Martial Arts' Film in China." *Post Script* 20.2–3 (2000): 43–60.

INDEX

Page numbers in *italics* refer to figures.

77–78; sudden appearance in films, 67–68, 72; technologies, 59–60, 88; visual pleasure and, 60, 88

digital remediation, 56, 168–69

digital visual effects, 2–3; combined with analog effects, 16, 91, 169, 174, 184; deployment of, 13; historical contexts of, 4; scholarship on, 3–4, 115, 168; technologies, 184. *See also* spectacular digital effects

Dimendberg, Ed, 189n9

disasters, 88

Disney, 17–18, 133–34

Dr. Jekyll and Mr. Hyde (Mamoulian), 50, 159, 184; psychological repression in, 150–51, 175; transformation scene, 18, 139–40, *141*, 142

Dr. Strangelove (Kubrick), 24

Edgerton, David, 89

effects emblems: allegorical significance of, 12–13, 171–72, 174, 184; definition and function of, 6, 171–72; digital creatures as, 100; film narrative and, 6–7, 12, *171*, 184; historical changes and, 18–19, 57, 88; in independent films, 175; in *Melancholia*, 175–79, 181–83; morphs as, 138–39, 158, 162, 166, 168–69; multitudes as, 60, 70–71, 86, 88; verticality as, 30, 57–58; viewing pleasure and spectatorship of, 172, 173–74

Eisenstein, Sergei, 21, 34, 58, 153; on animation and plasmaticness, 17, 132–34, 136–37, 148; *October*, 61

El Cid (Mann), 61

Elsaesser, Thomas, 5–6

Emblematum Liber (Alciati), 7–8; "About Astrologers," 8–10, *9*; "About Reckless People," 22–24, *23*; "Gluttony," 112; "Lust," 107, *110*; "Sirens," 107, *110*, *111*; "Whatever Is Most Ancient Is Imaginary," 135, *136*

emblem books, 7–8, 107, 173; and cinematic visual effects differences, 171–72; focus on death, 182–83; temporality themes in, 177. See also *Emblematum Liber* (Alciati)

emblems: of apocalypse, 70–74, 82, 86–87, 177; baroque, 12, 18–19, 112; concepts and usage, 6–8, 12; digital creatures as, 129; and images of verticality, 22–24, 53; of loss, 125; of Proteus, 134–38. *See also* effects emblems; emblem books

Emmerich, Roland: *The Day after Tomorrow*, 27; *Godzilla*, 26, 106, *109*, 115–16, *116*; *Independence Day*, 25, 67, 81, 84–85; *2012*, 27

E.T. (Spielberg), 24

exhibition practices, 1, 5

Farlie, Robert, 8, 10–11, *11*, 62, 81

figure, definition of, 93

Fordham, Joe, 104–5

Forrest Gump (Zemeckis), 14, 60

freedom: from confinement/constraint, 137–38, 142–43, 155; and control aspects, 160–64; protagonists' desire for, 27, 151–53, 159

Gandhi (Attenborough), 61

genetic and binary code convergence, 17, 94–95, 119, 129; in *Avatar*, 127–28; in *X-Men*, 157

genetic mutation (mutants): of Bruce Banner (the Hulk), 151, 158–59; in *X-Men*, 148–50, 156–58, *157*, 165–66

Geuens, Jean-Pierre, 14

globalization, 19, 87

Godzilla (Emmerich), 26, 106, *109*, 115–16, *116*

Godzilla/Gojira (Honda), *108*

gravity-defying action: in *Avatar*, 51; in *Crouching Tiger, Hidden Dragon*, 41; in *Hero*, 34–37, *37*; in *The Matrix*, 45–46, 175; settings for, 3; verticality and, 27, 29

Greek mythology: *The Odyssey*, 134–35; Phaeton, 22–24, *23*, 57; Proteus, 17, 133–38, *136*, 155

Greenaway, Peter, 128

green screens, 2, 14

Grusin, Richard, 188n46

Gunning, Tom, 5, 12, 96, 113, 185n4

themes, 162; historical and evolution-
ary themes, 45, 65; morphs, 153–56,
154, 162–63, 163; plasmatics and prison
worlds, 147–48; skyscraper imagery,
46–47; vertical action in, 44–46, 46, 47
media: digital, 168–69; old and new con-
vergence, 1–2, 188n46
Melancholia (von Trier), 18, 181; allegorical
meanings in, 181–82; prologue shots,
175–79, 177, 179, 182–83, 183; protago-
nists' psychological states, 176, 179–81,
180
Merbabies (Disney), 133–34
metamorphosis, 17, 130–31; Eisenstein's
discussion of, 17, 132, 134, 137; freedom
dynamic, 137, 155; of Jekyll into Hyde,
139–40, 141, 142; of the Thing, 166–69.
See also morphs; transformations
Mission: Impossible (De Palma), 25
mobility: downward, 29, 47, 49, 55; of
morphs, 159–60, 162; themes in
Titanic, 33–35; upward, 26, 28; verti-
cal, 53
Moffitt, John F., 8
*Moral Emblems: With Aphorisms, Adages,
and Proverbs of All Ages and Nations*
(Cats and Farlie), 8, 10–11, 11, 62, 81
morphs: and digital remediation, 169;
endings to films featuring, 164–66;
freedom and control aspects of, 17–18,
130, 137–38, 160–64; function of, 131;
genetic mutations, 148–50; in *The
Matrix*, 153–56, 154, 162–63, 163; mo-
bility of, 159–60, 162; origins and ana-
log precursors of, 132; prison settings
for, 17, 137–38, 142–47; software pro-
grams, 17, 131; in *Terminator 2: Judg-
ment Day*, 142, 152–53, 153; in *X-Men*,
156–59, 157. *See also* metamorphosis;
plasmatics/plasmaticness; transfor-
mations
motion capture technologies, 3, 14; for
emotions and expressions, 104–5
multitudes. *See* digital multitudes
Mummy, The (Sommers), 59, 101, 121; his-
torical occultation in, 63; Imhotep,
104, 113; prologue, 64

Mummy Returns, The (Sommers), 105–6,
106
mutants. *See* genetic mutation

Naked Jungle, The (Haskin), 62
narrative: effects emblems and, 6–7, 12,
171, 184; spectacular digital effects
and, 4–6, 173, 184
Ndalianis, Angela, 3, 86, 114
Negri, Antonio, 19, 78, 192n25
New Media, 3
Nutty Professor, The (Shadyac), 132, 160,
163

October (Eisenstein), 61
Odyssey, The (Homer), 134–35
ossification, 165–66

Pesic, Peter, 135, 138
Phaeton, myth of, 22–24, 23, 57
photorealistic images, 2; audience re-
action to, 129; of creatures, 13, 15–16,
92, 95; of morphs, 132
Pierson, Michele, 3
plasmatics/plasmaticness, 13; Eisenstein's
concept of, 17, 133–34, 136–37; and ge-
netic mutation, 148–50; and liberation
and imprisonment concepts, 151–58,
165–66; and prison worlds, 146–51;
and psychological repression, 150–51,
158–59. *See also* morphs
Poseidon Adventure, The (Neame), 24
postproduction practices, 1–3, 79
Prince, Stephen, 96, 105, 185n4; on digi-
tal effects, 2–4, 174, 183; on *The Thing*,
167–68
protagonists: desire for freedom, 27,
151–53, 159; occulted histories of,
85–86; photographing/filming digital
creatures, 115–17; power struggles, 38,
56, 81–82. *See also* psychological in-
teriorities
Proteus, myth of, 17, 133–38, 136, 155
psychological interiorities, 5, 92, 174; of
protagonists in *Melancholia*, 176, 179–
81; repression concept, 138, 150–51,
158–59, 163, 175

unity, 10–11, 77, 192n25. *See also* collectivity/the collective

Van Helsing (Sommers), 66
Vaucanson, Jacques de, 94
vernacular modernism, 18
verticality and vertical axis: conflict and power struggles and, 28, 39–40; emblematic functions of, 22–24, 57–58; gravity and laws of physics and, 26–27, 29–30, 42, 56–57; historical continuity and, 26–27, 56–57; in 1970s films, 24–25; in 1980s and 1990s films, 21, 25; polarizing extremes and spatiality of, 22, 25–26, 34, 40; software and technologies, 13–14, 25, 56–57, 186n9. *See also* gravity-defying action

vital, definition of, 93
vitality (of digital creatures): deadly, 92–93, 96, 99–103, 112, 115, 123; excessive, 125, 129; networked, 126–27; unpredictable and uncontrollable, 120–21

War of the Worlds, The (Spielberg), 26–27
Williams, Raymond, 28
Willow (Howard), 131

X-Men (Singer), 131, 173; film's ending, 165–66; morphs, 156–60, 157; plasmaticness in, 148–49

Zemeckis, Robert: *Back to the Future Part III*, 25; *Forrest Gump*, 14, 60
Zhang, Zhen, 189n9